This book belongs to

...........................

IN
THE
GARDEN
OF MY
DREAMS

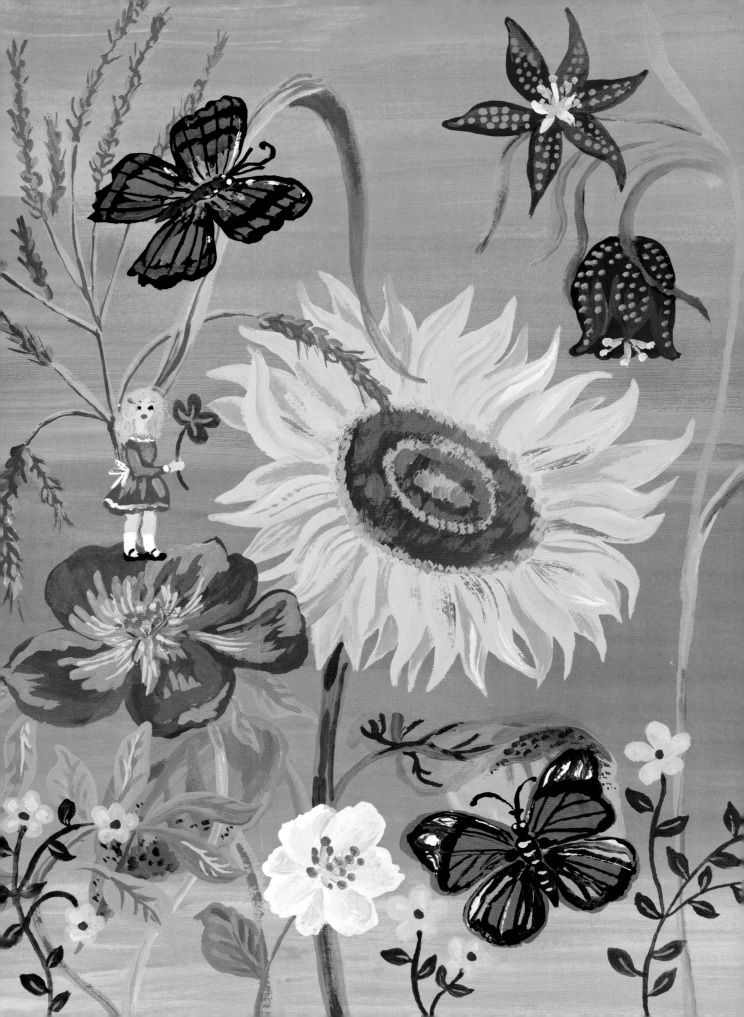

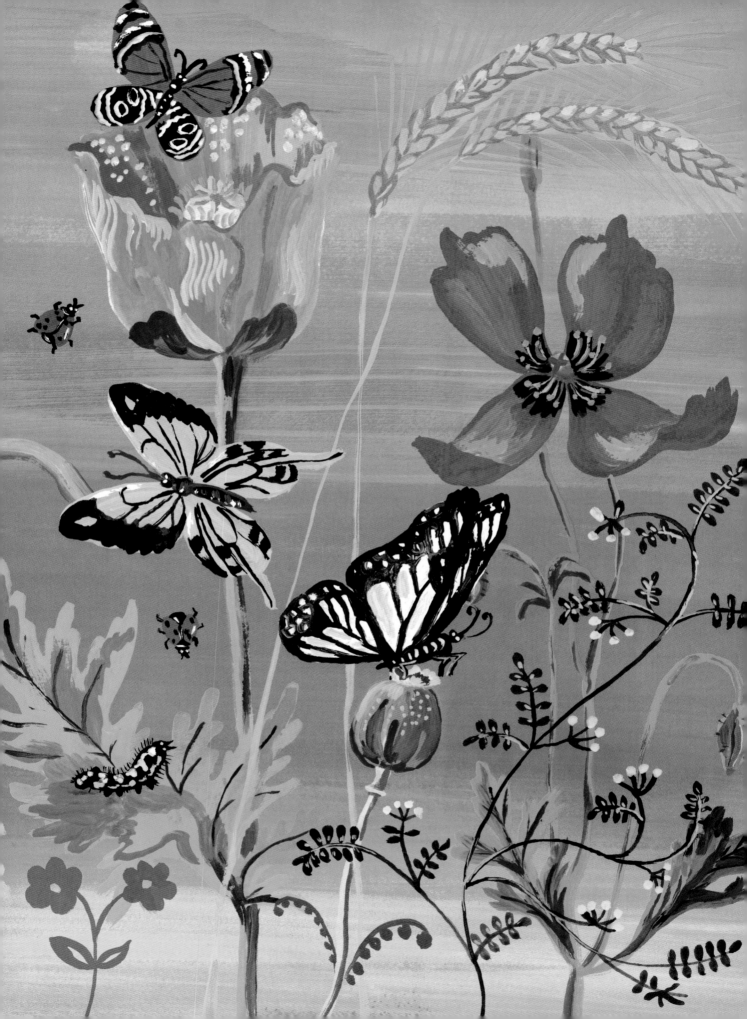

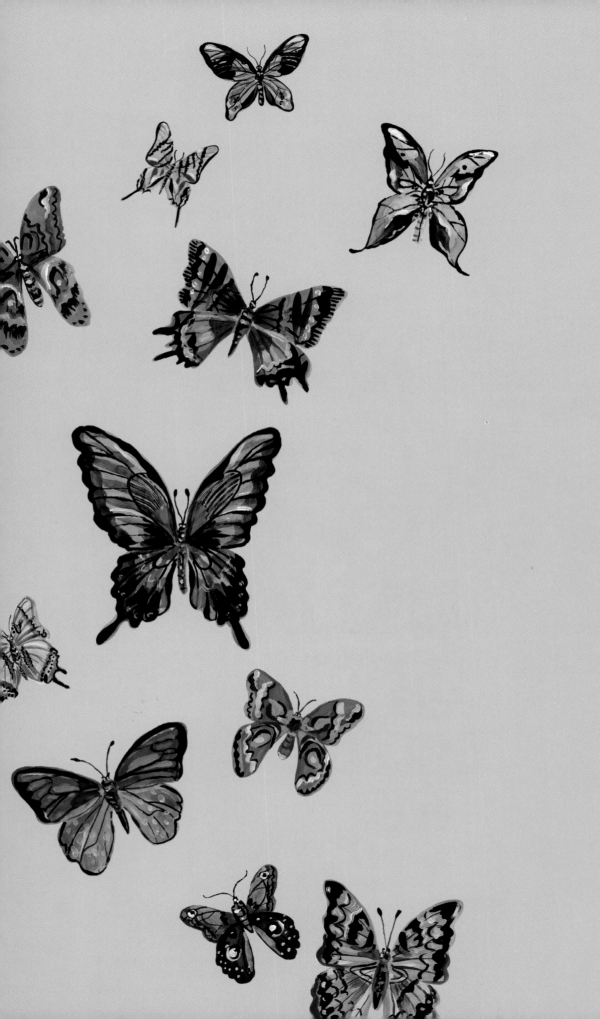

In the Garden of My Dreams

The Art of Nathalie Lété

FOREWORD BY *John Denian*

ARTISAN NEW YORK

Library of Congress Cataloging-in-Publication Data

Names: Lété, Nathalie, 1964–, artist.
Title: In the garden of my dreams / Nathalie Lété.
Description: New York : Artisan, a division of
Workman Publishing Co., Inc., 2017. | English and French.
Identifiers: LCCN 2017024232 | ISBN 9781579657215 (paper-over-board)
Subjects: LCSH: Lété, Nathalie, 1964—Themes, motives.
Classification: LCC ND553.L8384 A4 2017 | DDC 759.4—dc23 LC
record available at https://lccn.loc.gov/2017024232

Design by Nathalie Lété and Jane Treuhaft

Preceding artwork: "The Field of Flowers" ("Le champ de fleurs")

Artisan books are available at special discounts when purchased in bulk for
premiums and sales promotions as well as for fund-raising or educational use.
Special editions or book excerpts also can be created to specification. For details,
contact the Special Sales Director at the address below, or send an e-mail to
specialmarkets@workman.com.

Published by Artisan
A division of Workman Publishing Co., Inc.
225 Varick Street
New York, NY 10014-4381
artisanbooks.com

Artisan is a registered trademark of Workman Publishing Co., Inc.

Published simultaneously in Canada by Thomas Allen & Son, Limited

Printed in China

First printing, October 2017

2 4 6 8 10 9 7 5 3 1

Objets inanimés, avez-vous donc une âme
qui s'attache à notre âme et la force d'aimer?

—ALPHONSE DE LAMARTINE

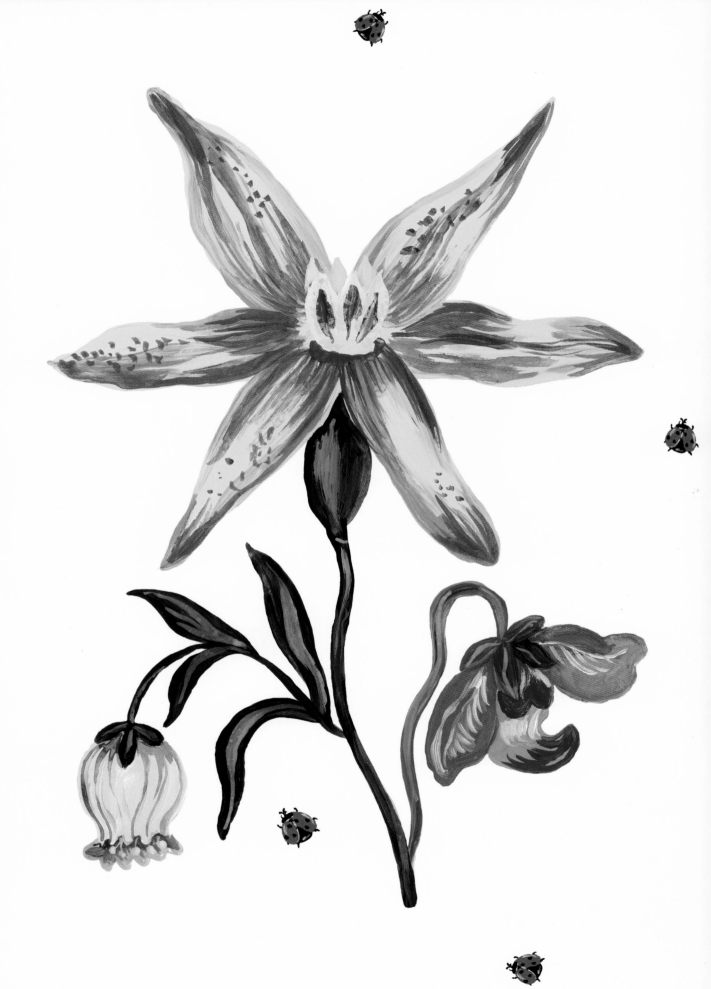

FOREWORD

During a trip to Paris in the early 2000s, I was stopped in my tracks by a large diorama of a butcher's shop that was displayed in a window of the upscale boutique Absynthe. The meat cuts were handmade, and hand-painted fabric pieces were hanging from butcher hooks, with friendly, painted-on faces. The colors were vibrant and the presentation was whimsical, but at the same time dark and deep. This dichotomy moved me: at first glance it seemed like one thing, and then my perception shifted and the piece seemed like something else altogether. I asked the boutique about the artist and learned that her name was Nathalie Lété.

I was soon making my first visit to her studio, where I was completely drawn in. Nathalie lives and breathes her art, her studio being a perfect physical manifestation of the world she's created. It is part treasure trove—brimming with her collection of rubber toys, dolls, vintage ornaments, and other trinkets that inspire her work—and part showroom, where her colorful tapestries, cushions, ceramics, paintings, and mixed-media pieces fill the space from floor to ceiling. Every single object seems to have a touch of playful rebellion, an extension of her persona. It is an explosion of a person's rich imagination, a place so wonderful it was hard for me to leave.

We decided to have an exhibition of her work in my newly expanded shop in New York, which marked the beginning of our retail partnership—my stores have been carrying her pieces ever since. She showed a variety of ceramics and paintings. Her sculptures of body parts and organs were as beautiful and covetable as the ceramic flowers and plates. That's because Nathalie has the rare ability to surprise us with truly innovative, original imagery, and make us long for the whimsy we've lost since childhood.

She is beautiful and exotic, lovely and dear, a true artist immersed so well in her magical world that sometimes it's as if she were one of her own creations. Throughout her career she has been incredibly prolific, and her work is an ongoing story told through a multitude of mediums. Among the pages of this book—her first-ever collection of art in book form—you'll find the enchanted and curious images that she's best known for. And you won't want to leave.

—JOHN DERIAN

INTRODUCTION

I've been painting, drawing, and crafting since I was a child in the 1970s. My mother would ask me to make her holiday cards; she loved sending them to everyone she knew. I'd have to start in September to be sure I was done on time.

When I was about ten, I took an oil painting class. I stayed in it only long enough to paint a cherry tree in bloom and a flamingo standing on one leg, and then I stopped going. I don't remember why, but it's too bad because I'm still painting a lot of trees and birds . . . maybe I'd have a broader artistic vocabulary if I'd stayed in that class until the end of the year!

At around age twelve, I signed up for a silk painting class at the youth center in Sceaux, a suburb of Paris where I lived until I was twenty. I was completely captivated by my teacher; I emulated her. She looked like what I always imagined an artist should look like—bohemian clothes with necklaces that seemed handmade. She was a muse for me, and I think that's one of the reasons I continued attending her workshops until I turned eighteen.

There were many people who influenced me when I was growing up, including an astrologer who read my birth chart when I was eighteen and promised me a successful artistic career. One year later, I was enrolled in the École des Arts Appliqués in Paris, where I studied fashion; I then went on to study lithography at the École des Beaux-Arts.

Through these memories, and stories of my past, I realized that the work I do today is simply a continuation of what I did as a child. Having practiced my craft and painted nearly every day for more than twenty-five years, I'm just fulfilling my destiny, nursing my wounds, keeping my secrets, displaying my joys and my desire for happiness.

Each morning, I happily go to my studio to paint. I open my books on botany, textiles, birds, American or eastern European folk art, and I blend all these inspirations together on my sheet of paper. These paintings tell my life story and speak to my desires, my fears, and my love of color, of travel, and of primitive and folk art.

In the Garden of My Dreams, which I began working on two years ago, is filled with these paintings, of things that help me escape my day-to-day life and forget what's happening in the outside world, and that also mirror my life. I am of a reclusive nature, and creating a little scenery for myself, a composition that moves me, gives me a feeling of well-being and harmony. As does my garden, which I constructed little by little in front of my house and studio and which increasingly brings me the serenity I need to do my work.

I'm delighted to share my world with you through the pages of this book. I hope my paintings will bring you pleasure, joy, hope, and entertainment and that they'll make you dream!

Nathalie Lété

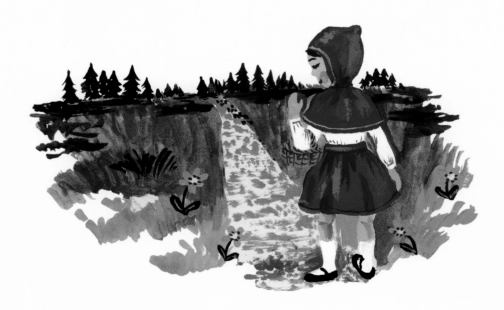

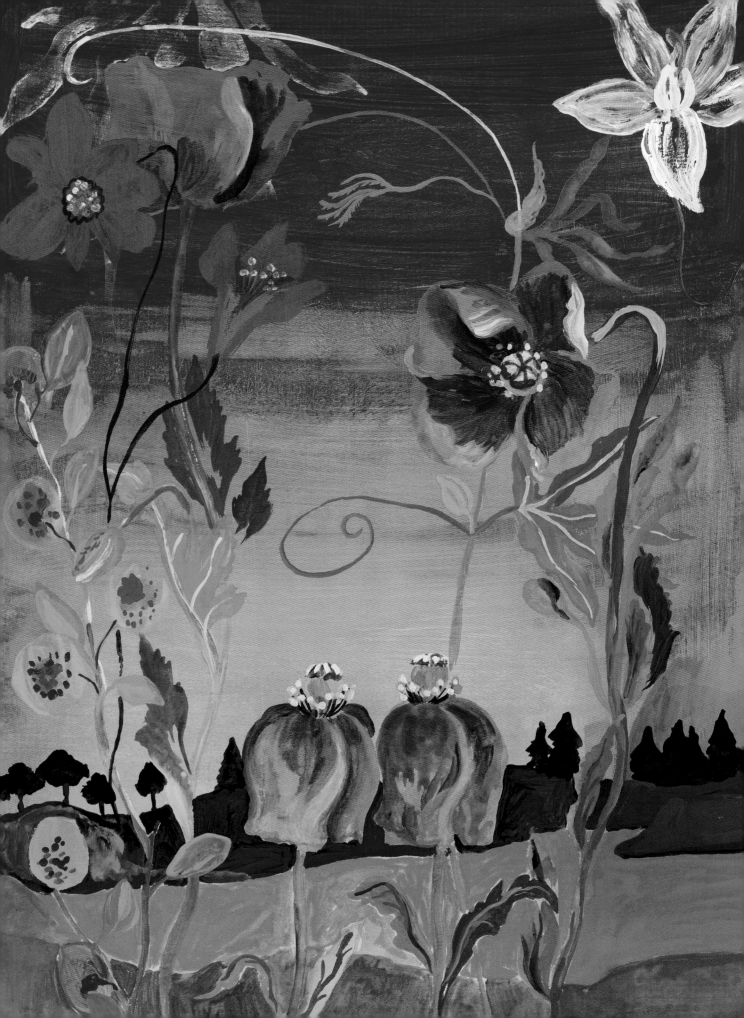

In the garden of my dreams, I can escape the world and paint.

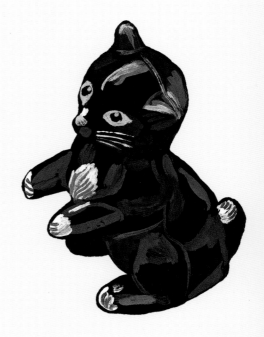

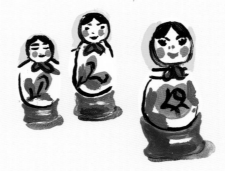

OPPOSITE: **My Miniature Garden** | *Mon jardin miniature*

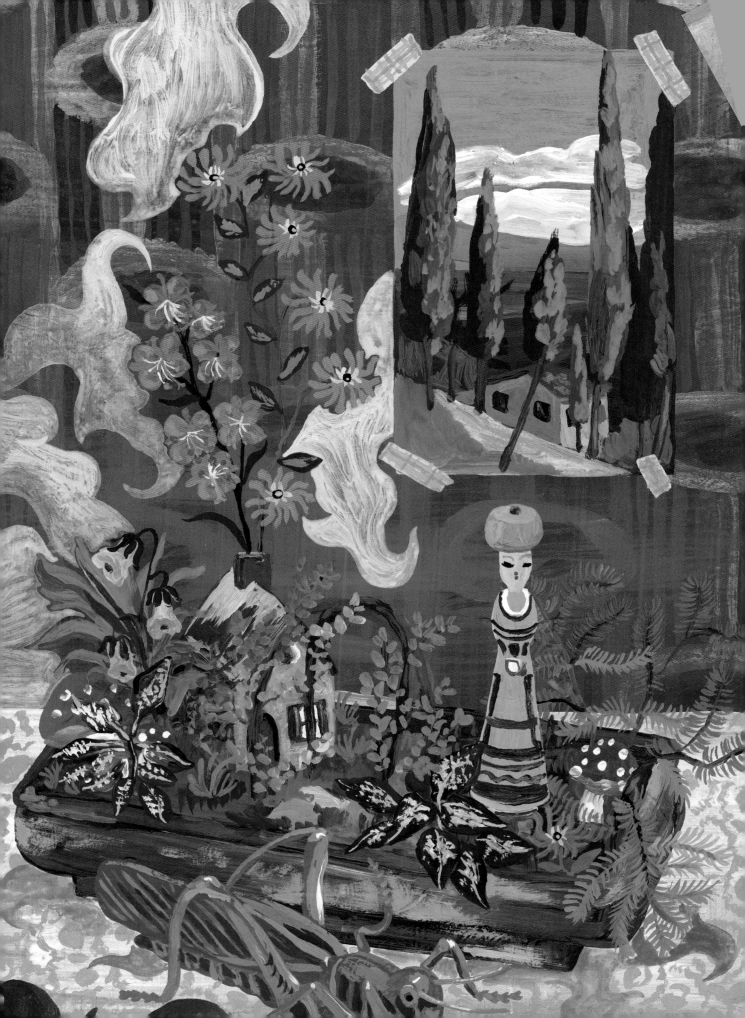

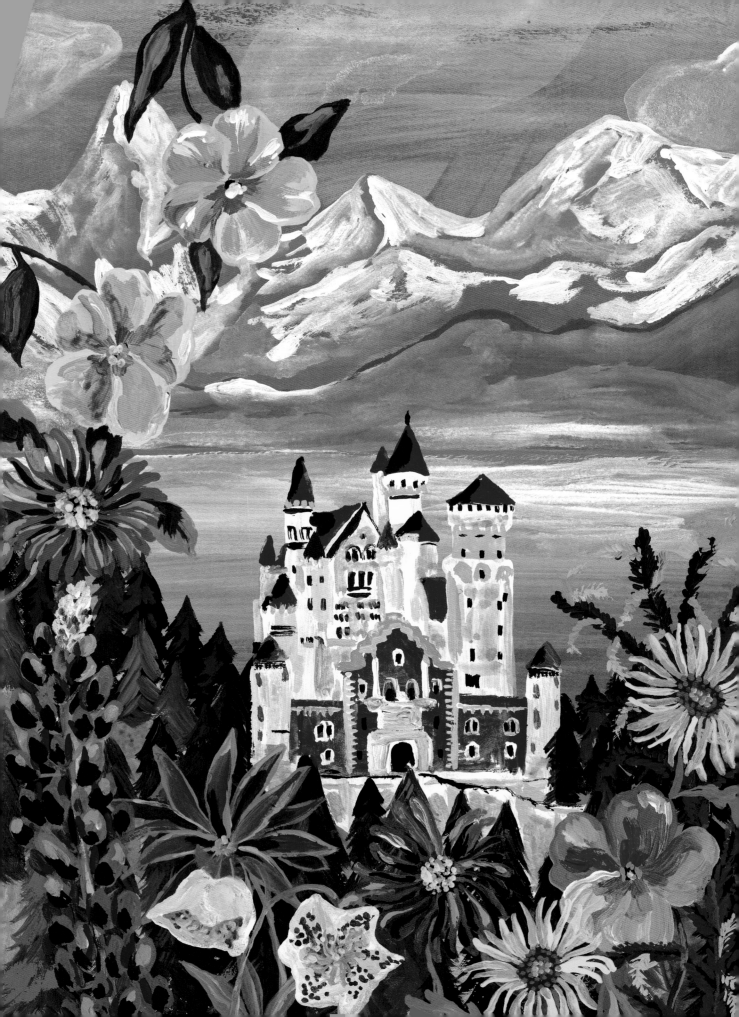

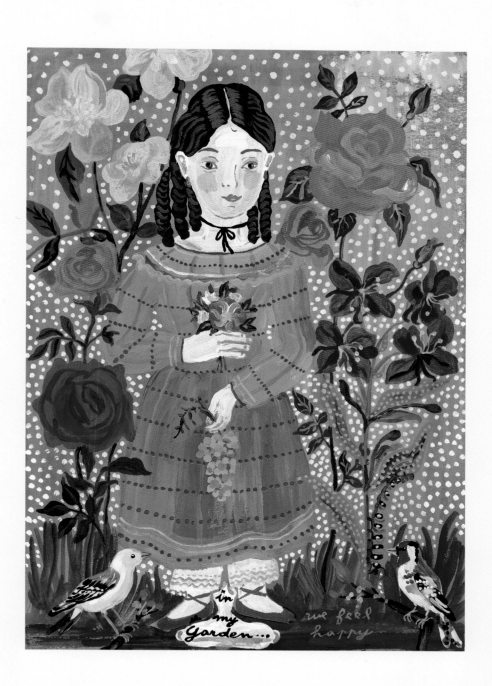

OPPOSITE: **My Castle in Bavaria** | *Mon château en Bavière*

ABOVE: **In My Garden . . . We Feel Happy** | *Dans mon jardin . . . on se sent heureux*

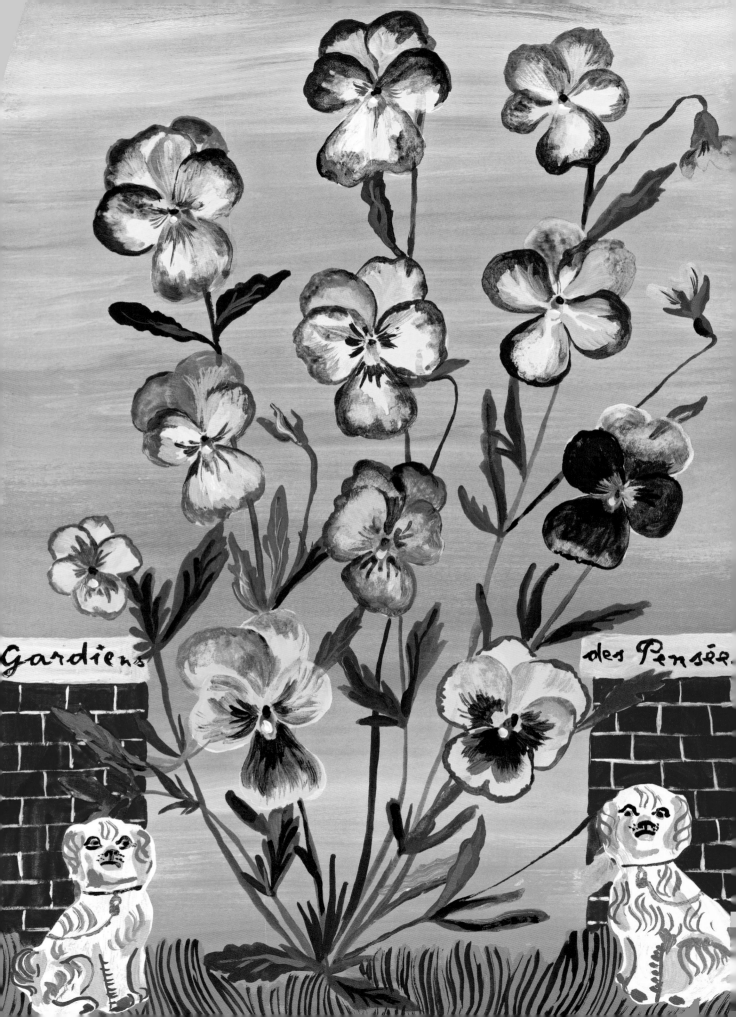

Gardiens des Pensées.

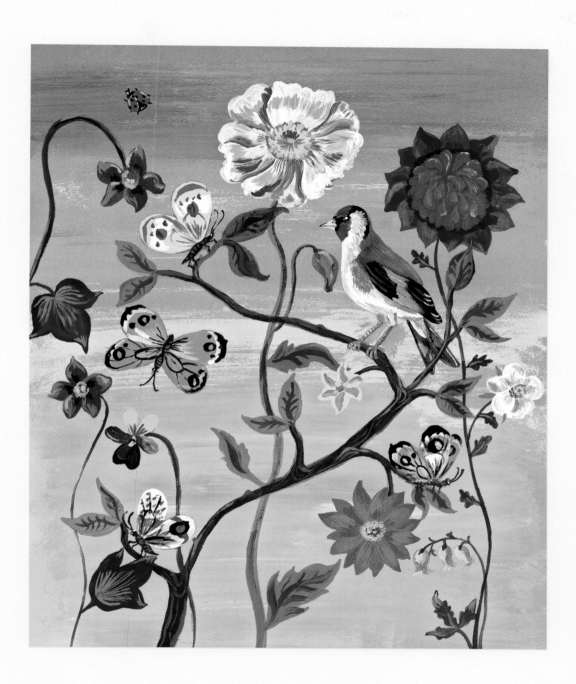

OPPOSITE: **Keepers of Thoughts** | *Gardiens des pensées*

ABOVE: **Botanica**

FOLLOWING PAGES: **Owl in a Vegetable Garden** | *La chouette dans le potager*

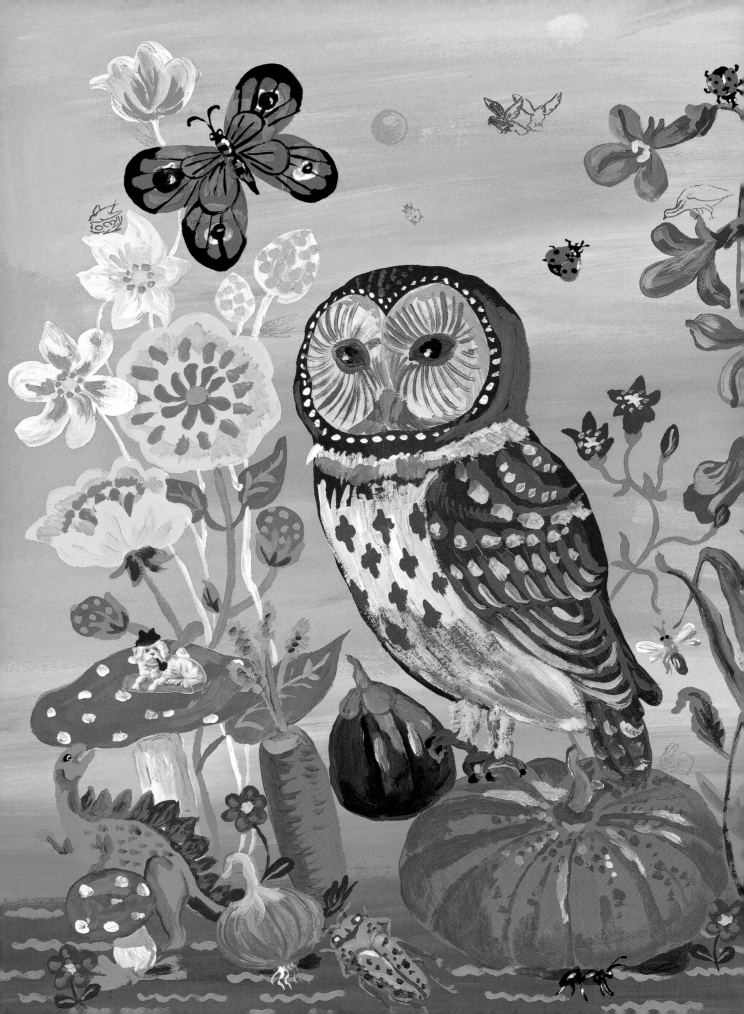

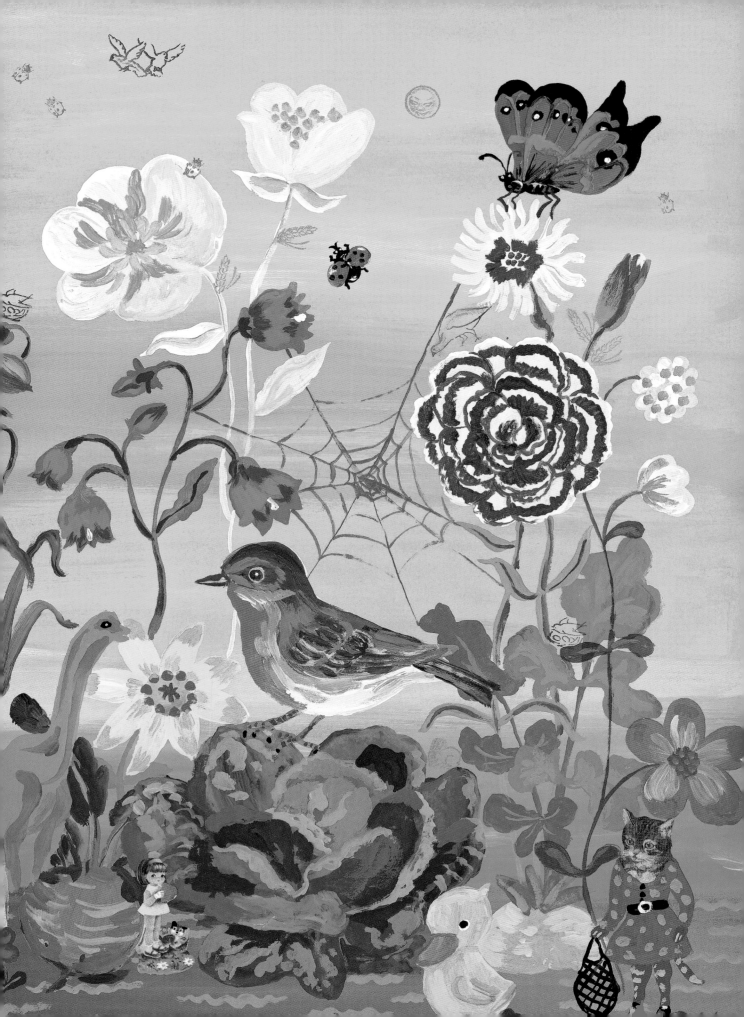

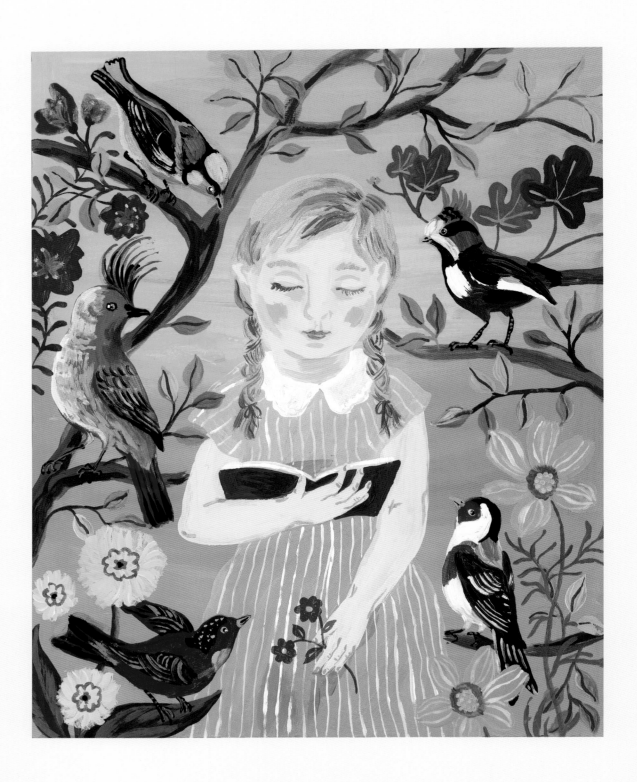

ABOVE: **The Girl Who Reads to Birds** | *La fille qui lisait aux oiseaux*

OPPOSITE: **Life in Pink** | *La vie en rose*

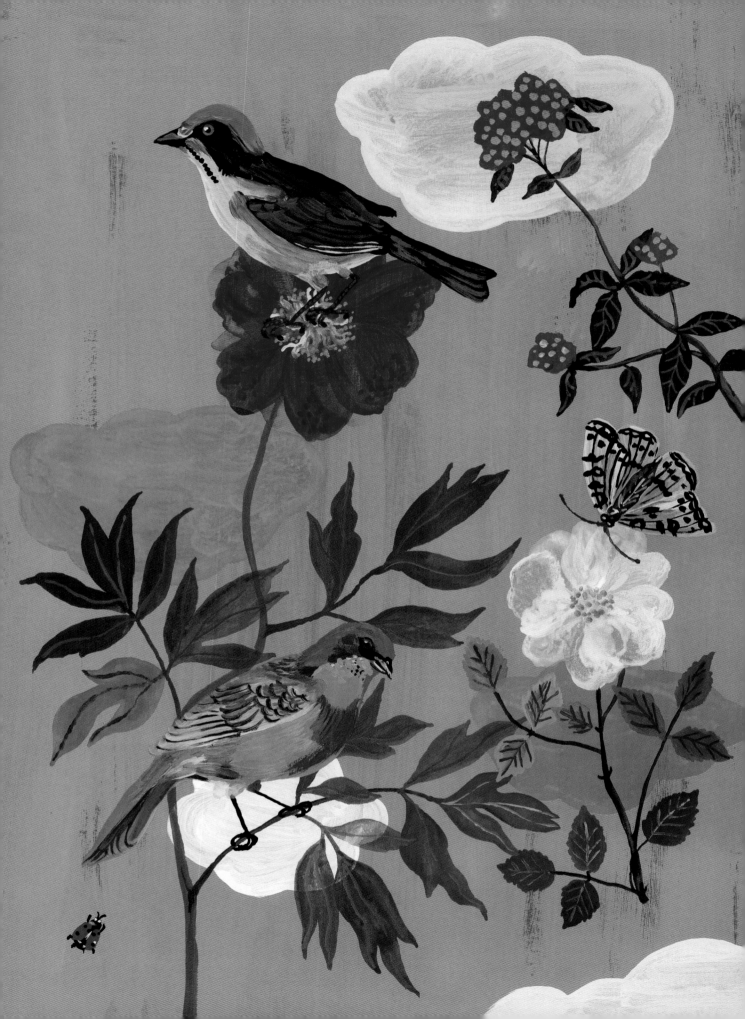

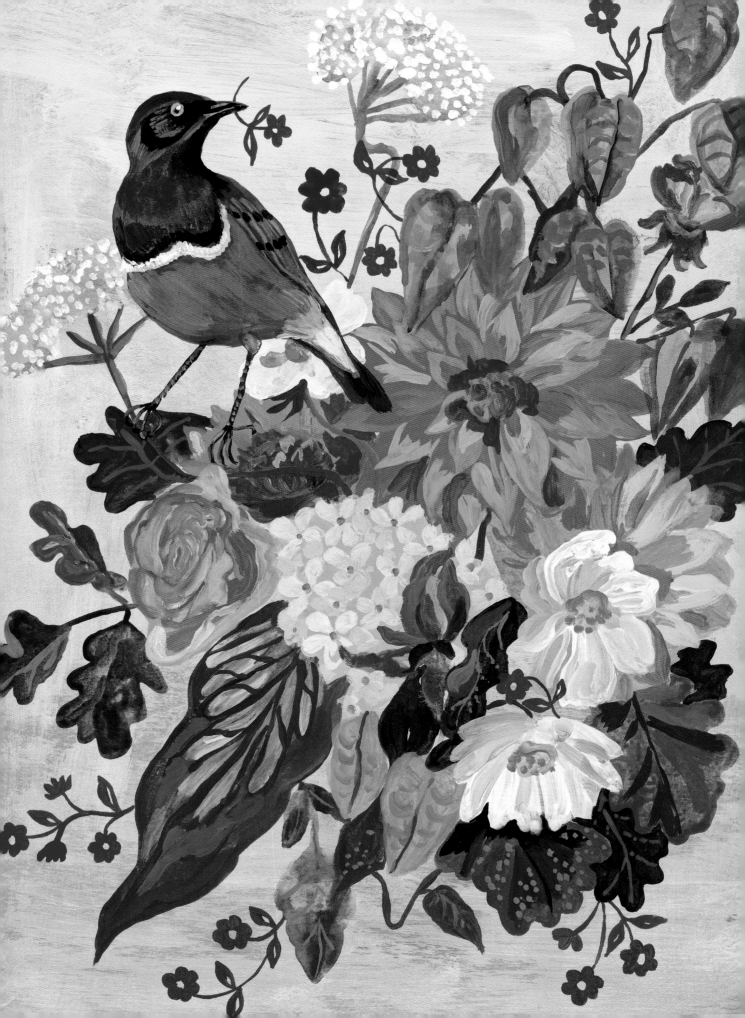

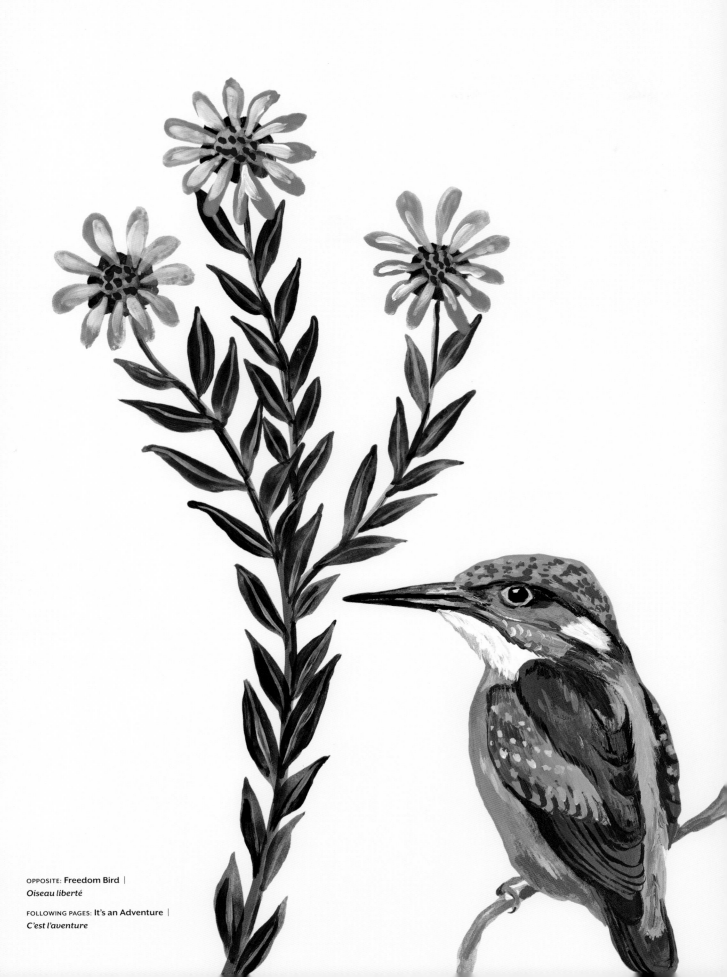

OPPOSITE: **Freedom Bird** │
Oiseau liberté

FOLLOWING PAGES: **It's an Adventure** │
C'est l'aventure

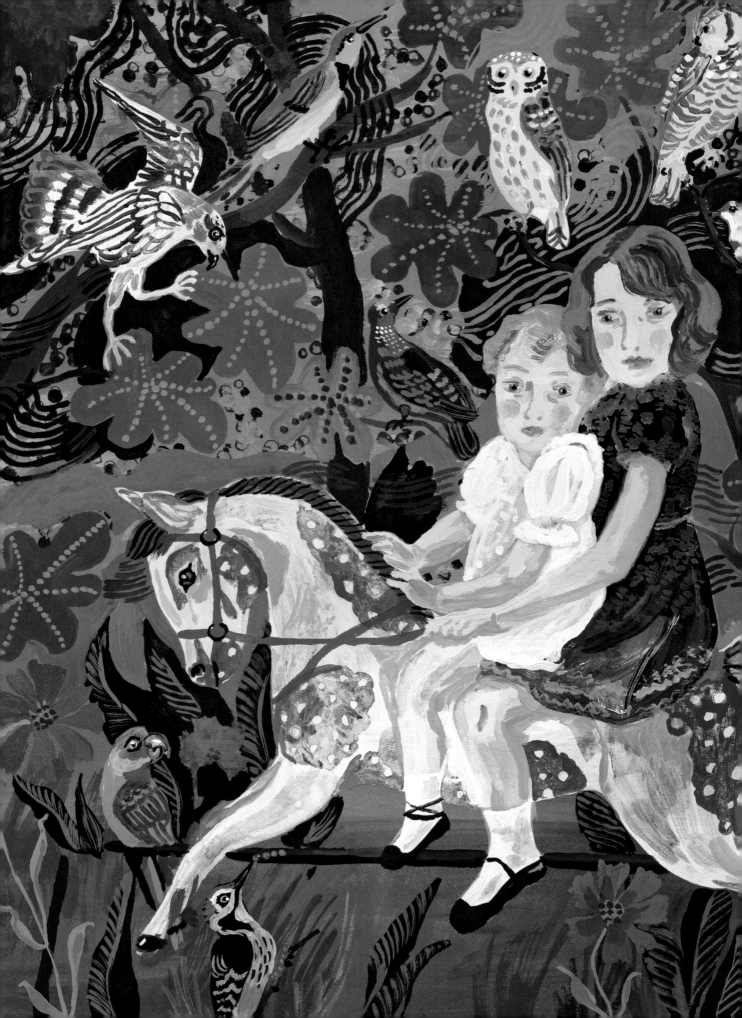

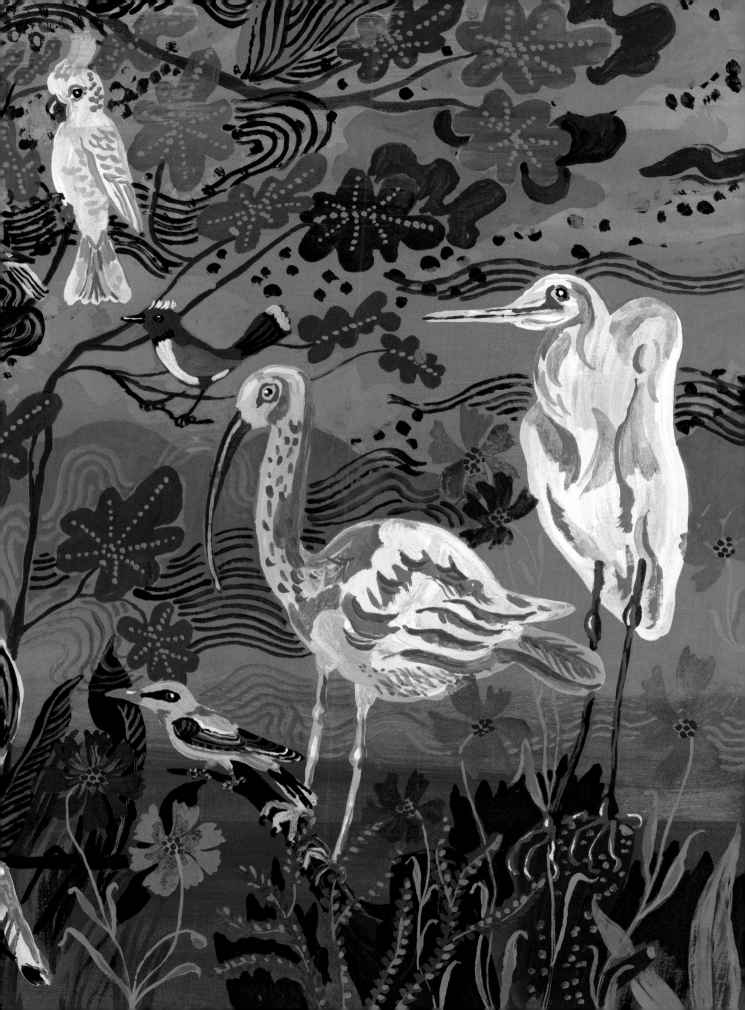

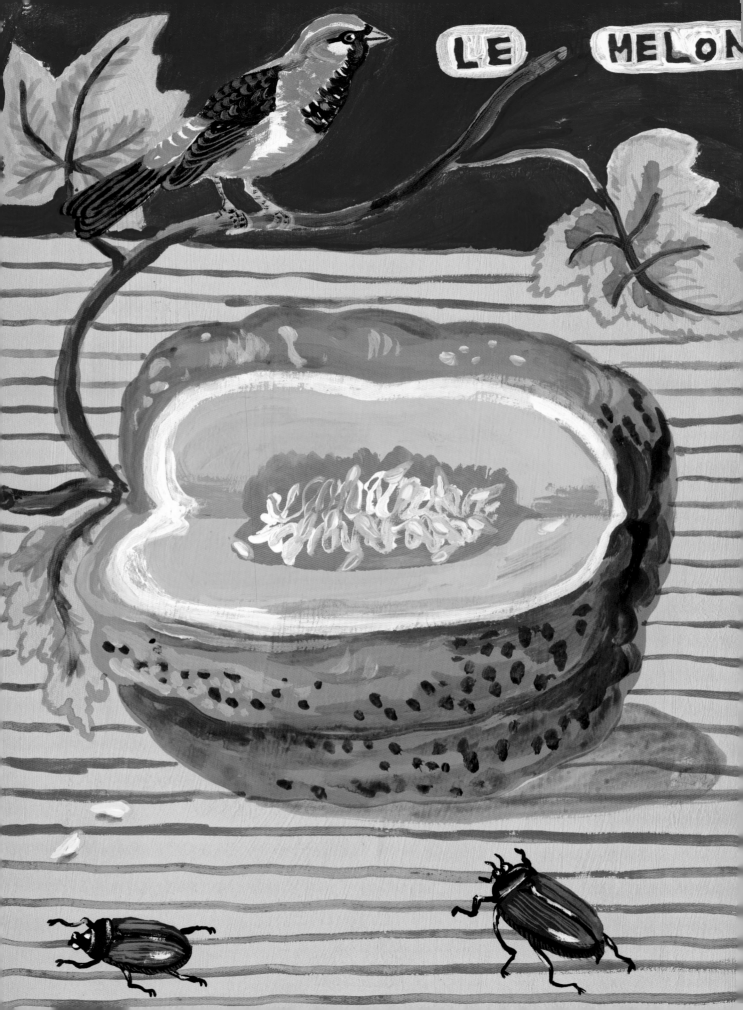

LE MELON

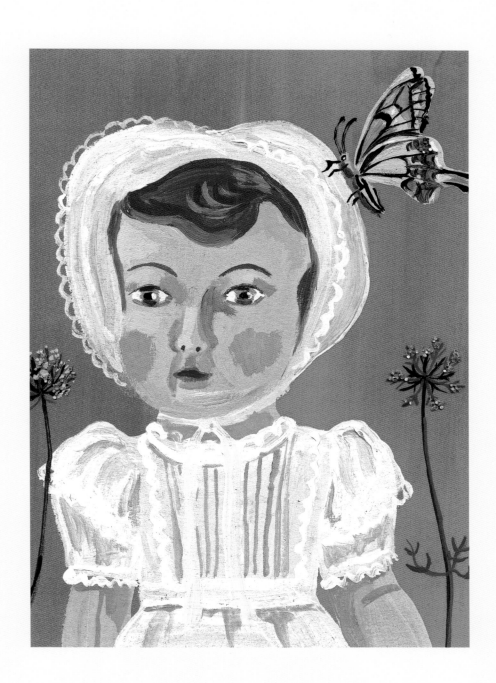

OPPOSITE: **Melon** | *Le melon*

ABOVE: **Little Girl** | *Fillette*

I WANT TO DRAW THE OBJECTS I'VE COLLECTED
IN THE WAY A PAINTER CHOOSES HIS MODEL
AND FALLS IN LOVE WITH HIS MUSE. I'M
LIKE A MOTHER WHO, WITHOUT KNOWING
WHY, FEELS TENDERLY TOWARD ONE OR ANOTHER
OBJECT AND CANNOT RESIST BRINGING IT BACK
HOME WITH ME.

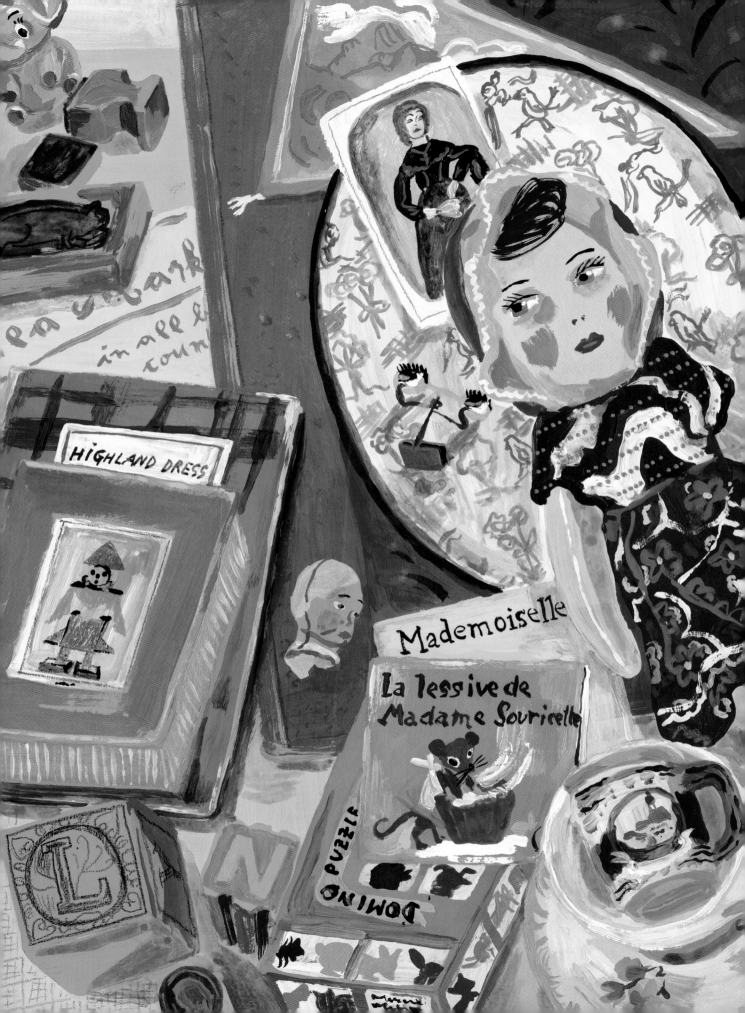

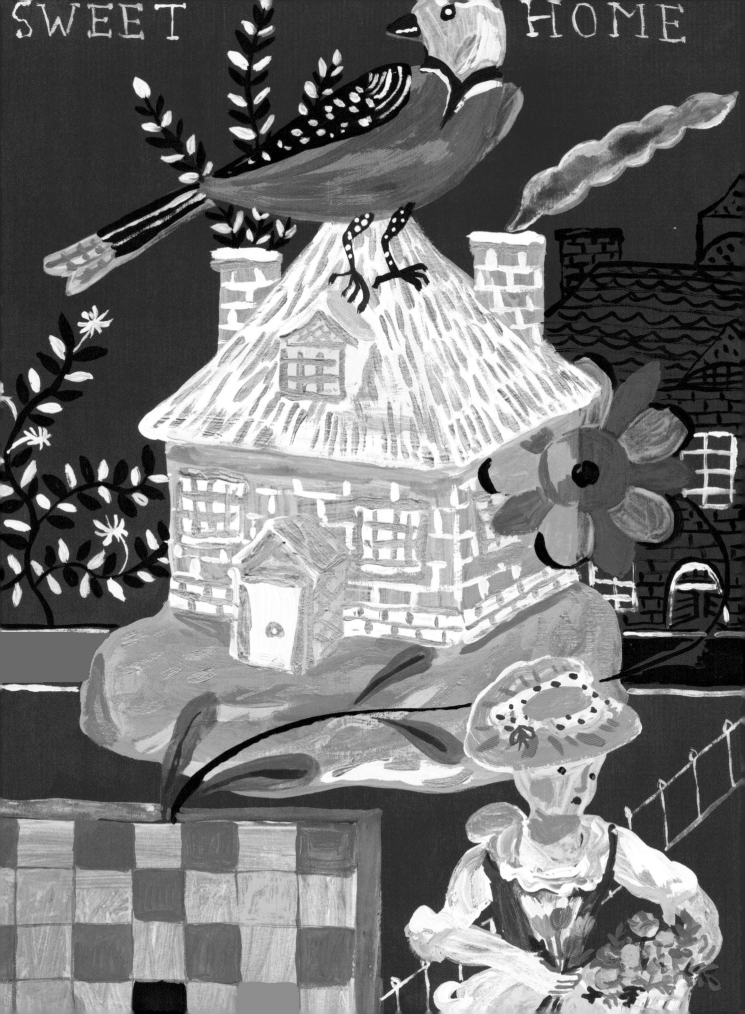

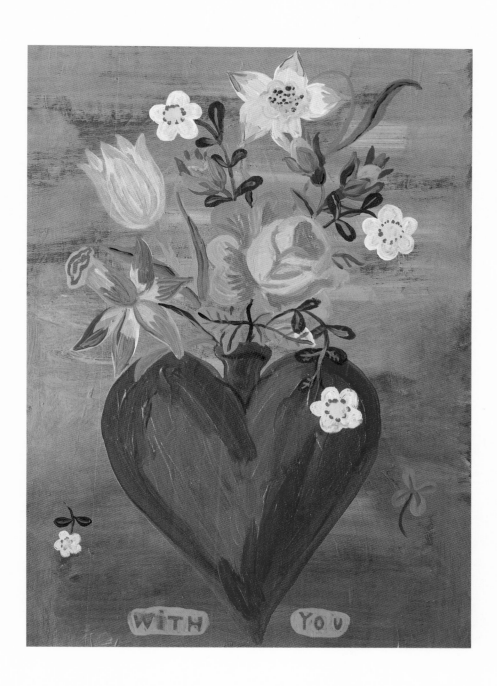

OPPOSITE: **Home Sweet Home**

ABOVE: **With You** | *Avec toi*

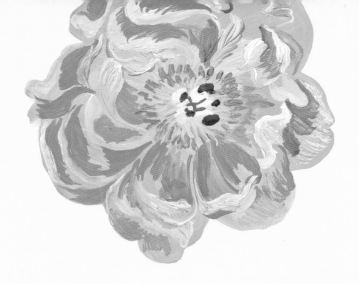

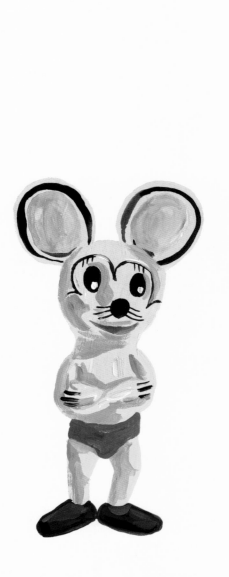

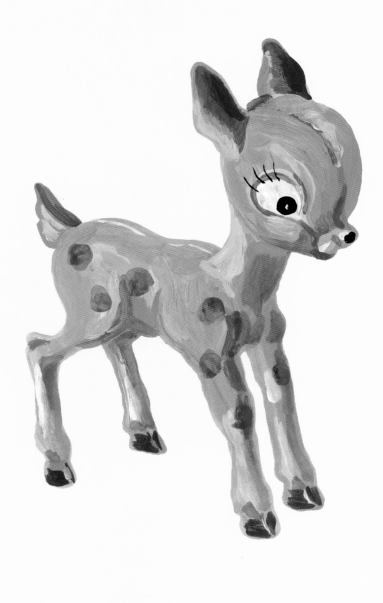

OPPOSITE: **My Little Friend** | *Mon petit ami*

FOLLOWING PAGES: **Two Gardeners** | *Les deux jardiniers*

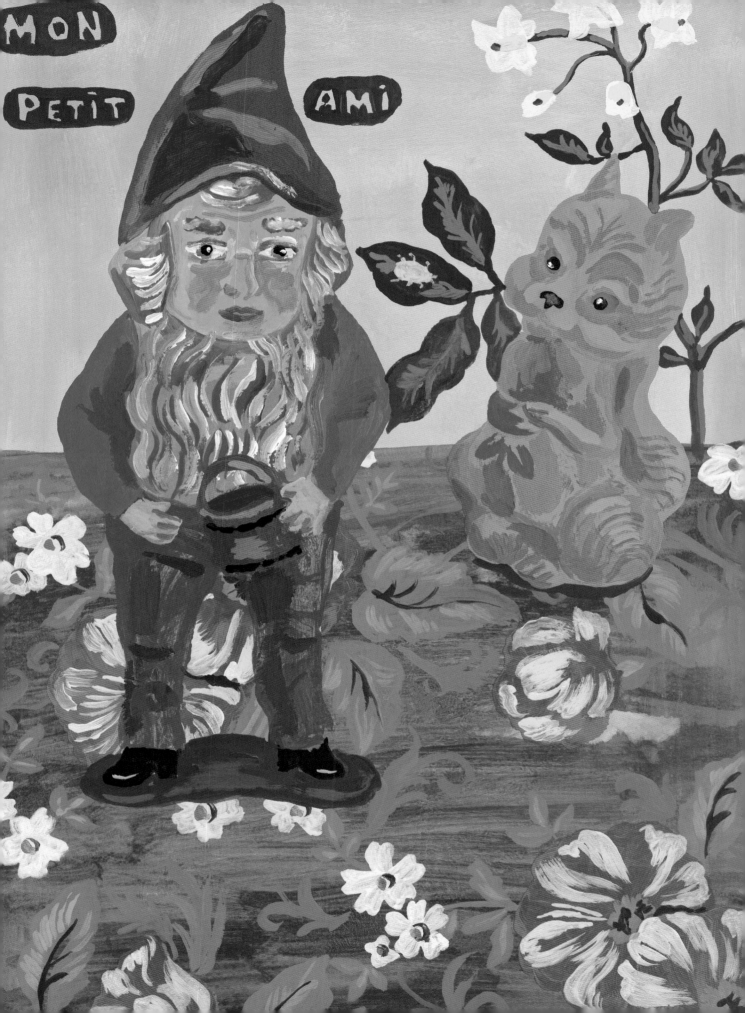

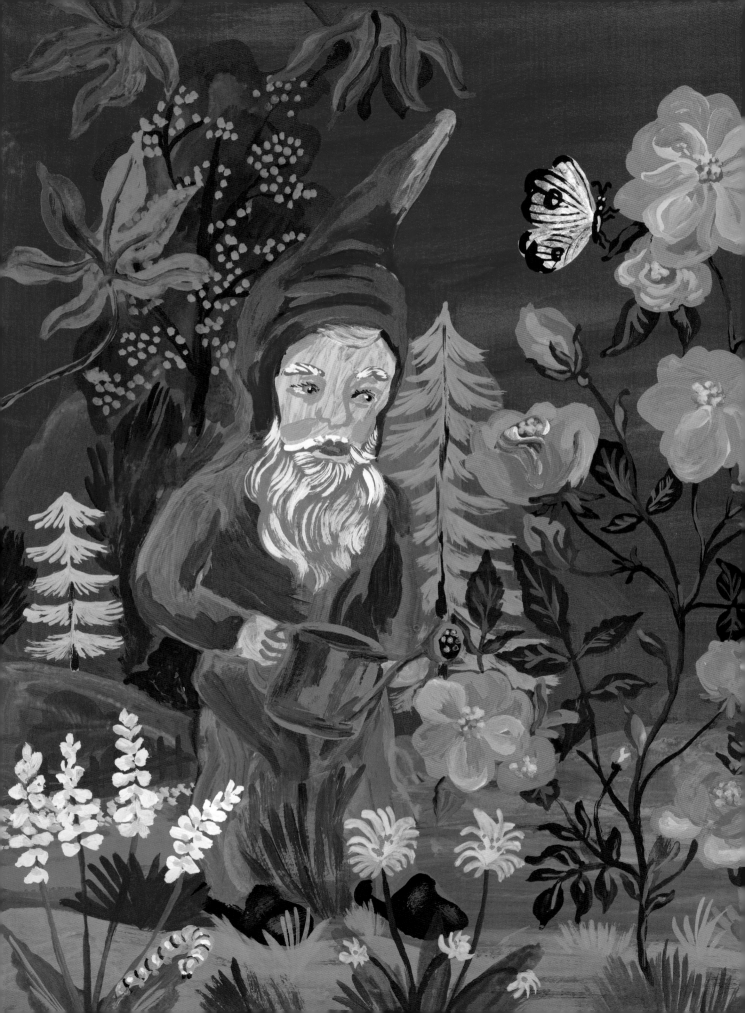

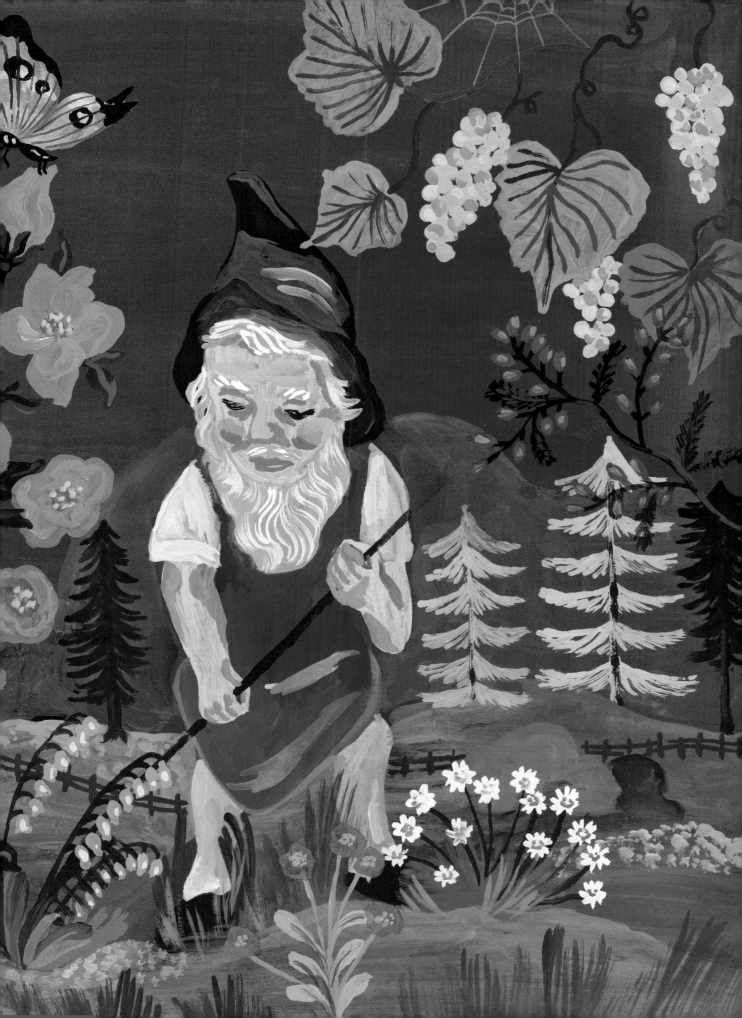

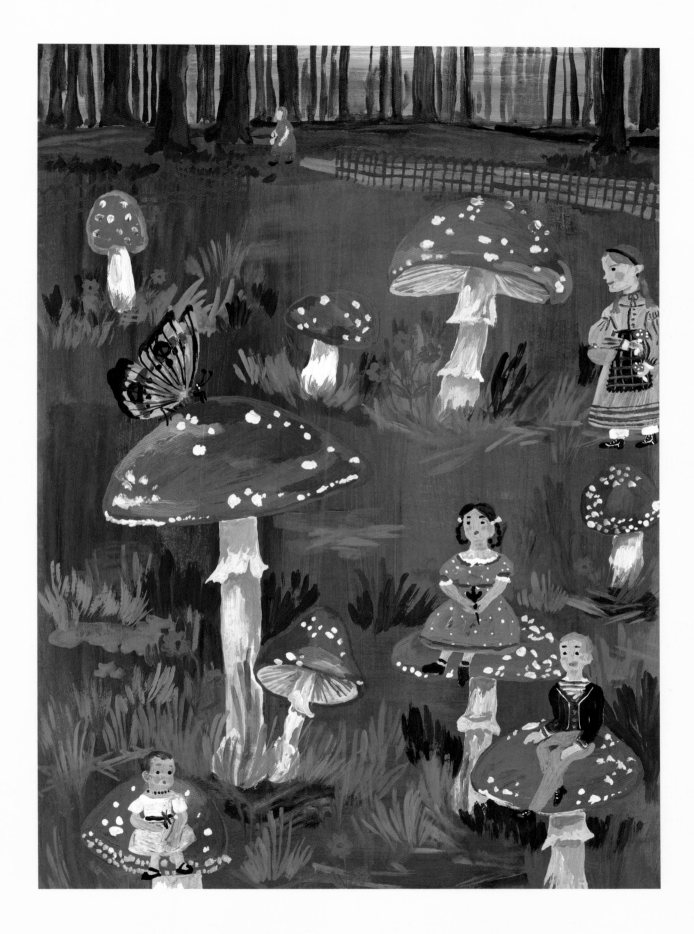

ABOVE: **The Field of Toadstools** | *Le champ d'amanites*

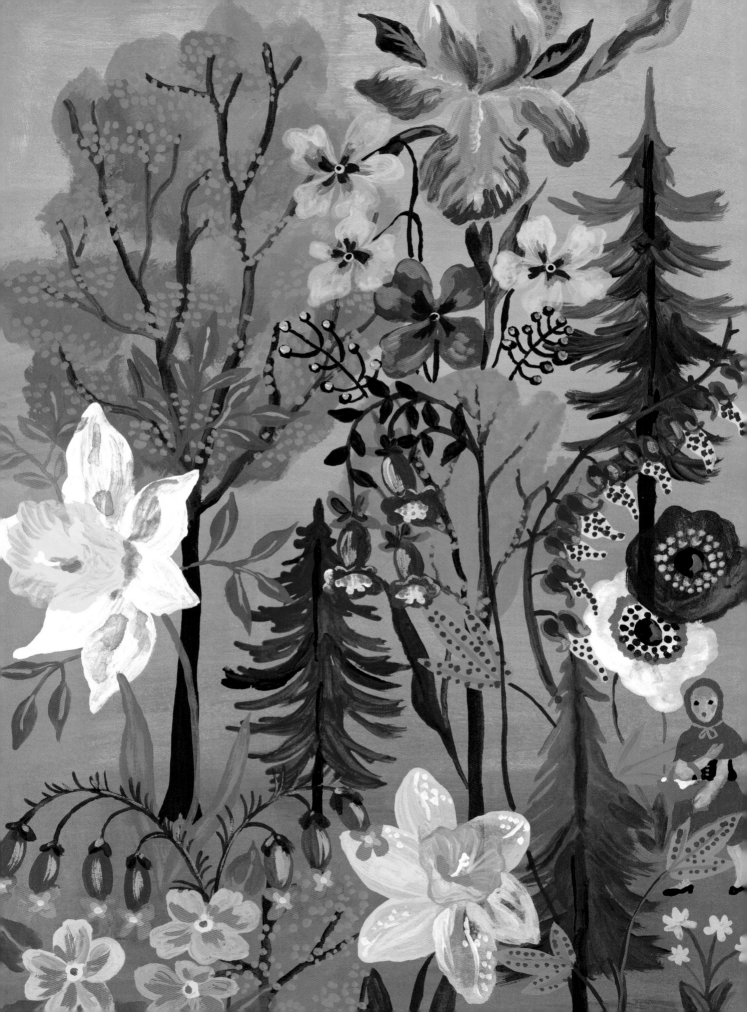

"LITTLE RED RIDING HOOD" IS ONE OF MY FAVORITE FAIRY TALES. WHEN I WAS A LITTLE GIRL, MY MOTHER, WHO GREW UP IN BAVARIA, WOULD BUY ME TRADITIONAL BAVARIAN RED CAPES, AND WHEN I WORE THEM IN FRANCE EVERYONE WOULD CALL ME LITTLE RED RIDING HOOD.

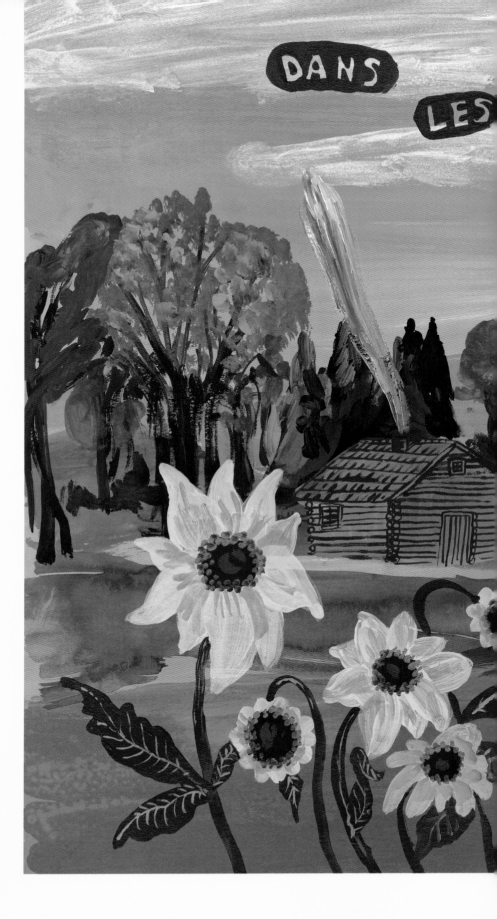

ABOVE: **In the Woods, There Are . . .** | *Dans les bois, il y a . . .*

FOLLOWING PAGES: **Clearing at Sunset** | *Clairière au soleil couchant*

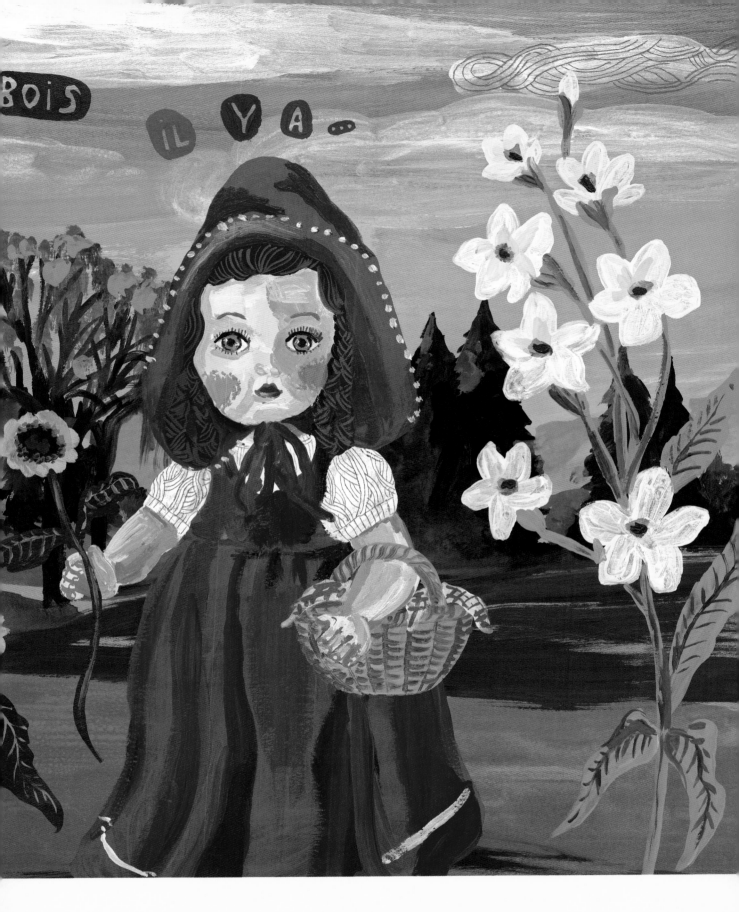

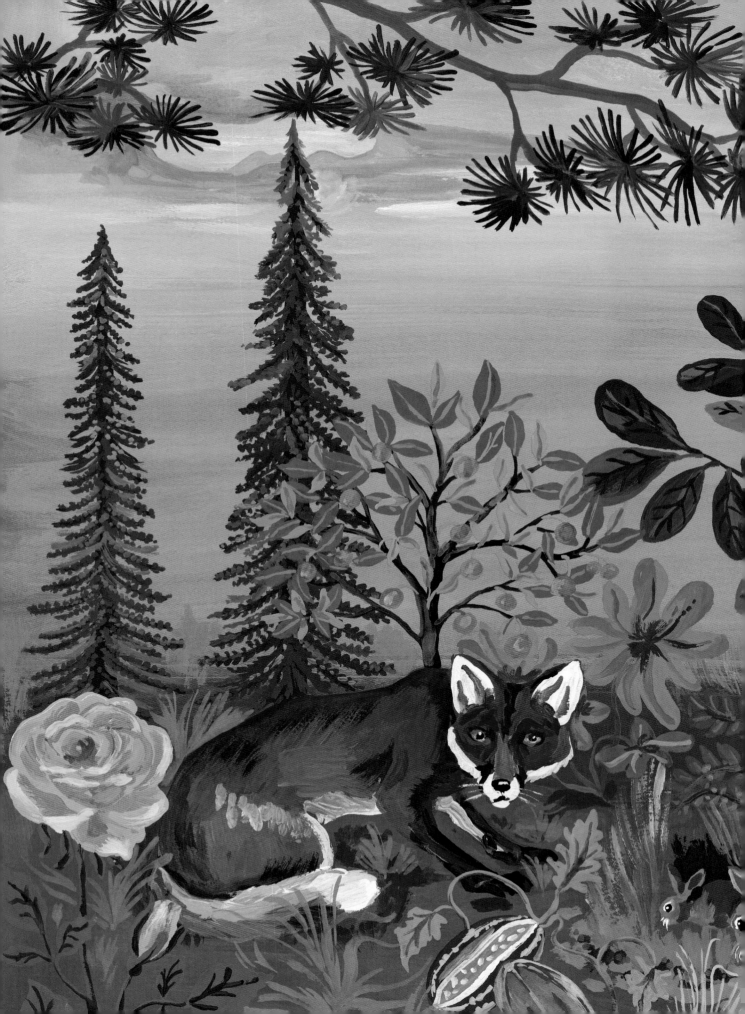

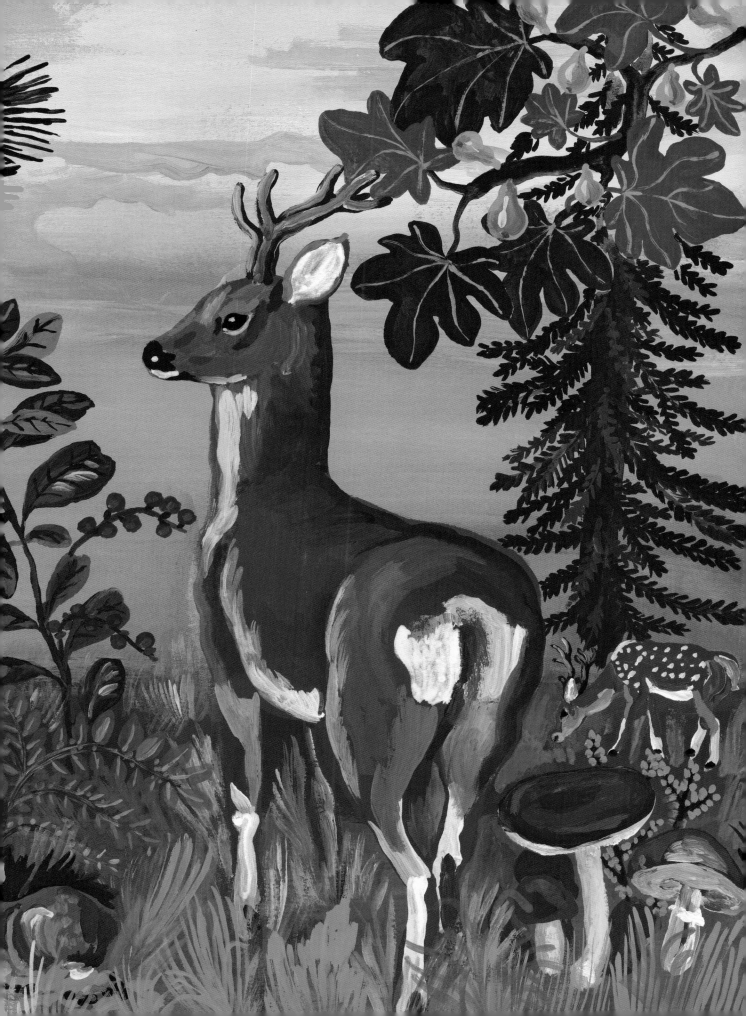

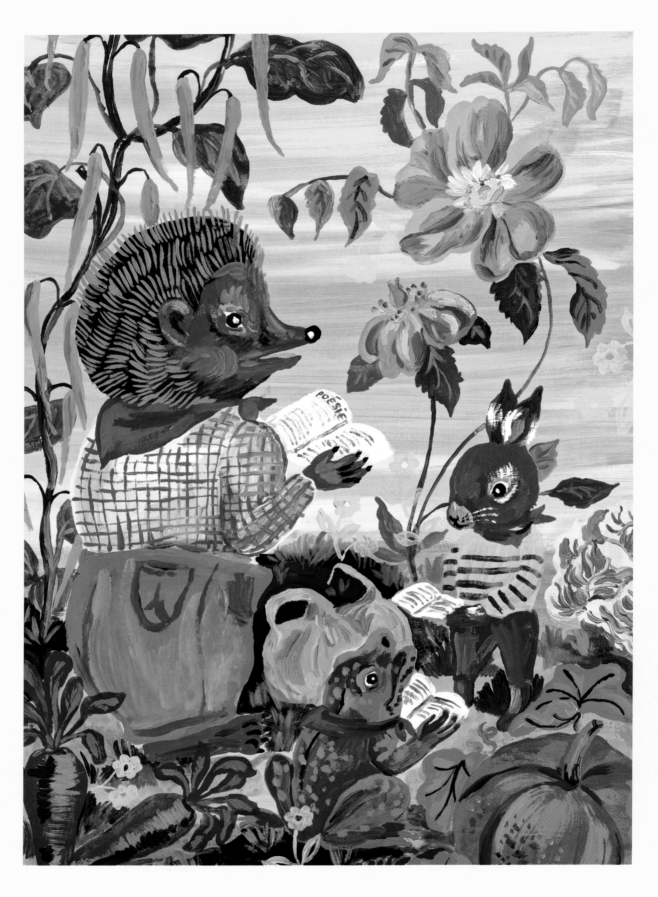

ABOVE: **Poetry Time** | *L'heure de poésie*

FOLLOWING PAGES: **Rabbits** | *Les lapins*

COLORS STIR UP EMOTIONS IN ME. THEY WAKE
UP MY SENSES. EVEN IF SOMETIMES I LIKE TO
BE A MINIMALIST, I CAN'T HELP BUT PAINT IN
COLOR IMMEDIATELY AFTERWARD.

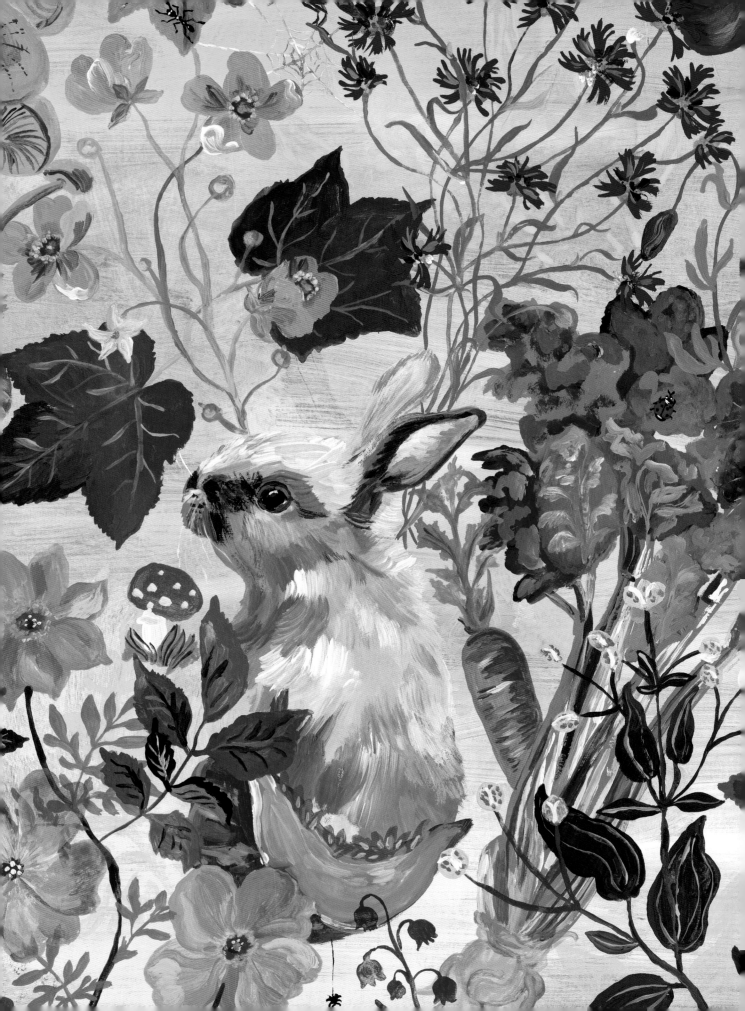

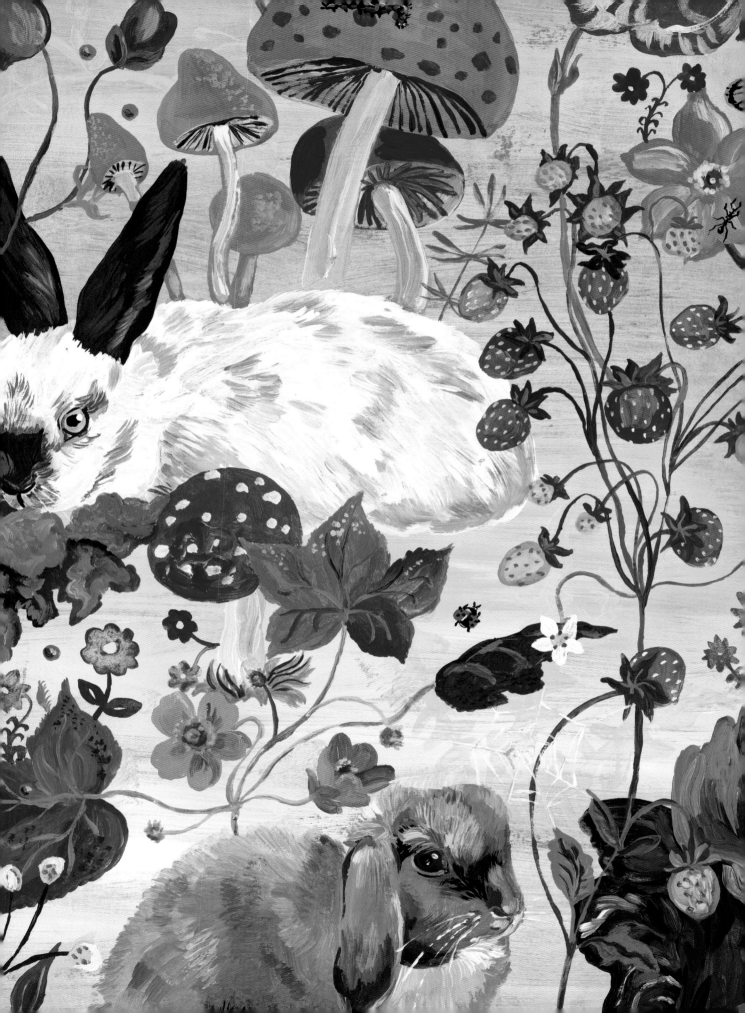

I REMEMBER ONCE DRESSING UP AS A TOADSTOOL, WITH A POLKA-DOTTED RED SKIRT OF MY MOTHER'S WRAPPED WITH A STRING AROUND MY NECK, A STRAW HAT FROM THE '50s LIKE A BIG BOWL TURNED UPSIDE DOWN ON MY HEAD, AND A PAIR OF RED RUBBER BOOTS ON MY FEET. I MUST HAVE BEEN SIX.

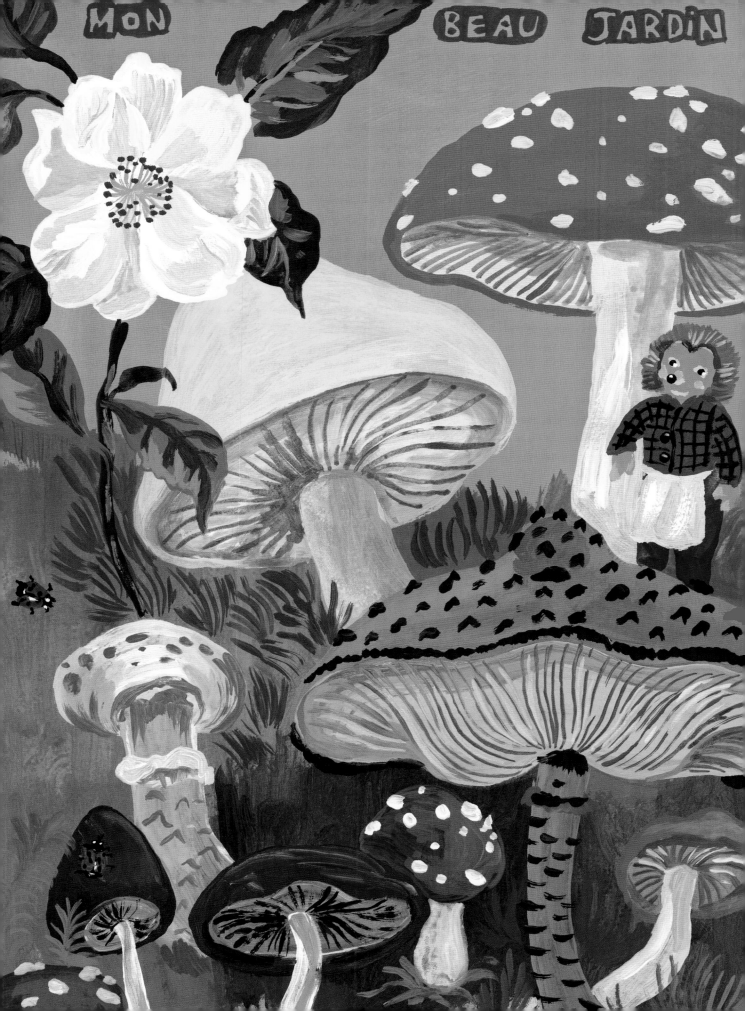

MON BEAU JARDIN

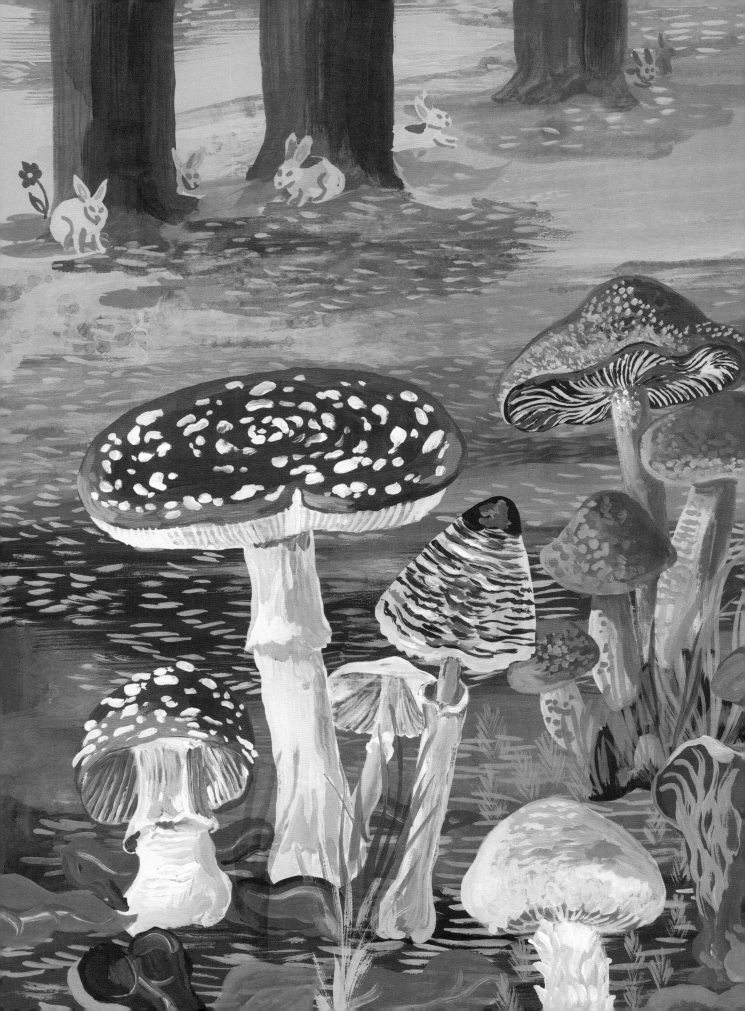

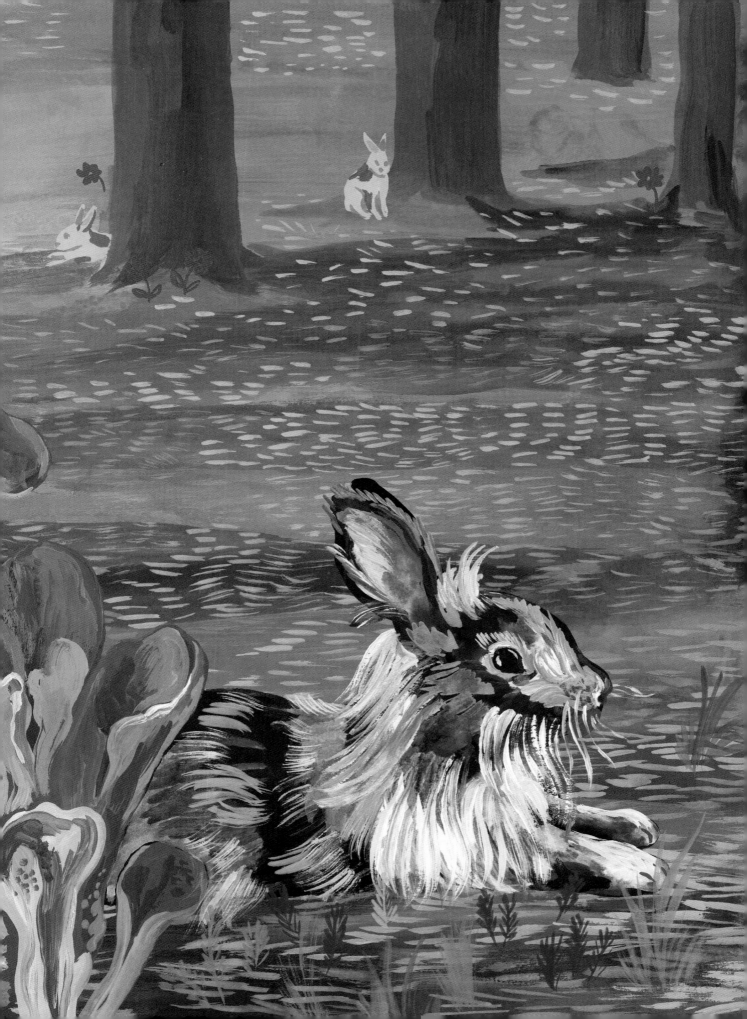

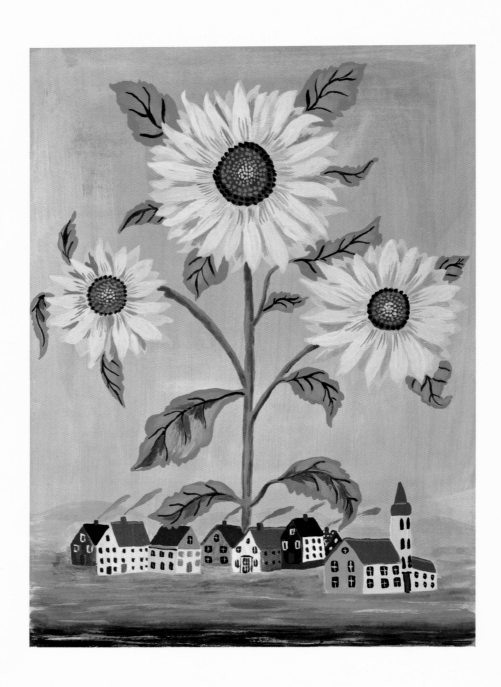

ABOVE: **A Village in the Sun** | *Un village au soleil*

OPPOSITE: **Mrs. Rabbit** | *Madame Lapine*

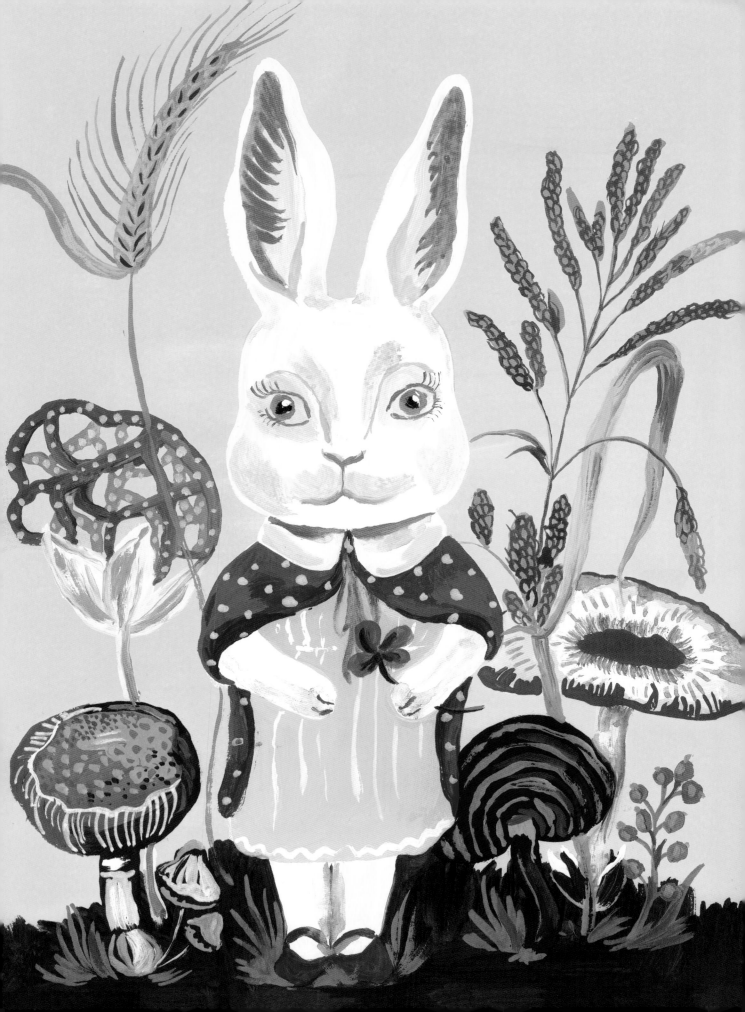

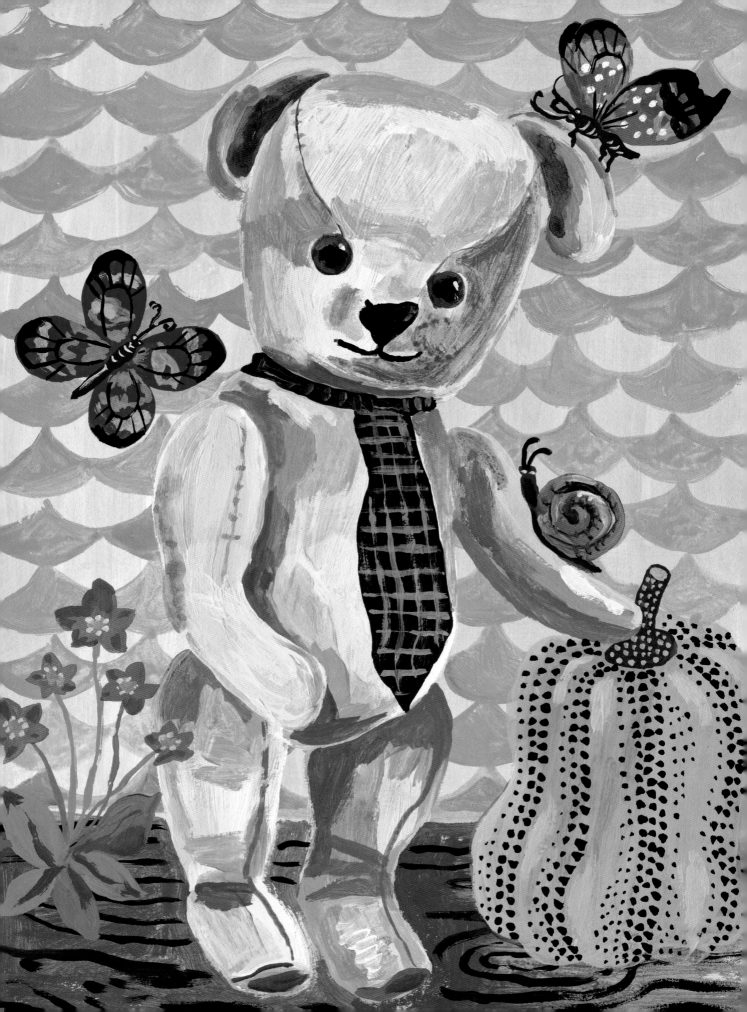

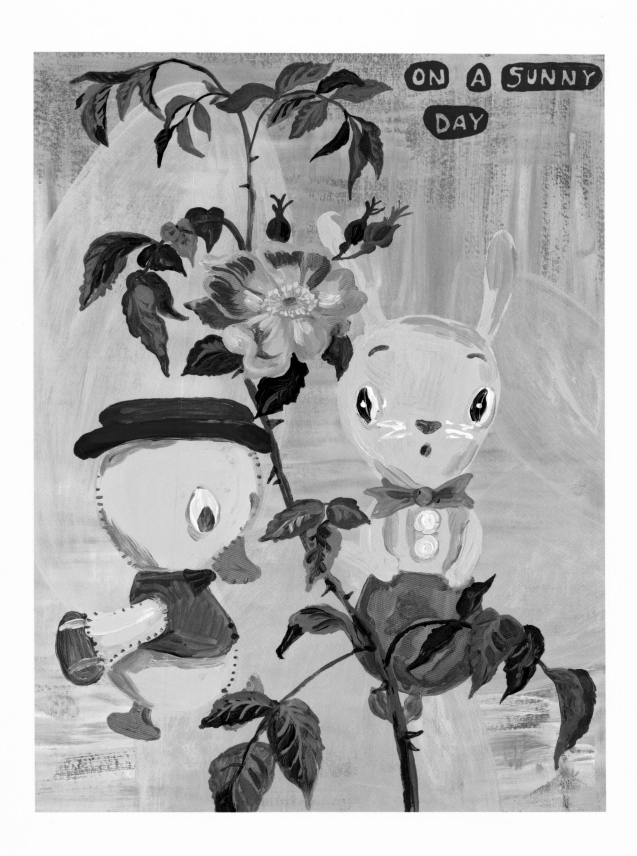

OPPOSITE: **Bear with a Squash** | *L'ours à la courge*

ABOVE: **On a Sunny Day** | *Par un jour ensoleillé*

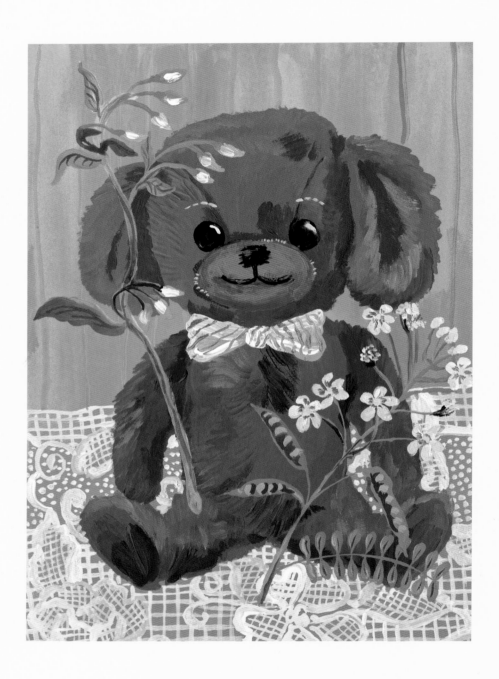

ABOVE: **Green Teddy Bear** | *Le nounours vert*

OPPOSITE: **Yellow Bear** | *L'ours jaune*

FOLLOWING PAGES: **The Rubber Friends** | *Les amis en caoutchouc*

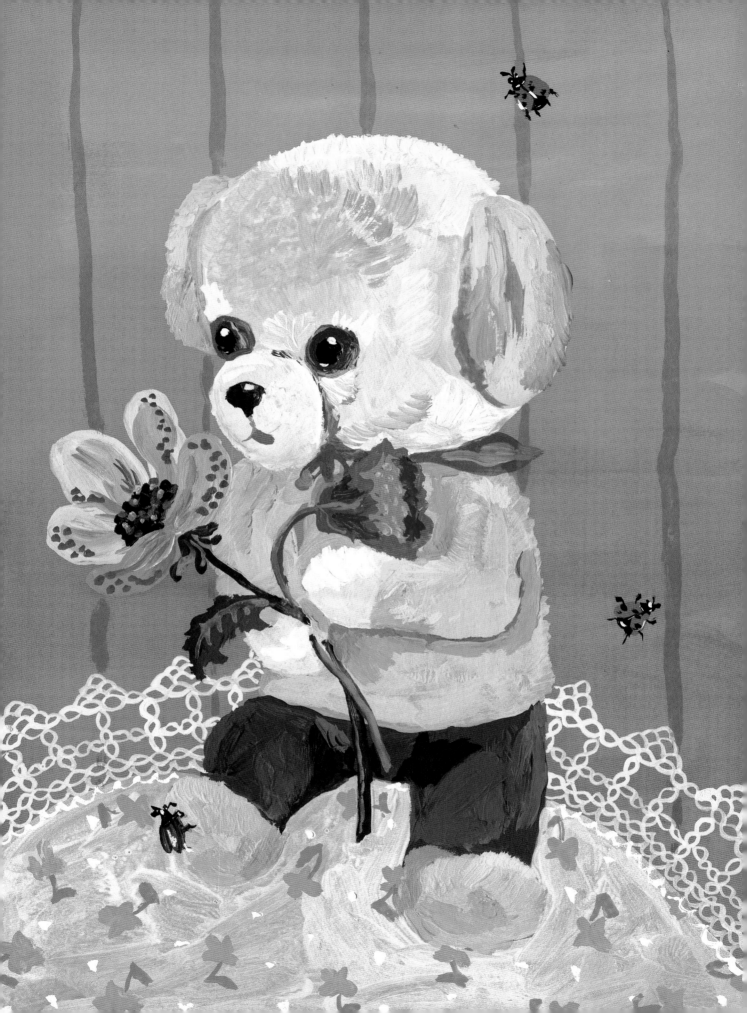

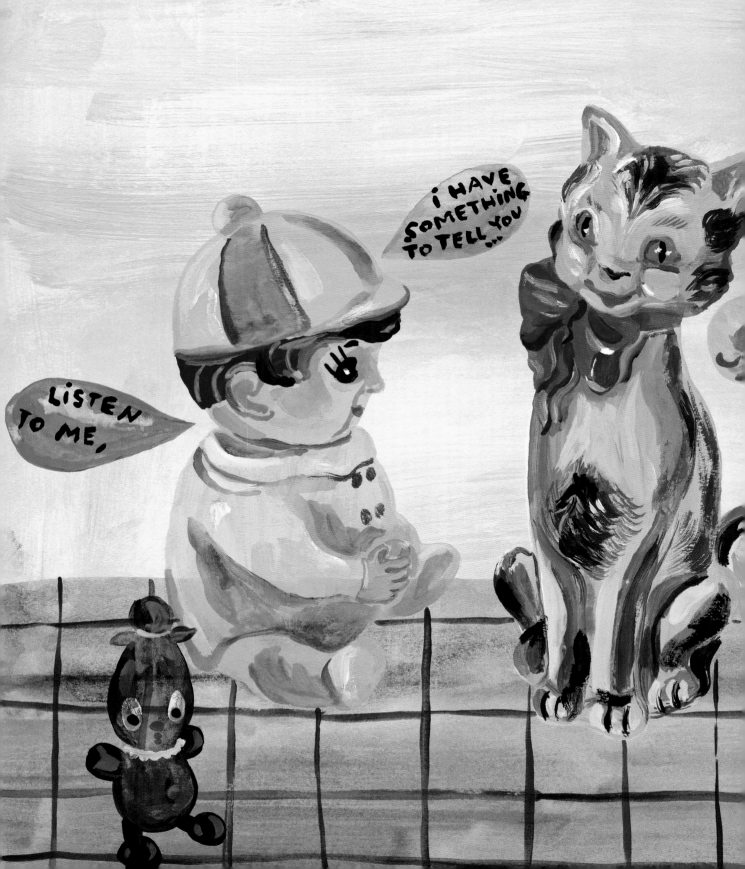

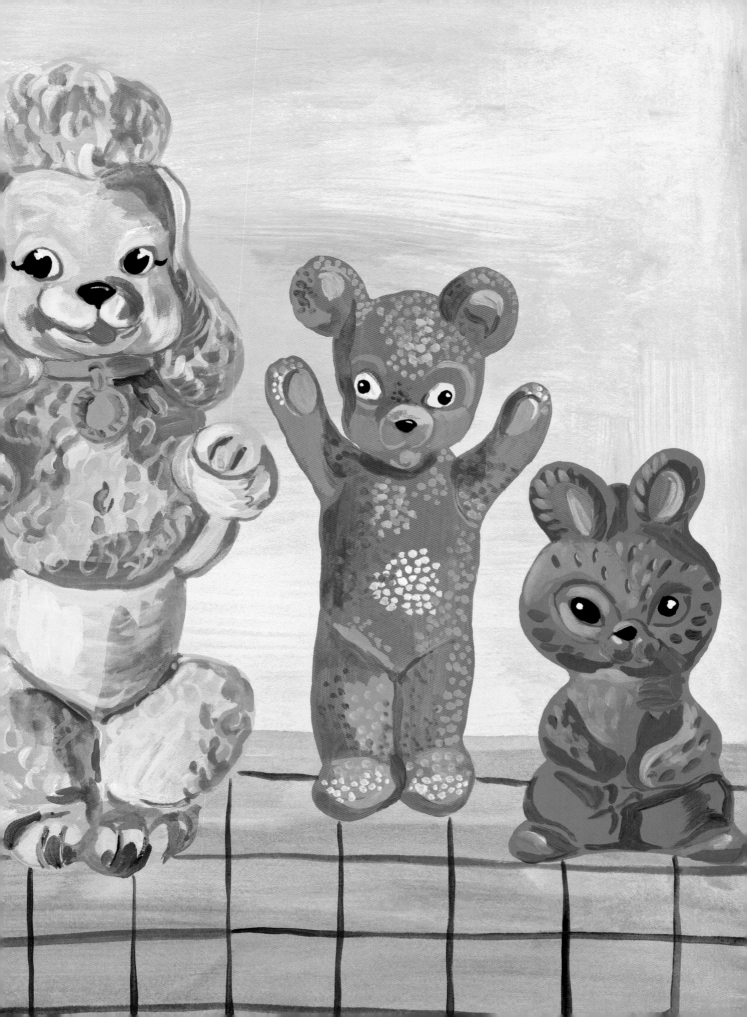

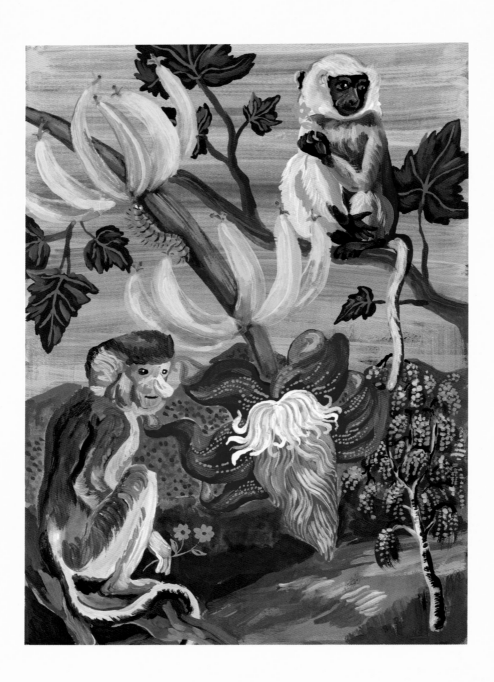

ABOVE: **In the Banana Tree** | *Dans le bananier*

OPPOSITE: **Pineapple and a Hummingbird** | *L'ananas et le colibri*

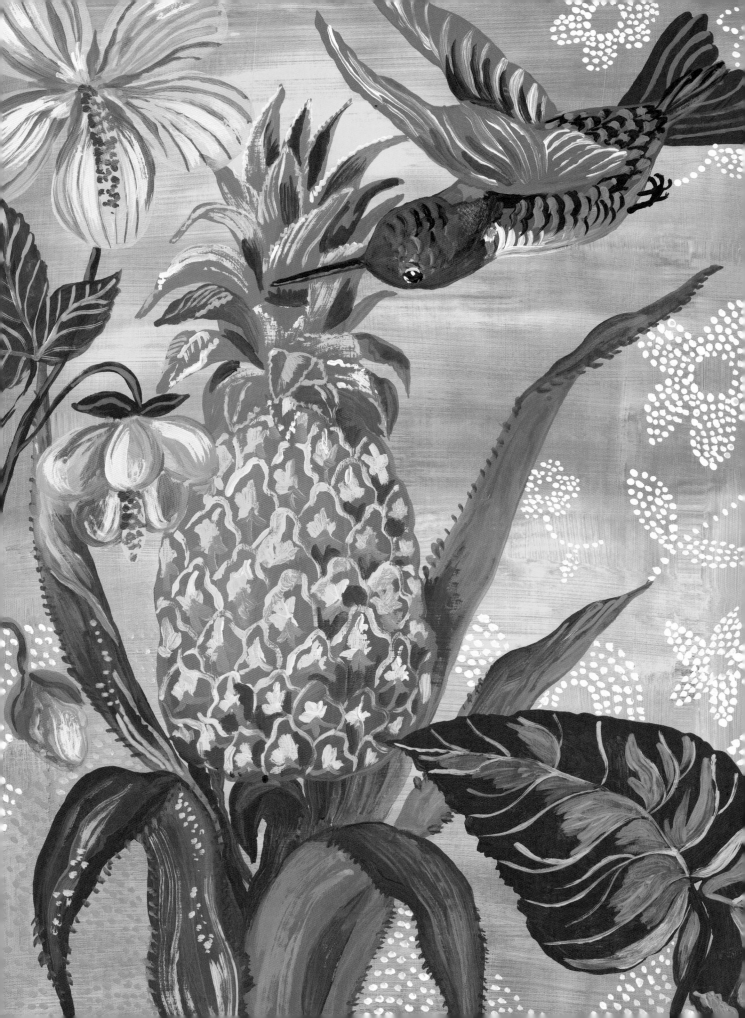

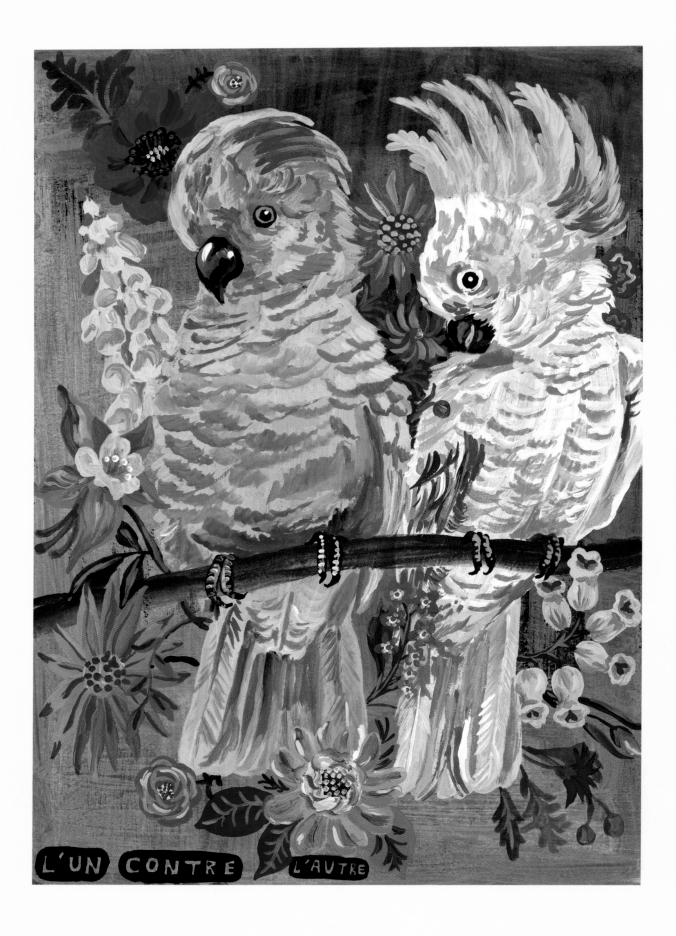

L'UN CONTRE L'AUTRE

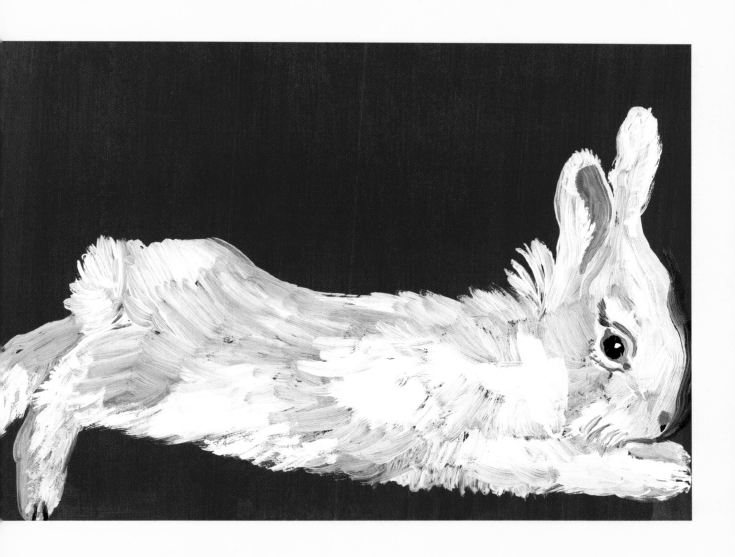

OPPOSITE: **One Against the Other** | *L'un contre l'autre*

ABOVE: **White Rabbit** | *Le lapin blanc*

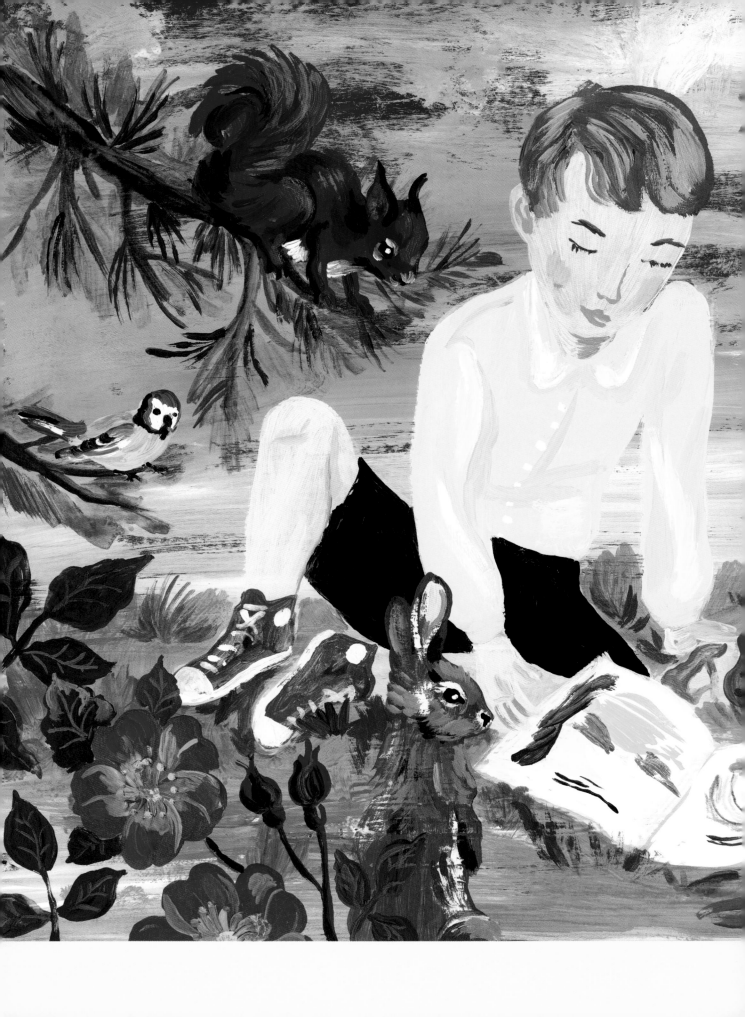

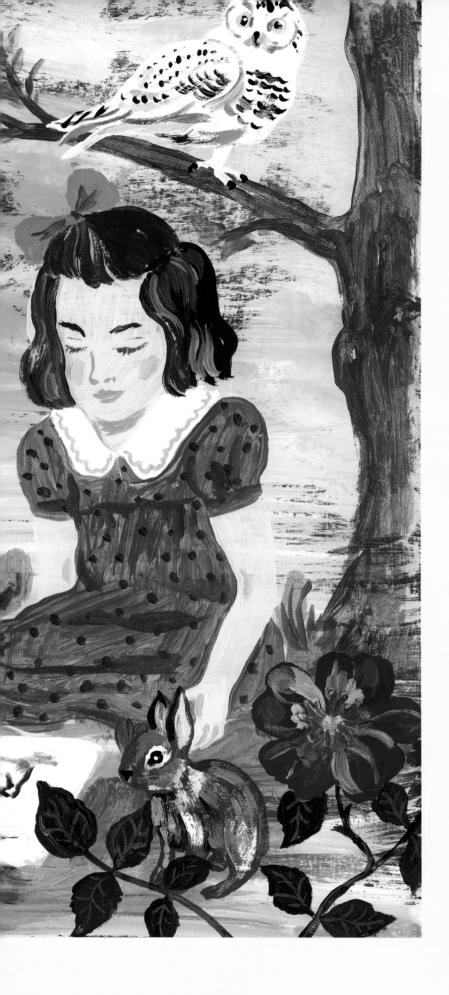

An Afternoon of Reading | *Un après-midi de lecture*

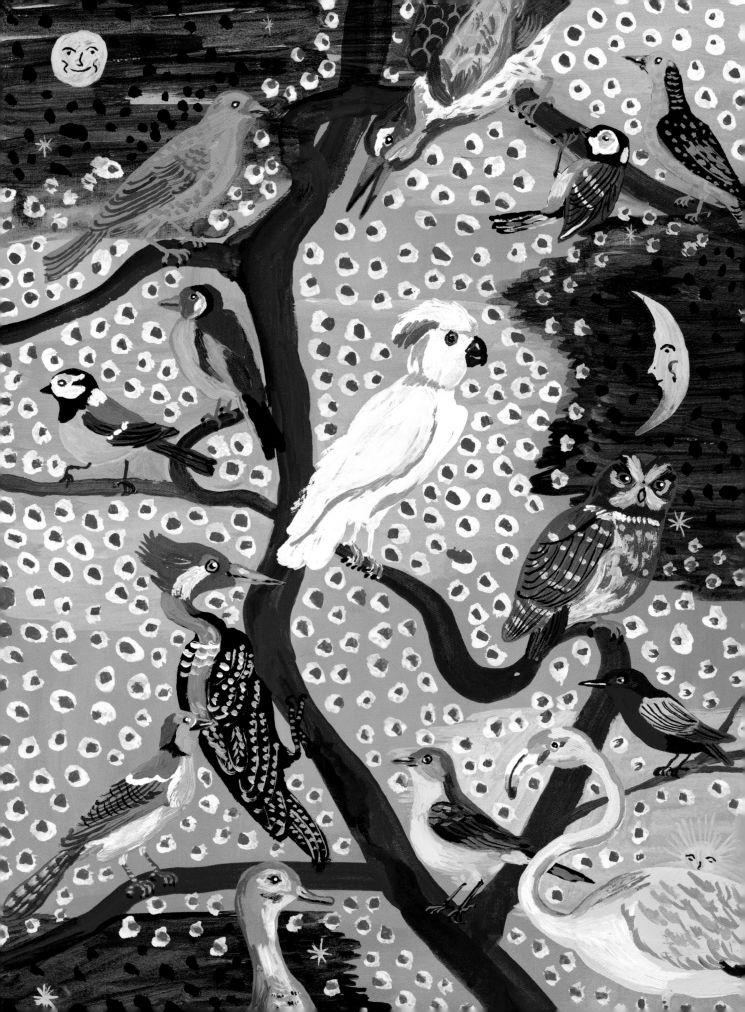

OPPOSITE: **Tree of Birds** | *L'arbre aux oiseaux*

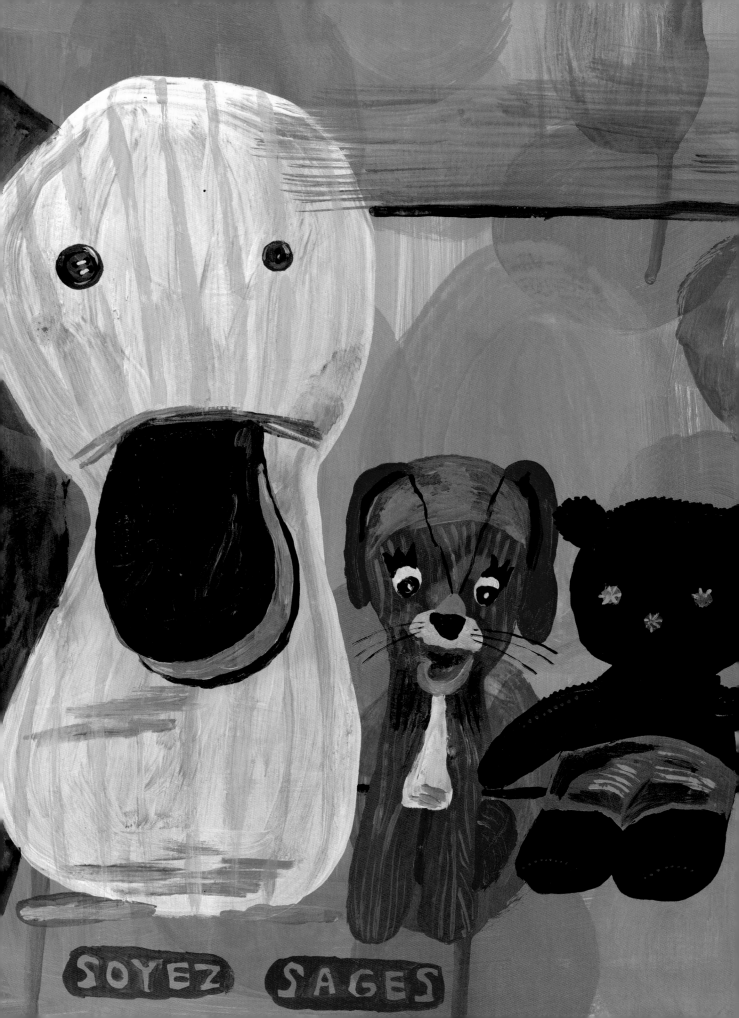

SOYEZ SAGES

I AM DRAWN TO VINTAGE TOYS BUT I AM ALSO INSPIRED BY PICTURE BOOKS... ENCOUNTERS BETWEEN CHARACTERS THAT COME TO LIFE WHEN I RE-CREATE THEM IN MY PAINTINGS... A LITTLE FAMILY I'VE MADE FOR MYSELF WHOSE MEMBERS BECOME THE HEROES OF MY STORIES.

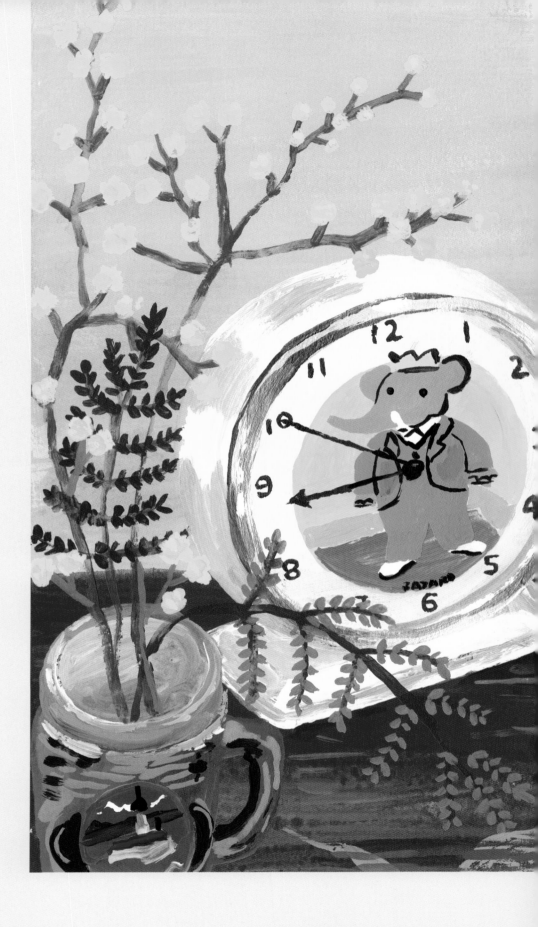

ABOVE: **The Sugar Box** | *La boîte à sucre*

FOLLOWING PAGES: **Surprise Ball**

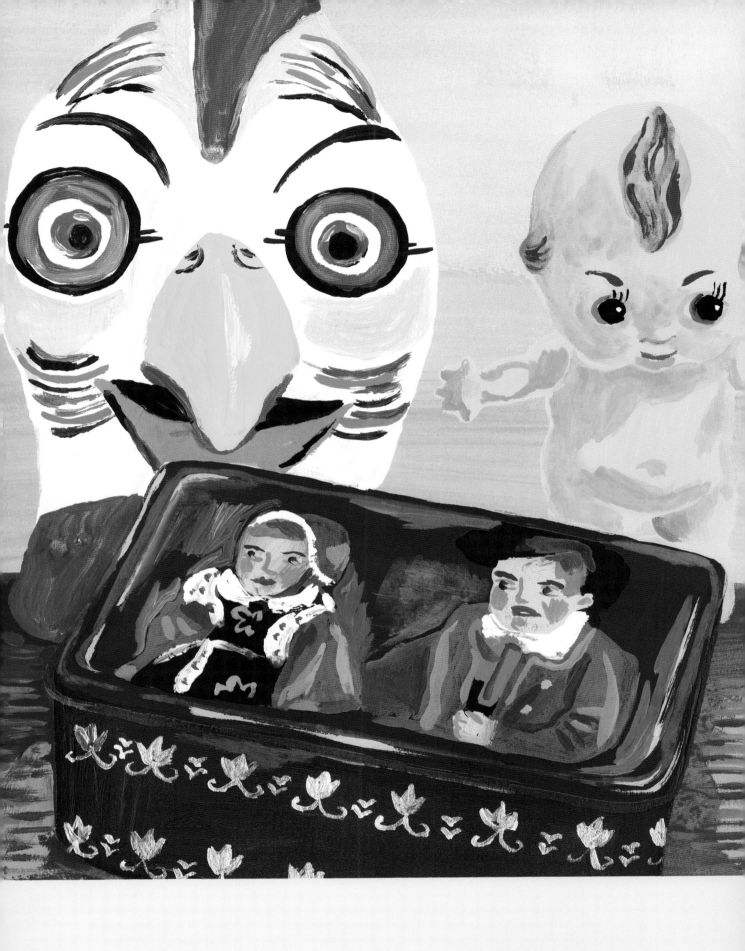

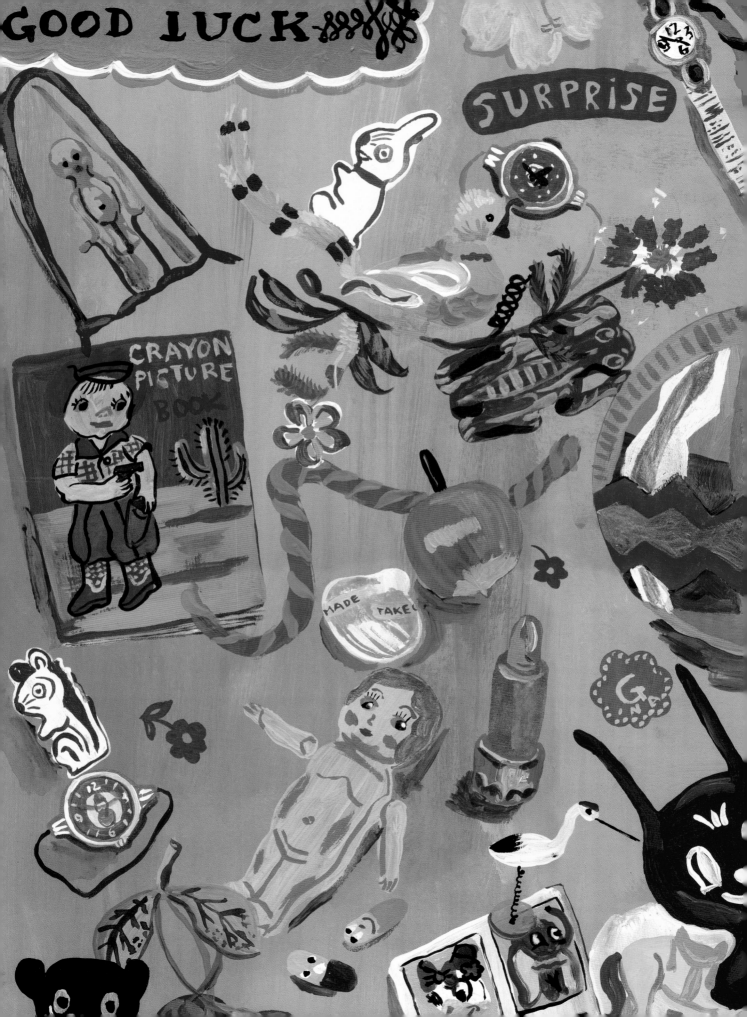

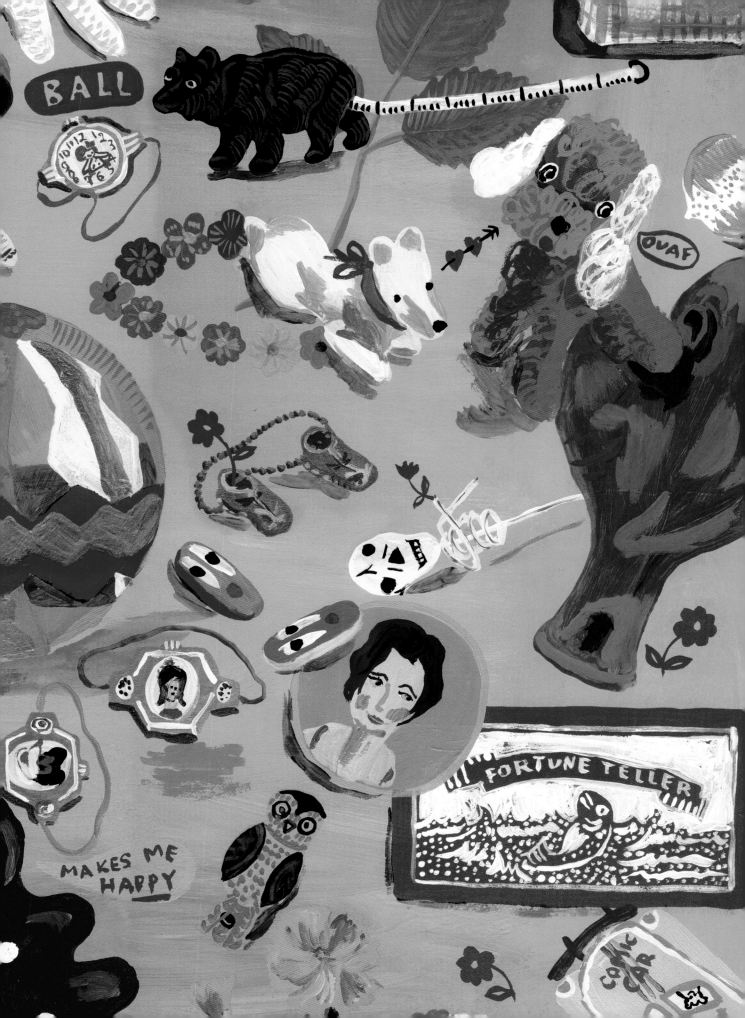

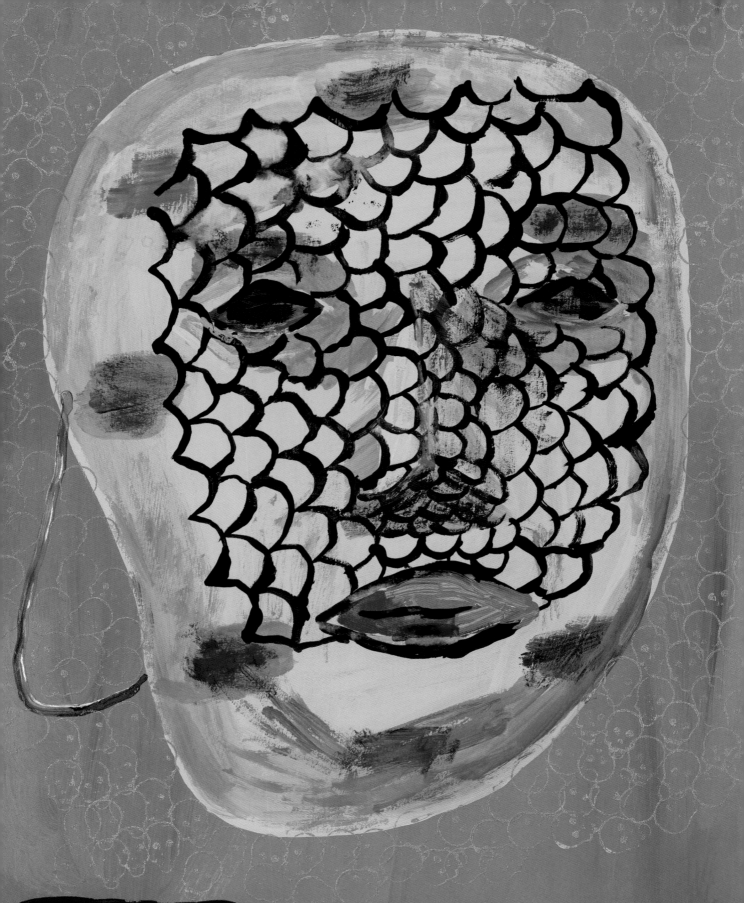

JUNGLE MAN

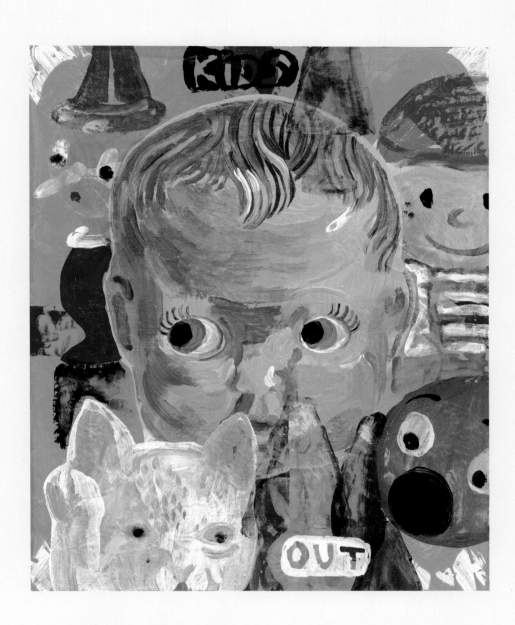

OPPOSITE: **Jungle Man**

ABOVE: **Kids Out** | *Les enfants dehors*

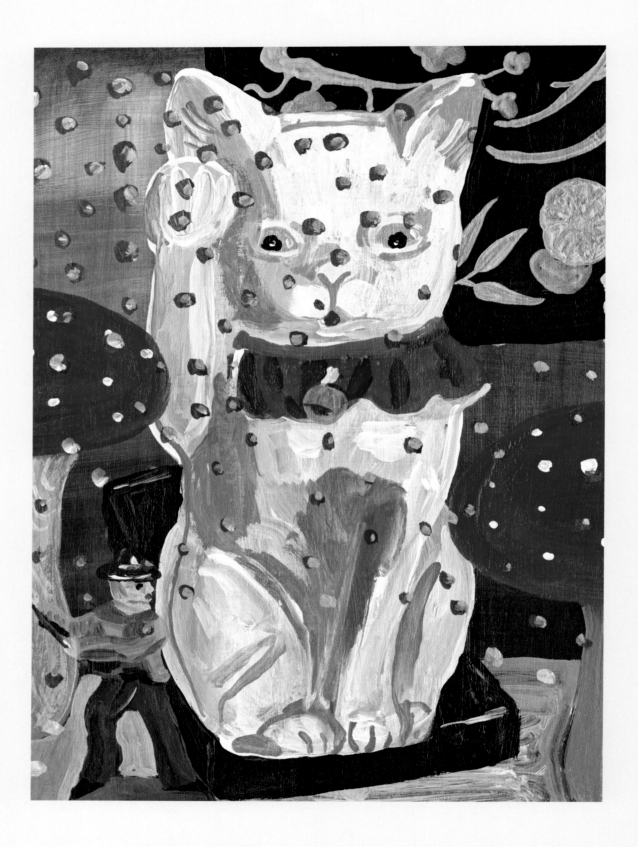

ABOVE: **Lucky Cat** | *Chat porte-bonheur*

OPPOSITE: **Fight** | *Combat*

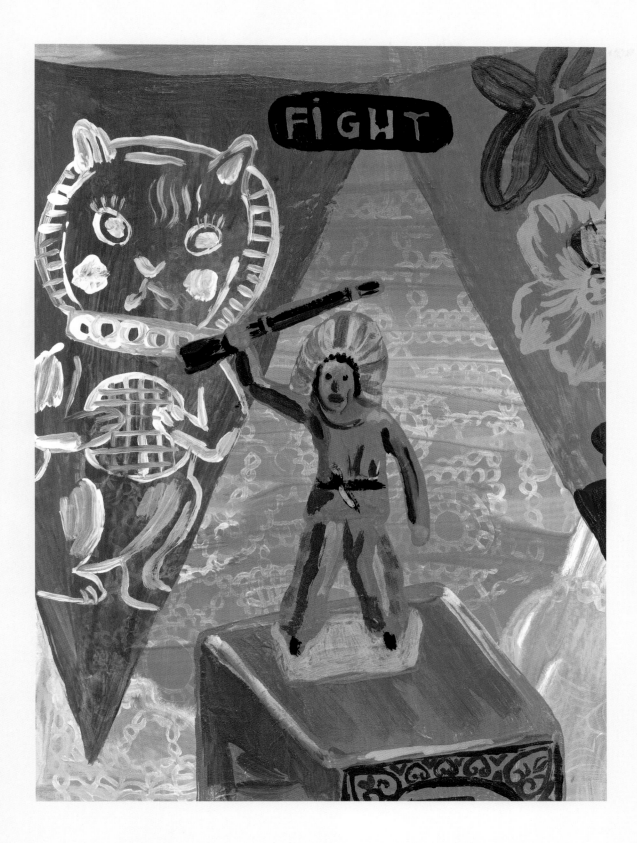

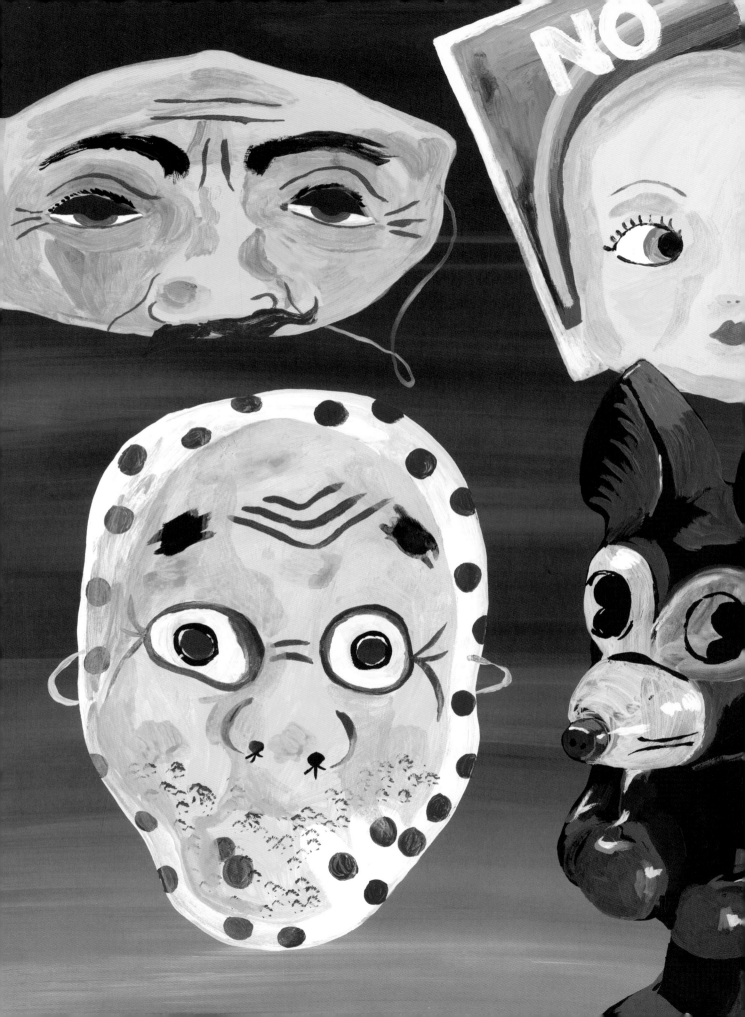

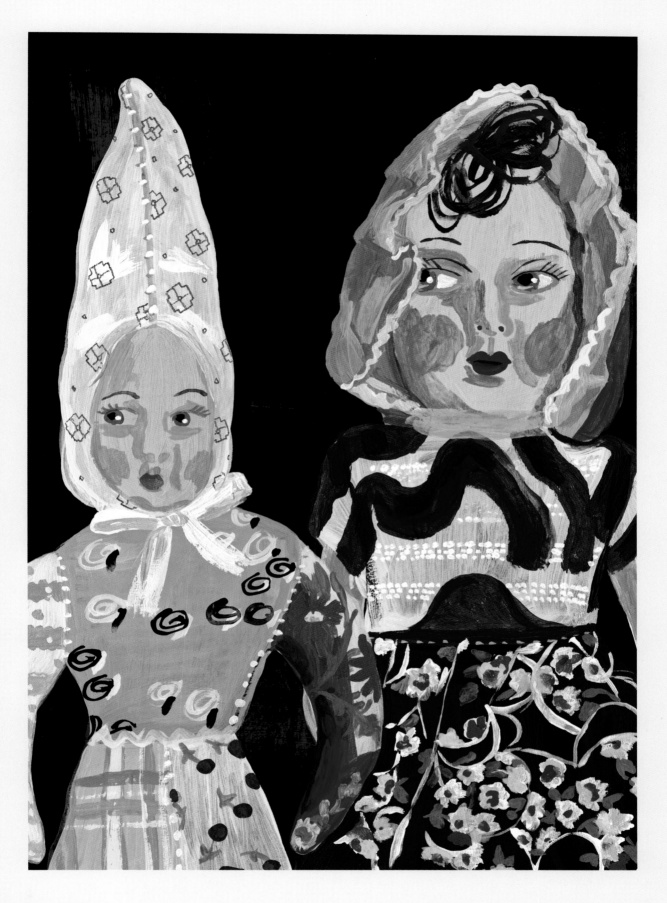

OPPOSITE: **No** | *Non*

ABOVE: **The Couple** | *Le couple*

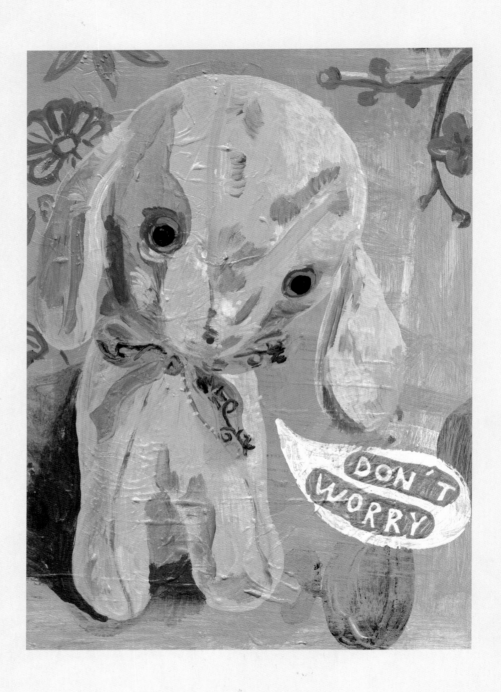

ABOVE: **Don't Worry** | *Ne t'en fais pas*

OPPOSITE: **Girl with a Bird** | *La fille à l'oiseau*

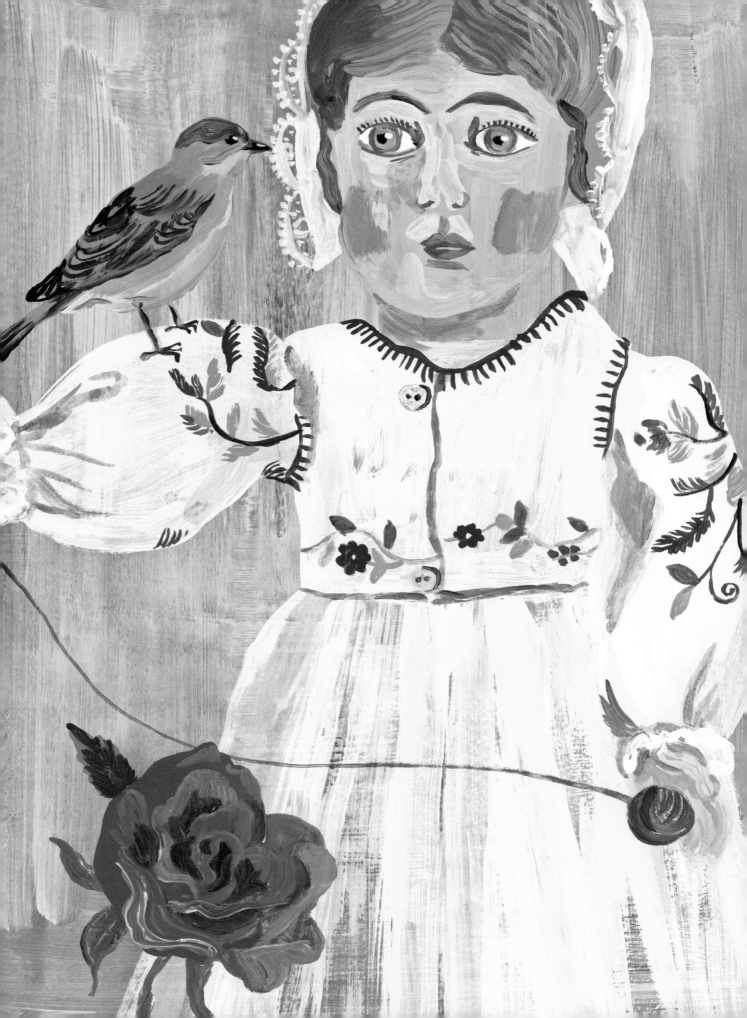

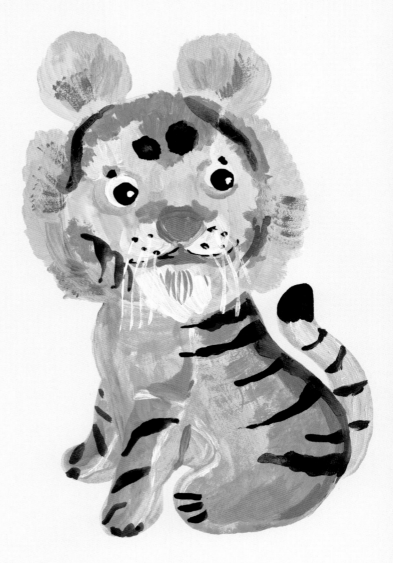

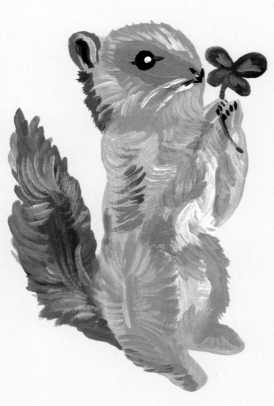

OPPOSITE: **Rabbit with Tulips** | *Le lapin aux tulipes*

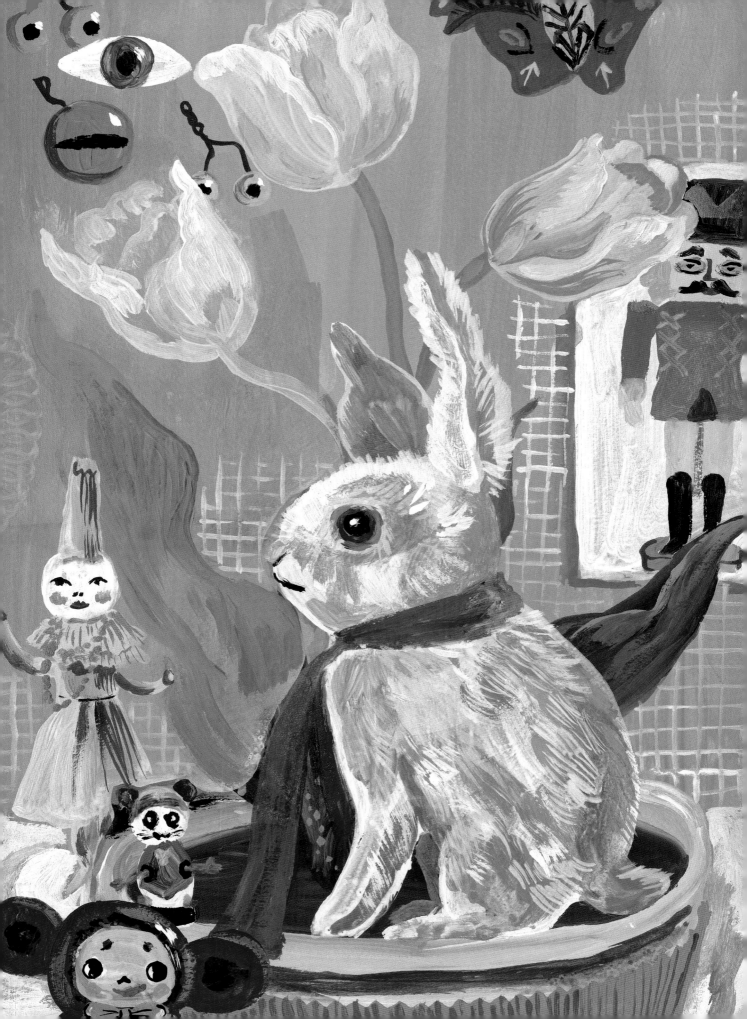

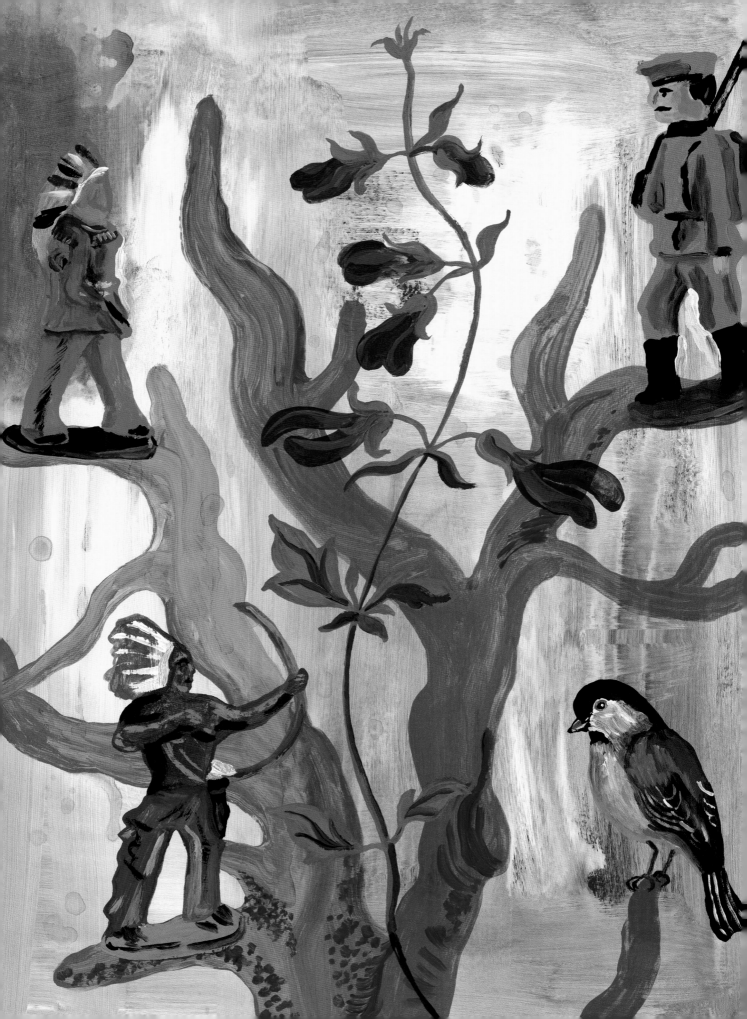

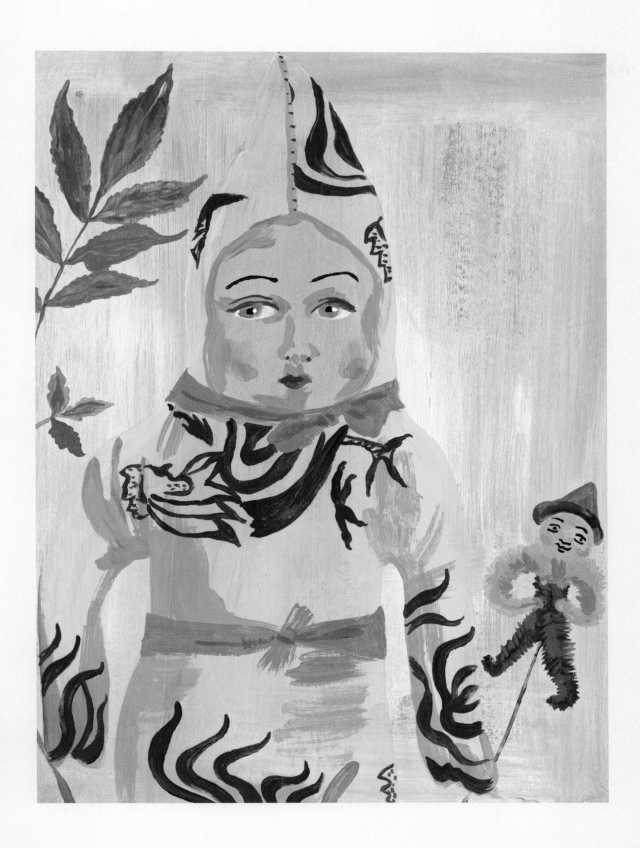

OPPOSITE: **Coral with Indians** | *Le corail aux indiens*

ABOVE: **Benoît**

MY PAINTINGS OFTEN HAVE TITLES, VERY SHORT
ONES, LIKE POST-ITS. MESSAGES THAT COME TO
MIND WITHOUT ME THINKING ABOUT IT, AT THE
EXACT MOMENT WHEN I FINISH THE PAINTING,
LIKE THE CHERRY ON TOP OF A SUNDAE, SOMETIMES
THEY BALANCE OUT THE COMPOSITION. OFTEN
THEY'RE RELATED TO THE MOOD OF THE DAY, JUST
LIKE MY PAINTINGS. IT'S A BIT LIKE A DIARY
OF THE MIND.

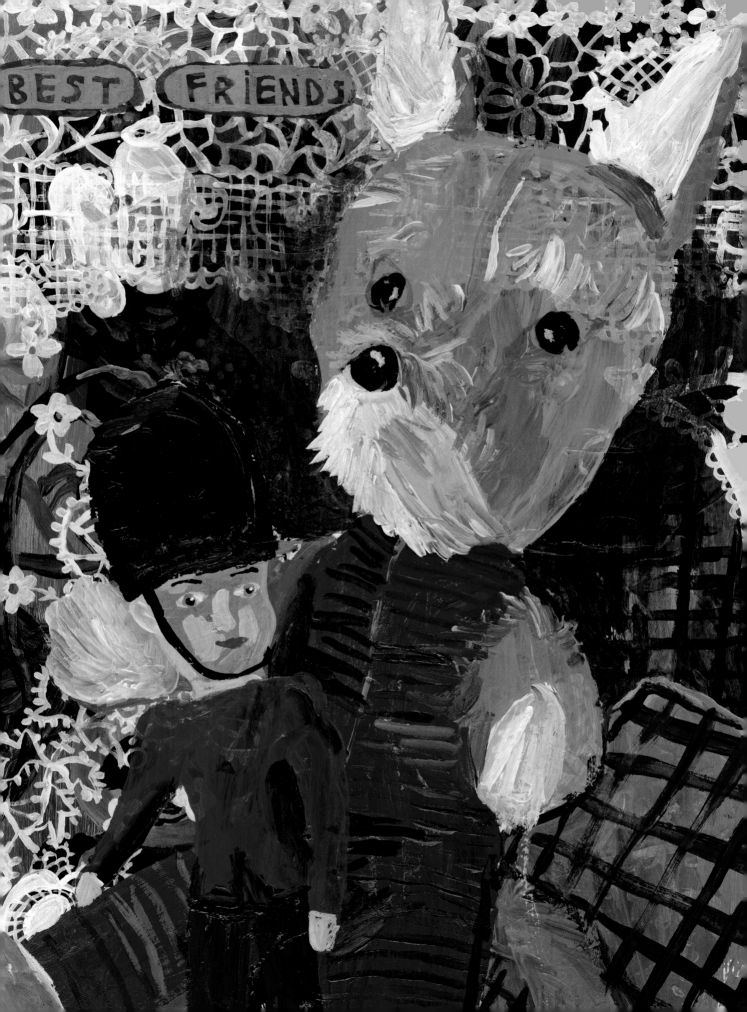

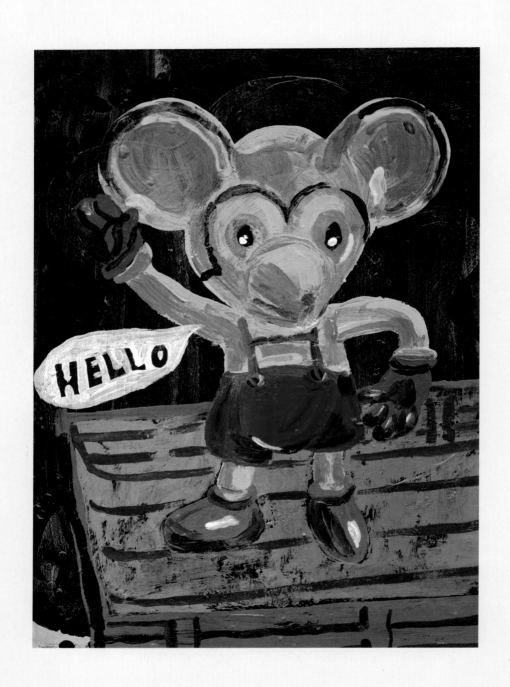

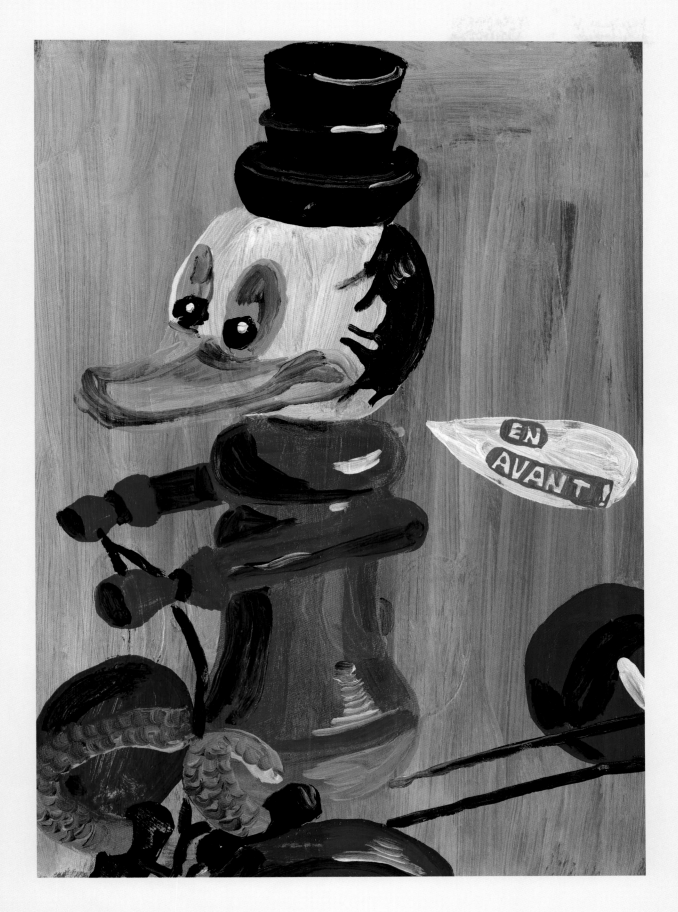

OPPOSITE: **Hello** | *Bonjour*

ABOVE: **Forward!** | *En avant!*

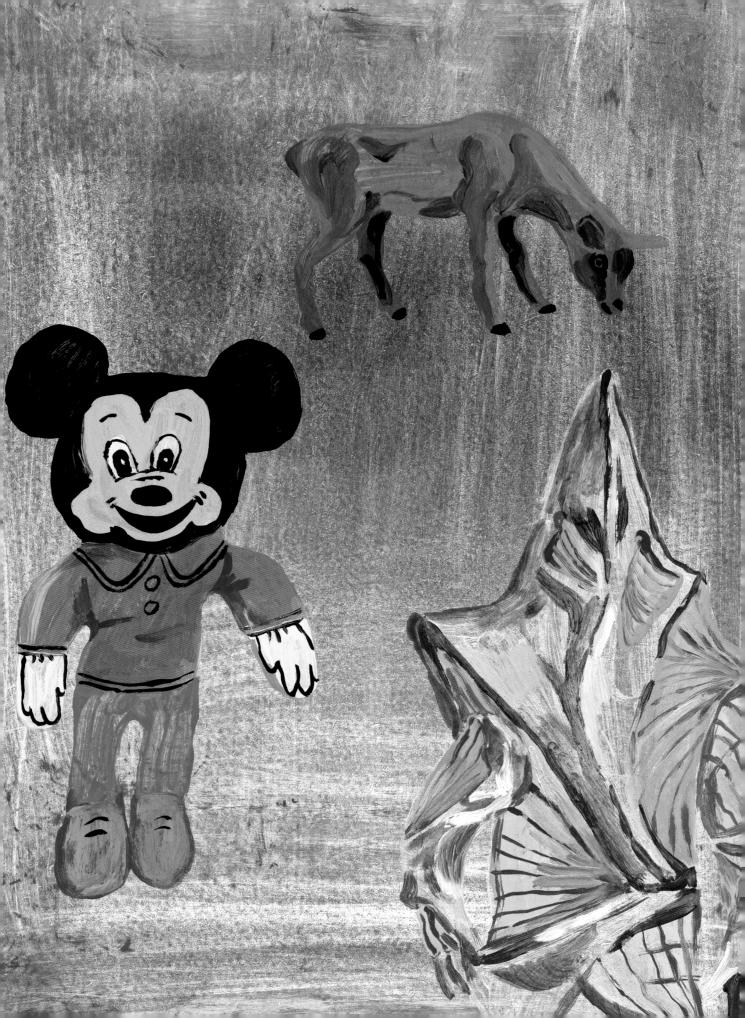

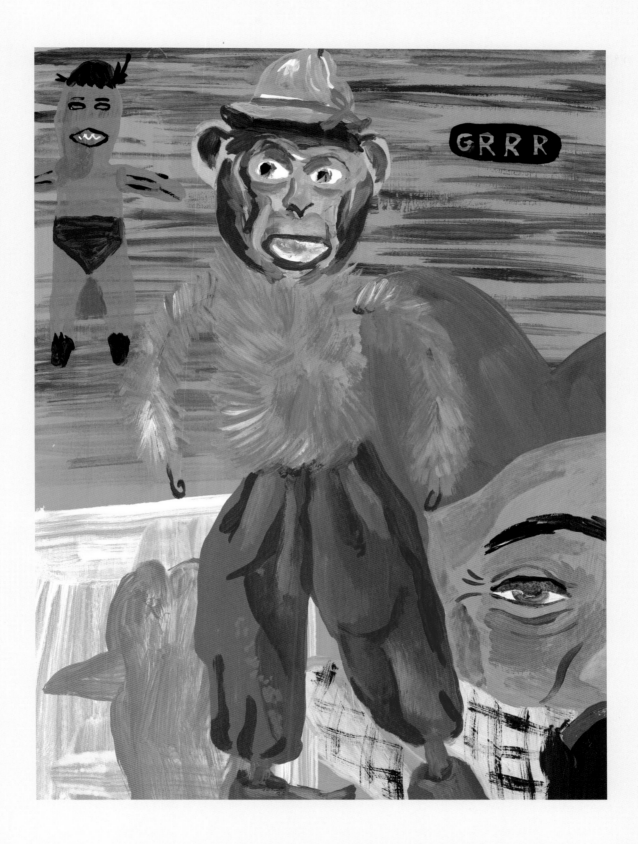

OPPOSITE: **Mickey**

ABOVE: *Grrr*

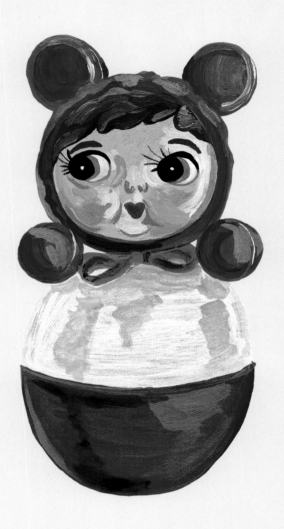

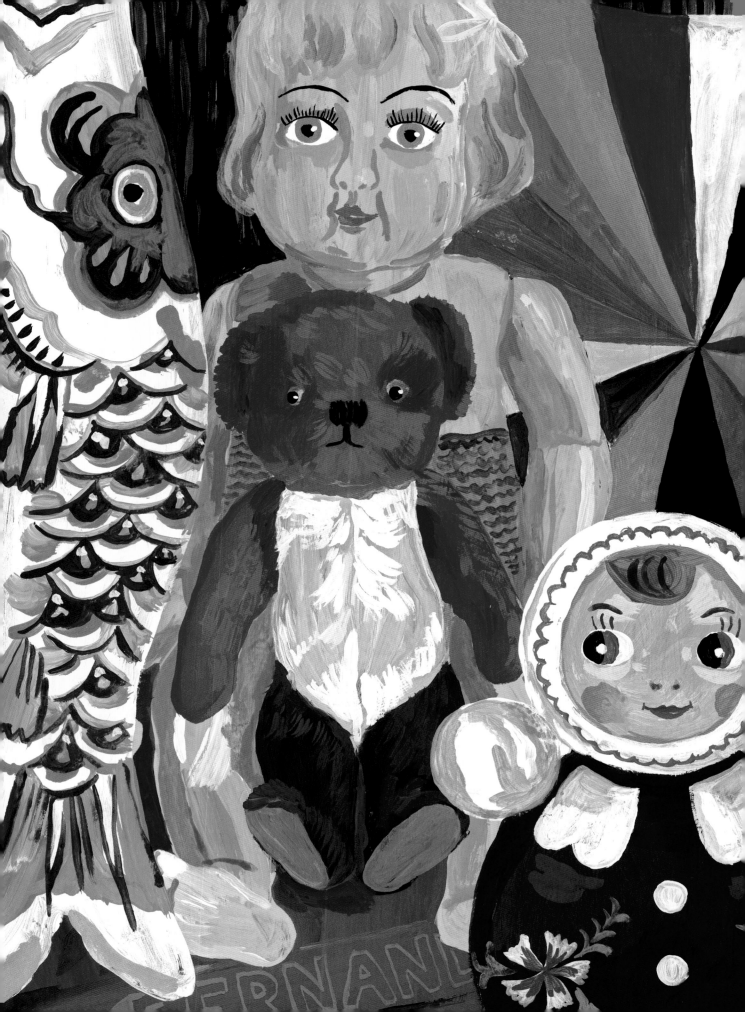

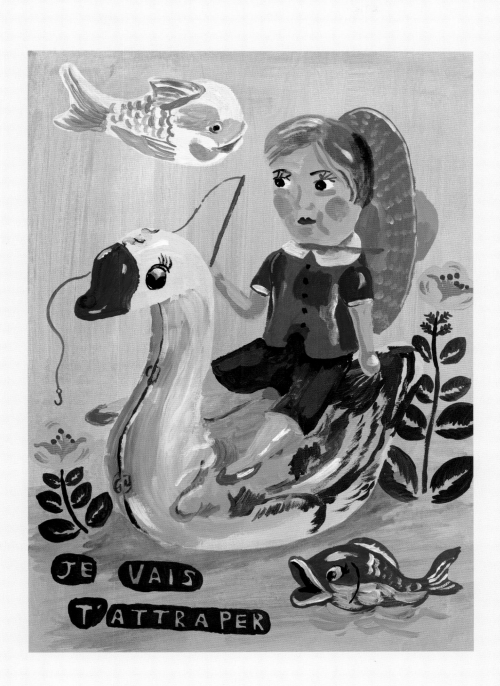

JE VAIS T'ATTRAPER

OPPOSITE: *Blic, Blic*

ABOVE: I'm Going to Catch You | *Je vais t'attraper*

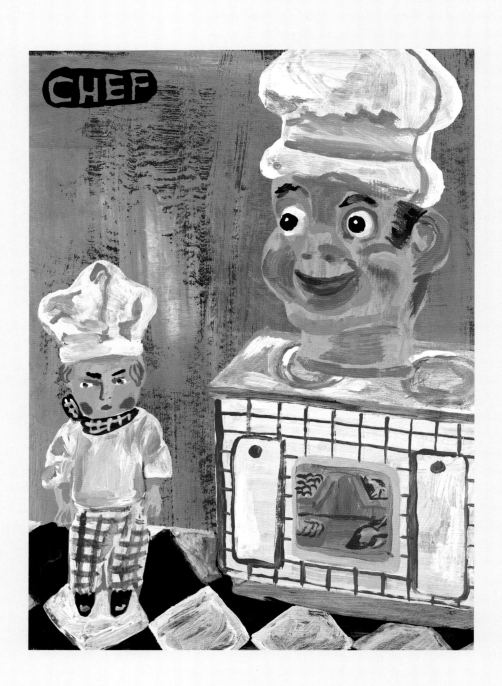

CHEF

ABOVE: **Chef**

OPPOSITE: **Chick in a Boater Hat** | *Le poussin au canotier*

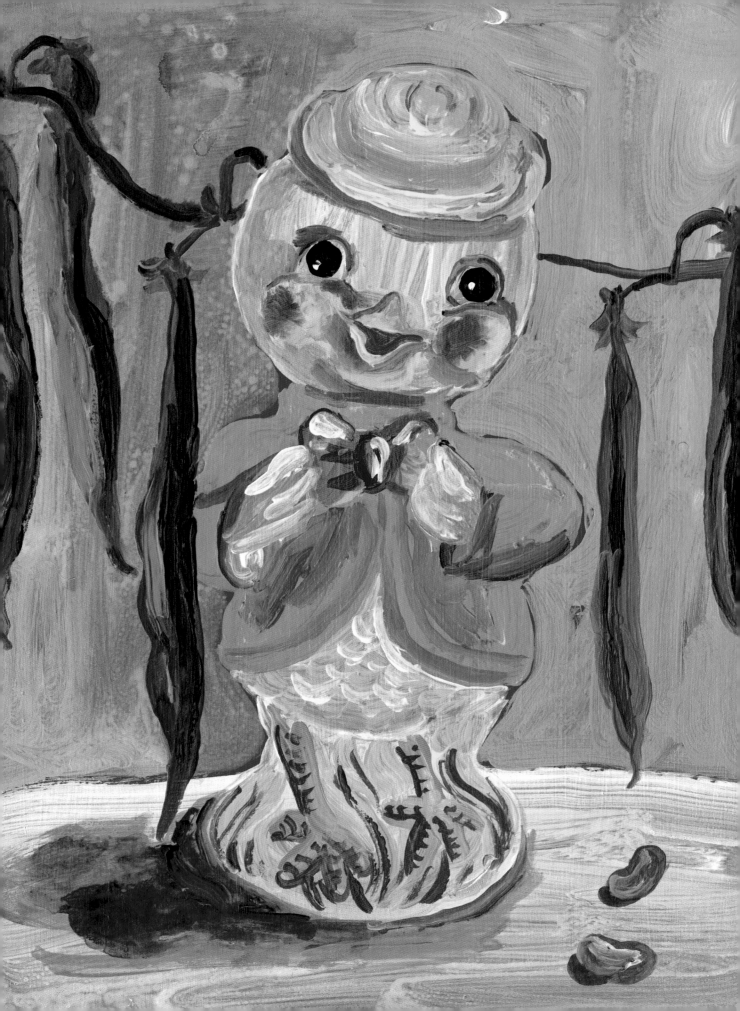

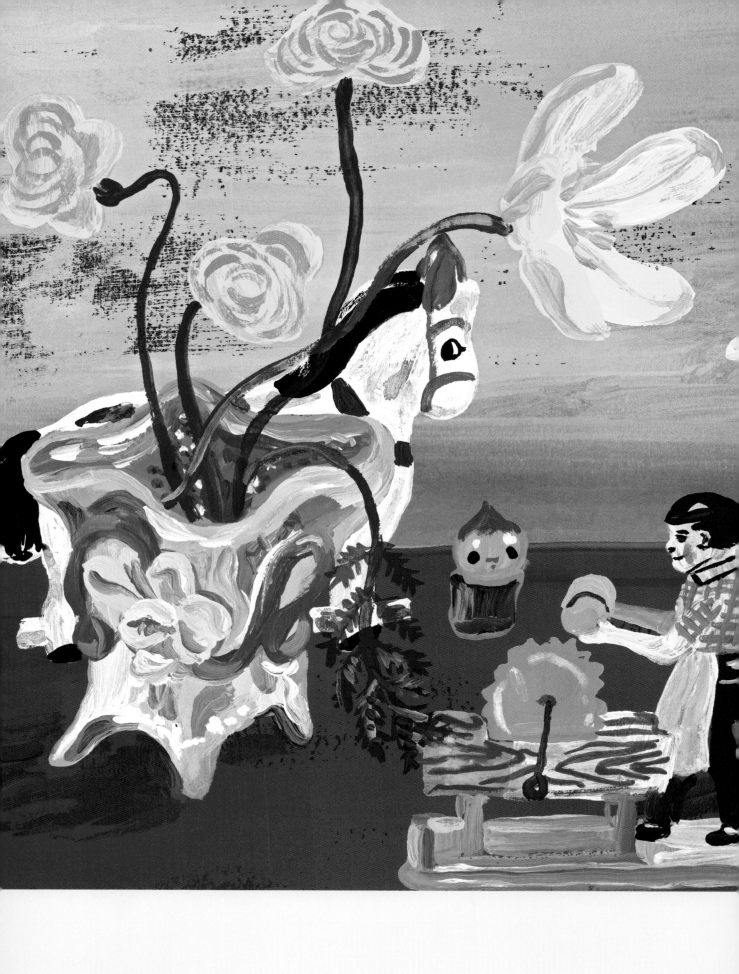

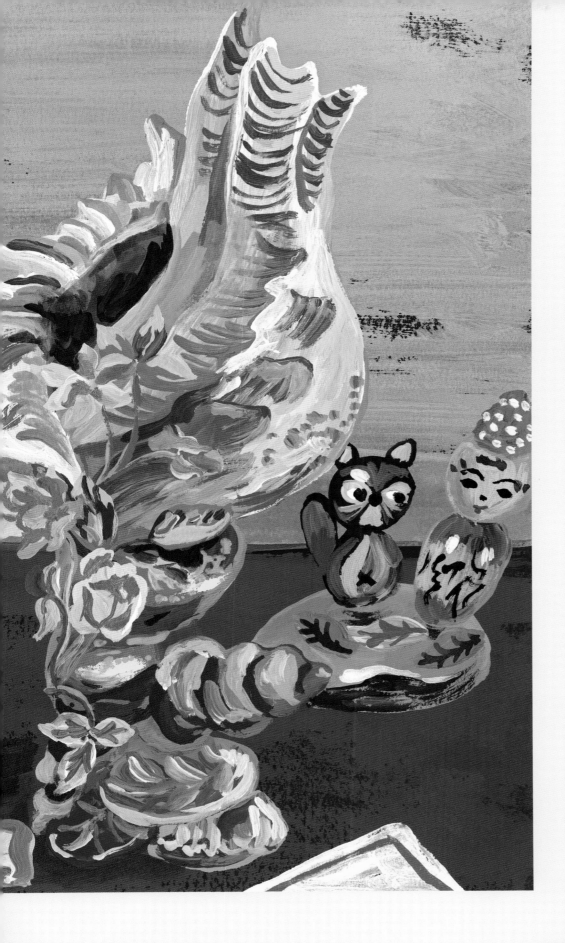

ABOVE: **The Carpenter** | *Le charpentier*

FOLLOWING PAGES: **Tirol**

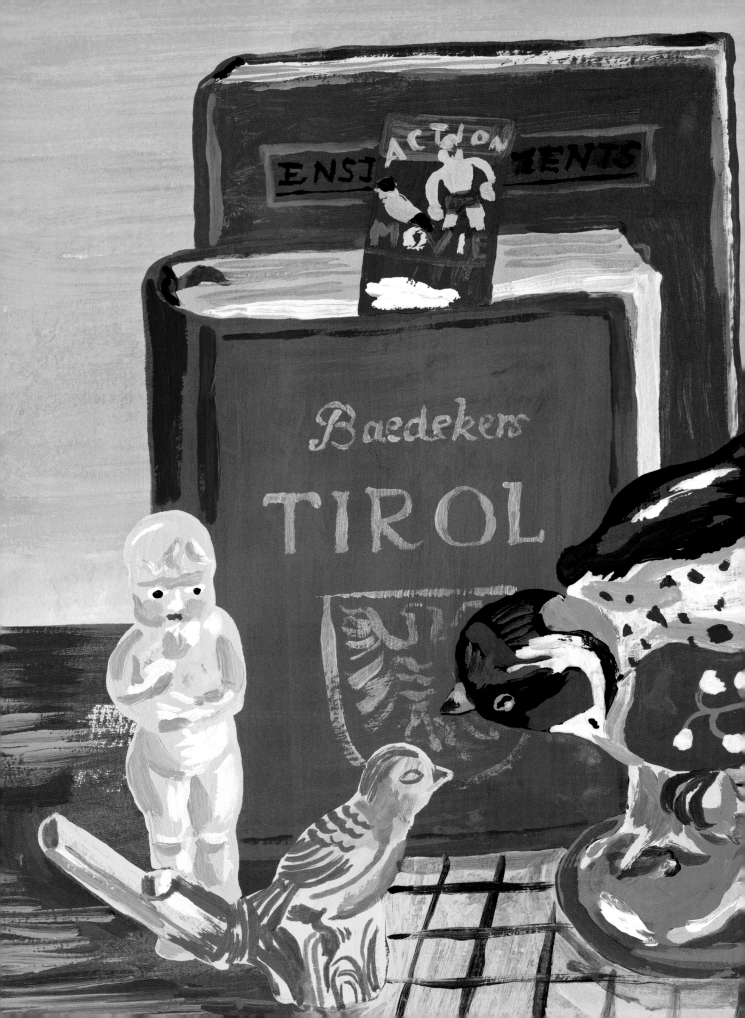

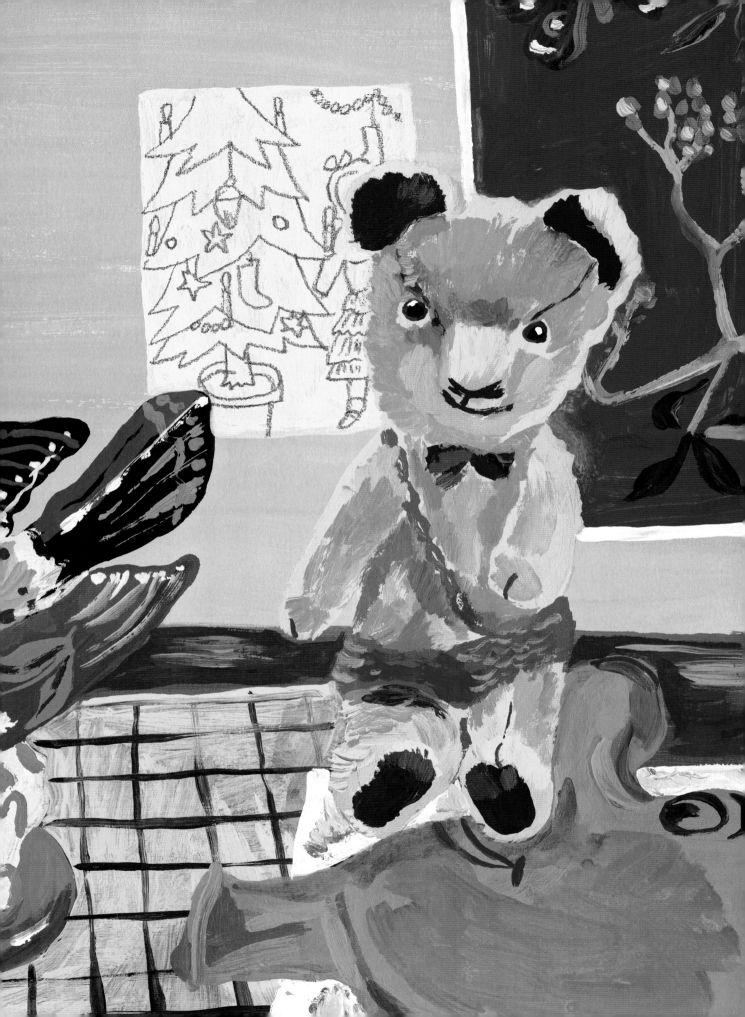

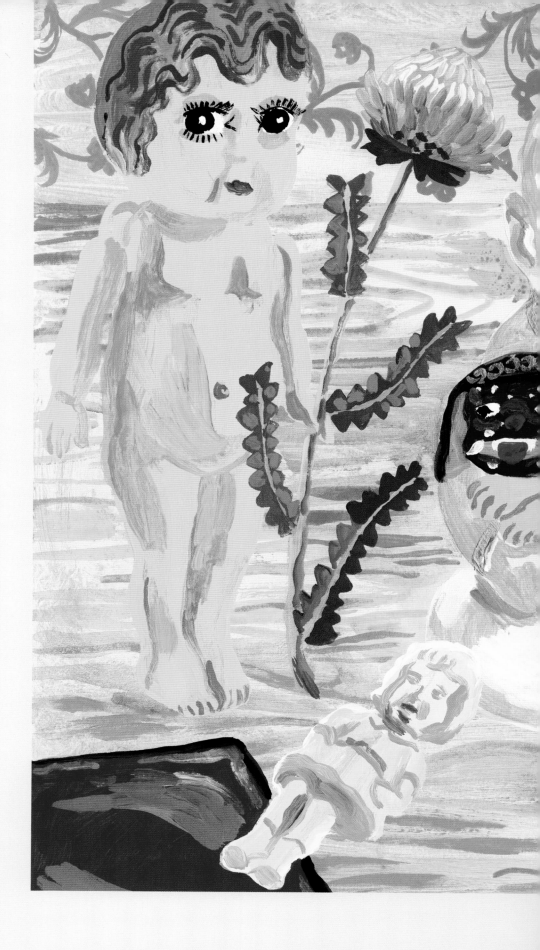

Little Buddha | *Petit Bouddha*

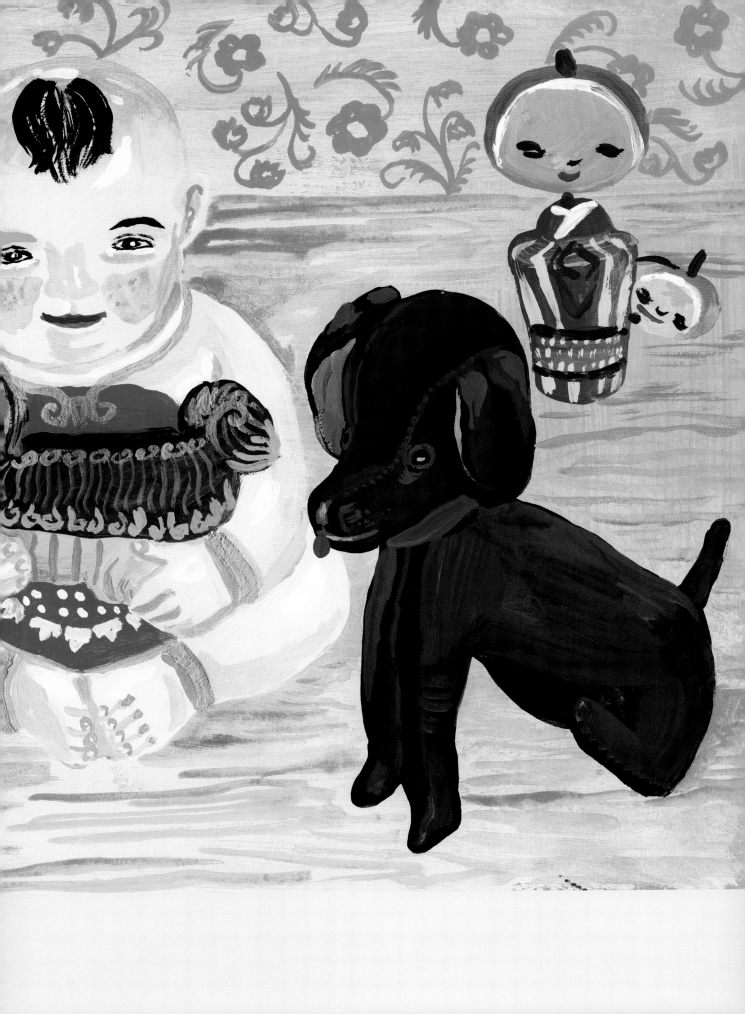

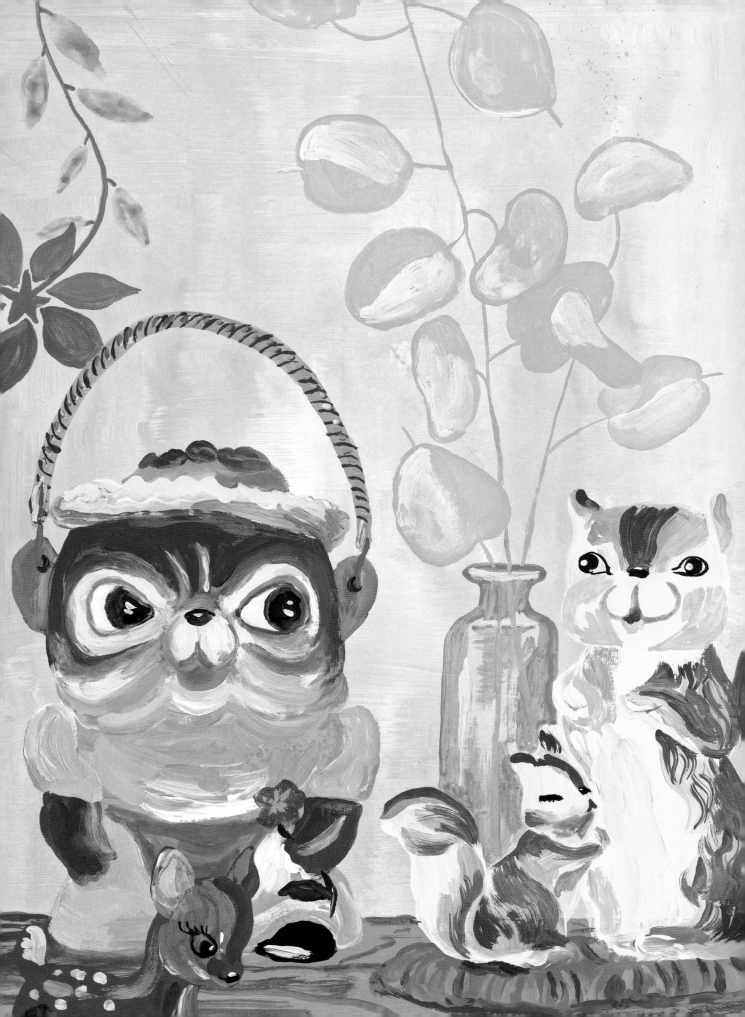

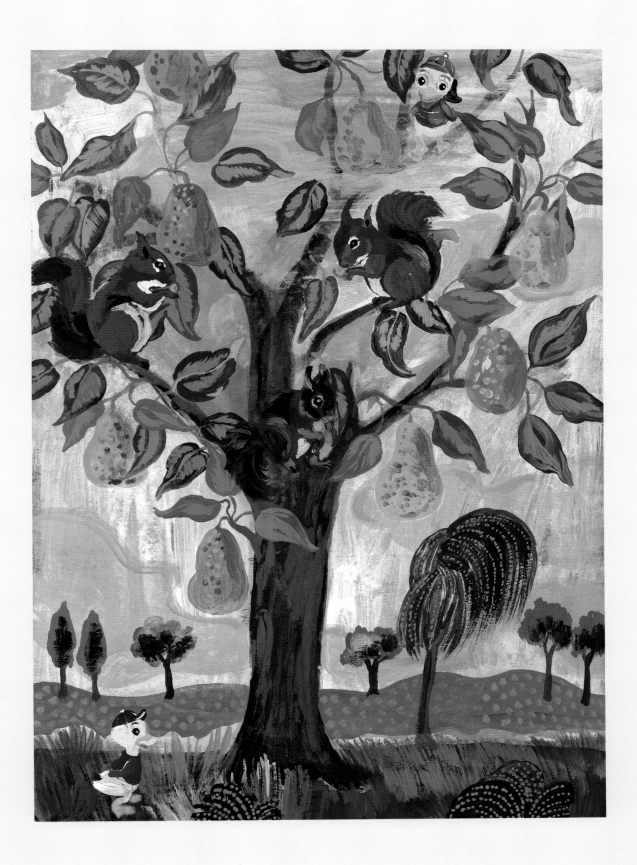

OPPOSITE: **Squirrels** | *Les écureuils*

ABOVE: **Greedy Squirrels** | *Les écureuils gourmands*

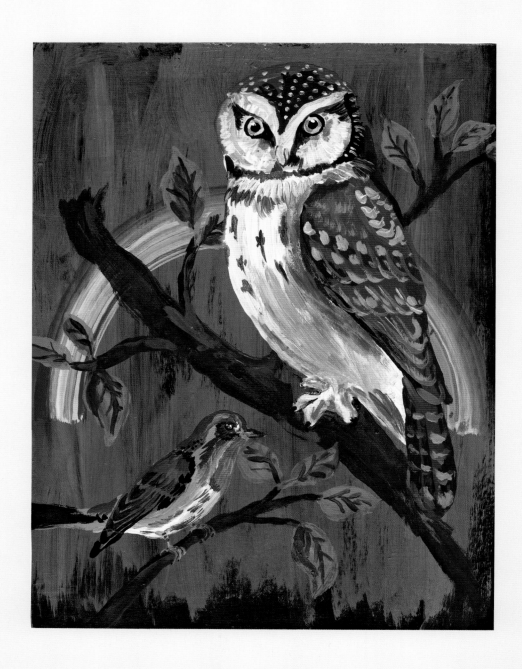

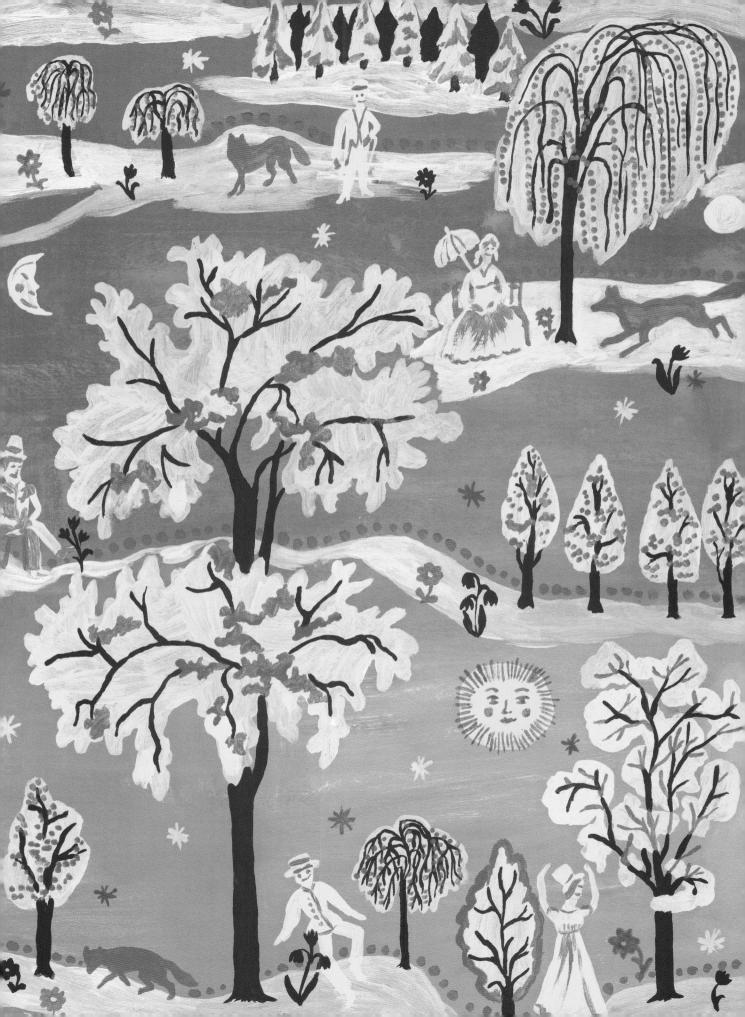

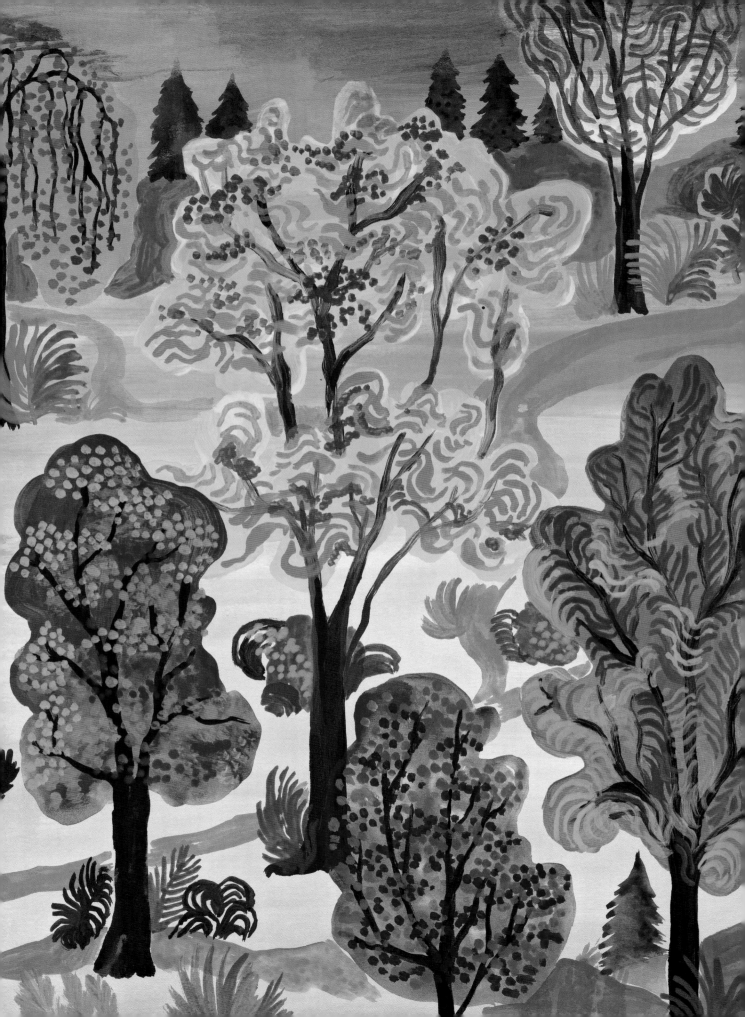

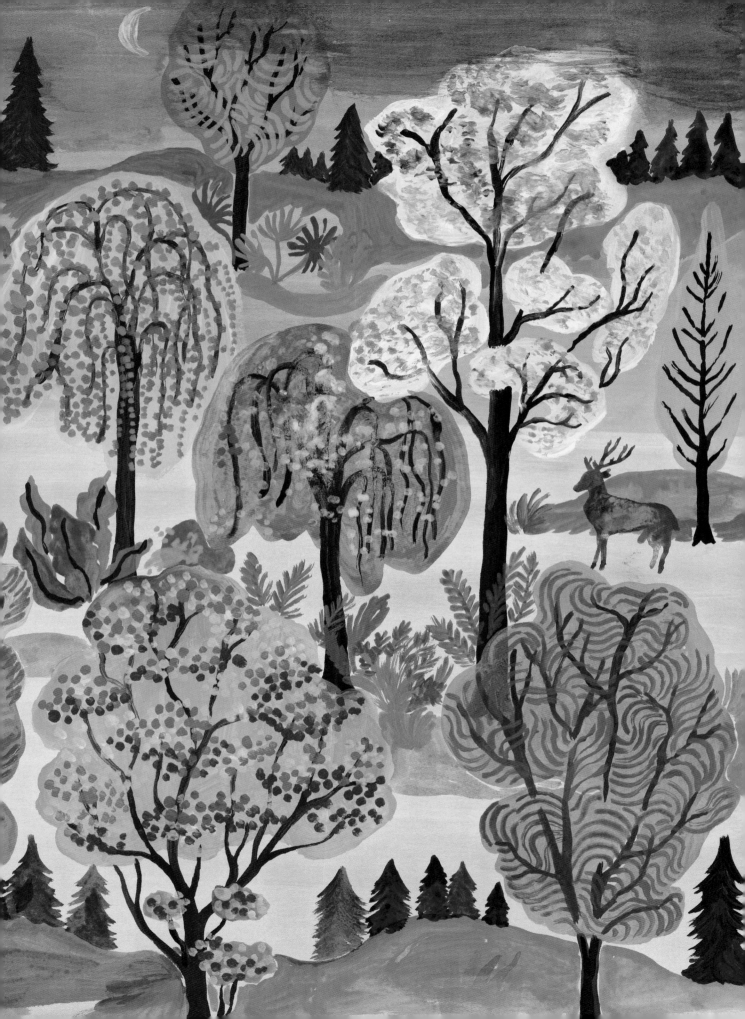

OPPOSITE: **Two Pears** | *Les deux poires*

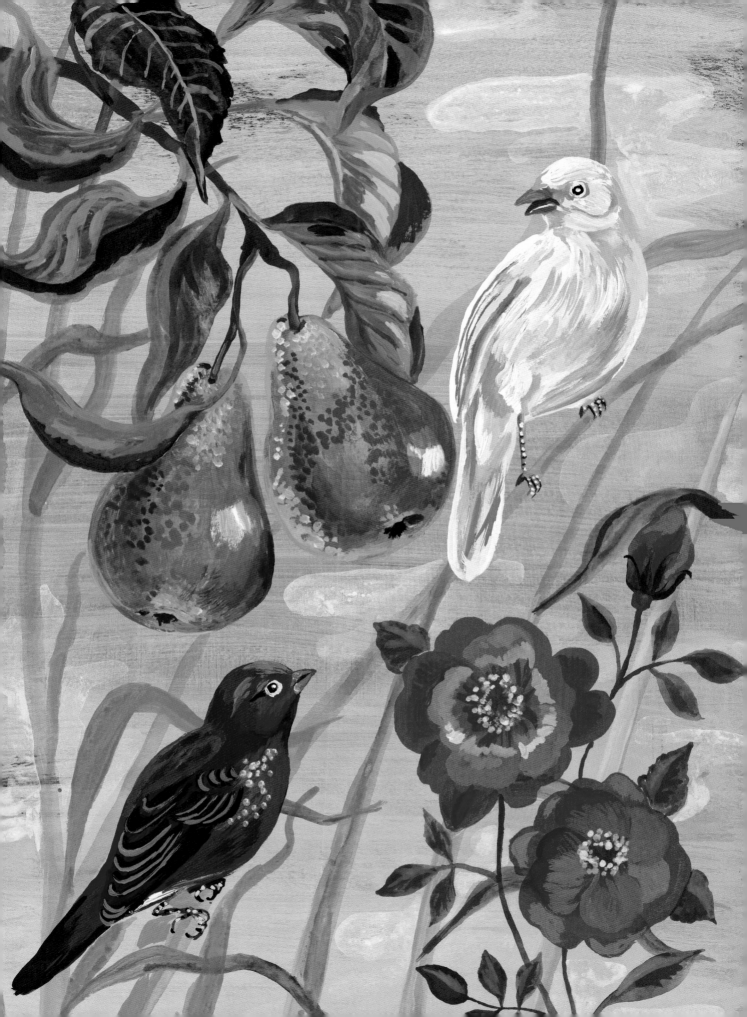

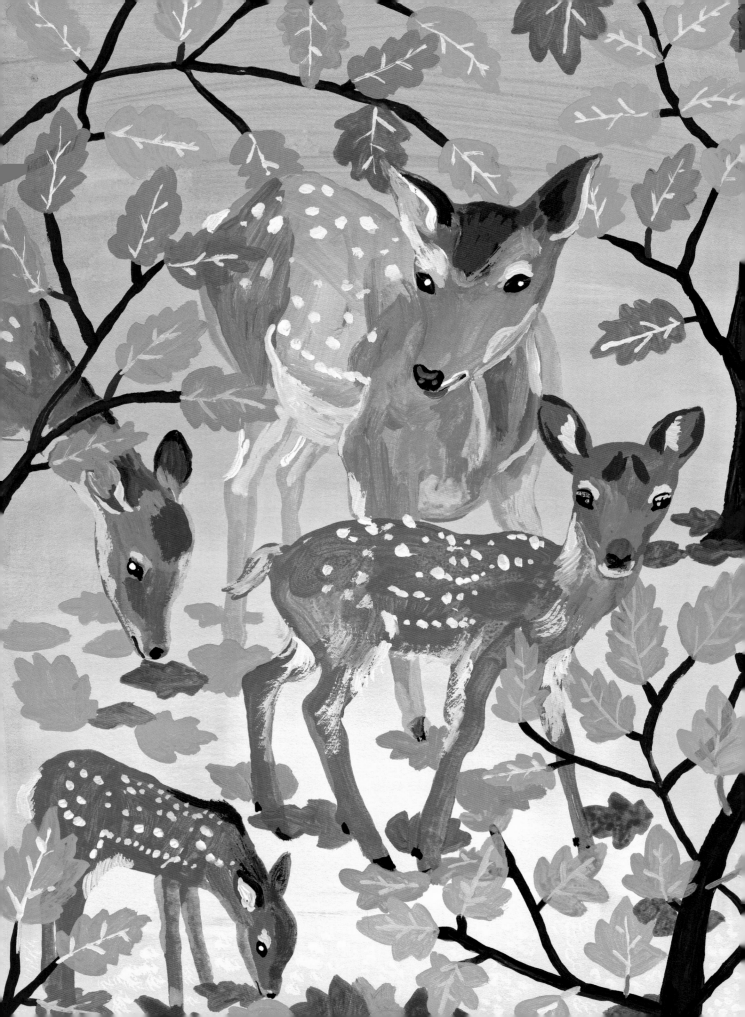

I love sad stories, and I loved crying when I watched the movie Bambi for the first time. On a few occasions, I came upon some deer in the forest, and those are strong, stirring images that stuck deeply in my mind, like precious gifts from life.

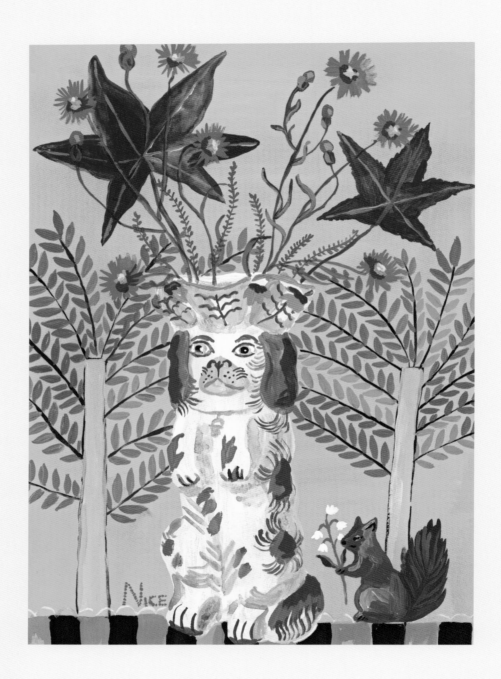

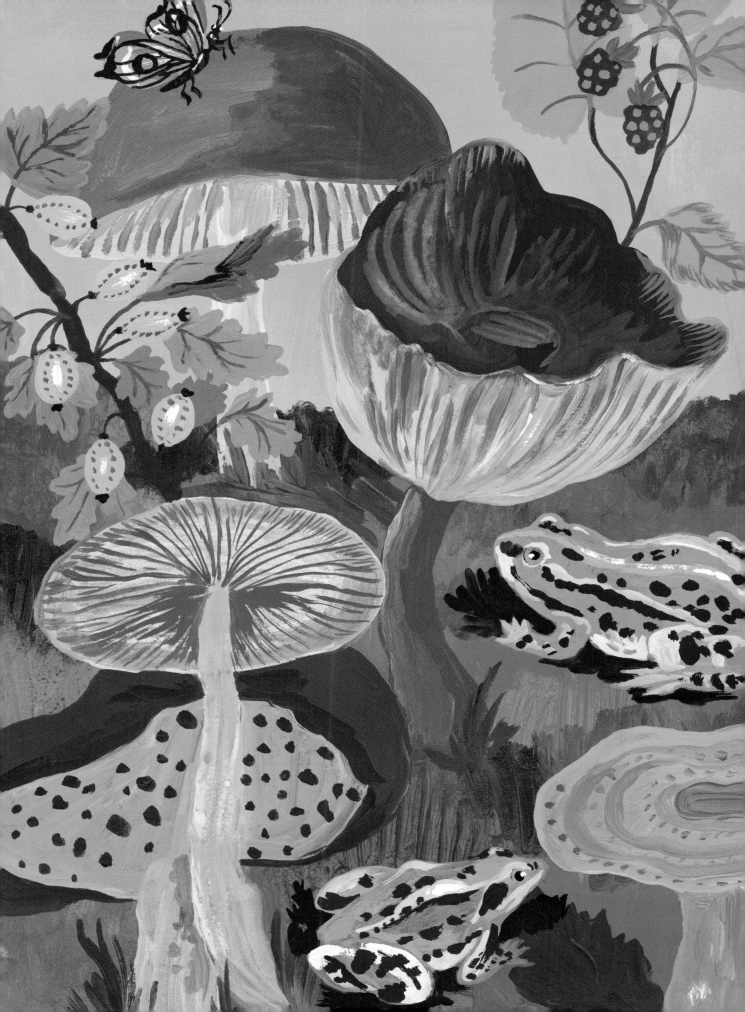

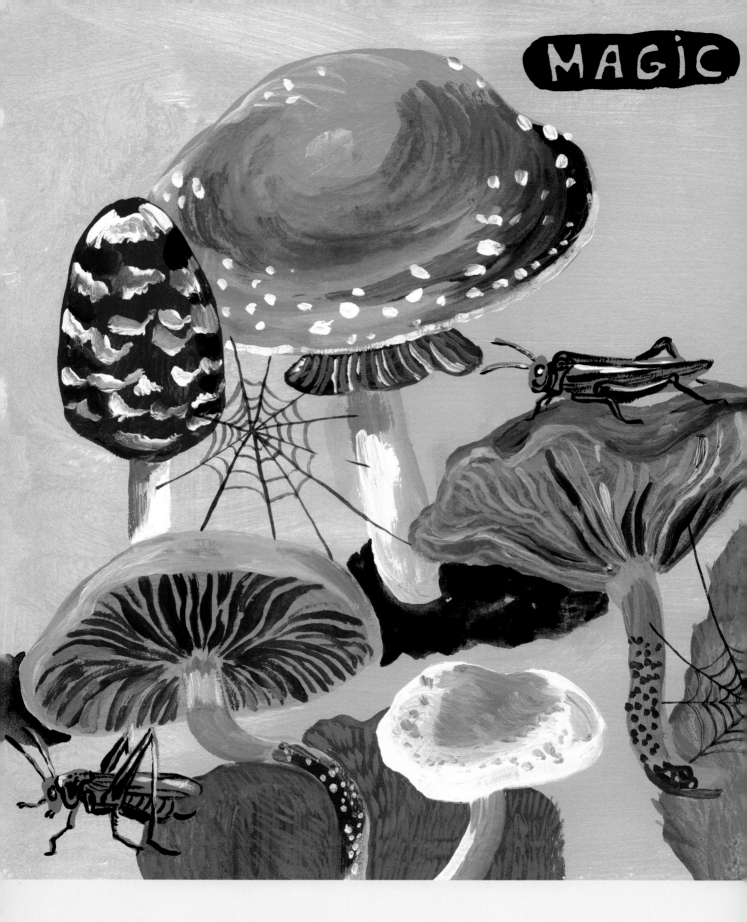

MAGIC

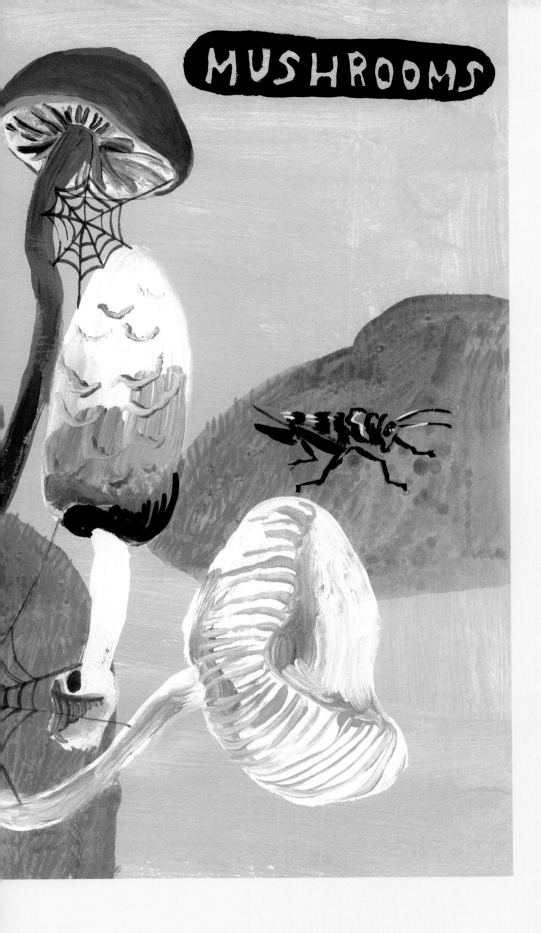

MUSHROOMS

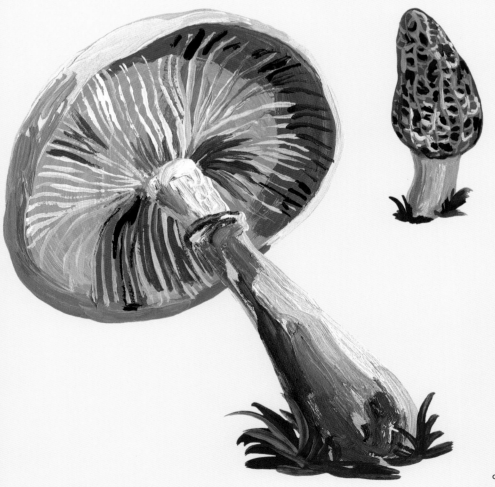

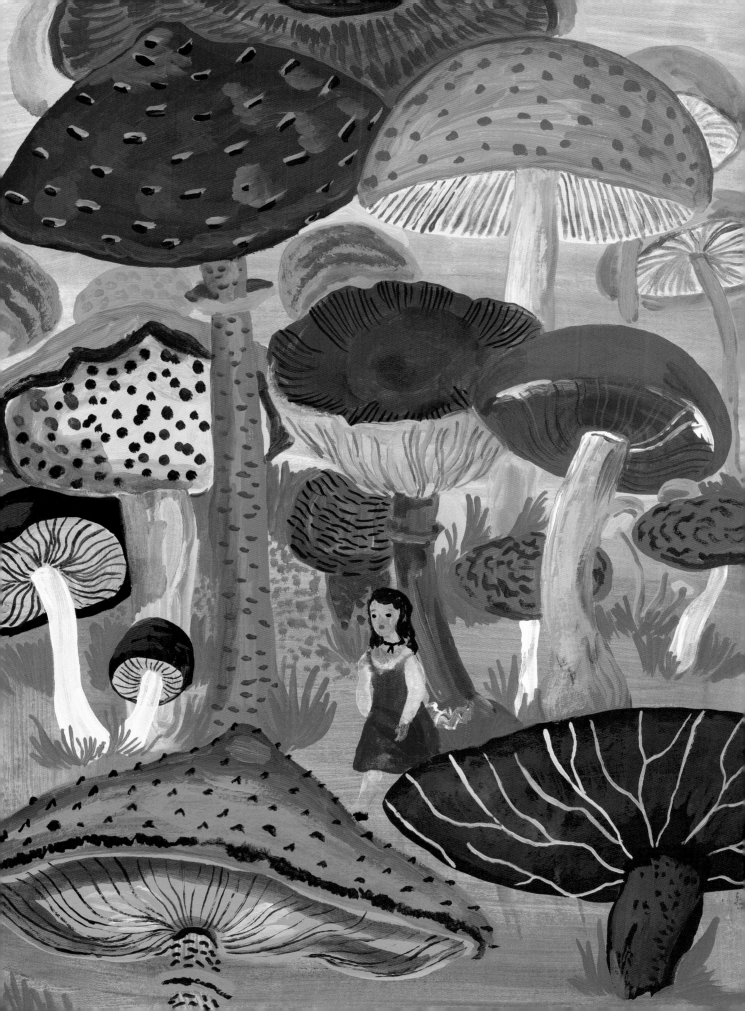

I especially like painting birds because of the variety of their species and colors, but also because of their song and everything that it evokes in me. When I paint them, their free spirits embody me, and I can feel the freedom they must have when they fly in the sky.

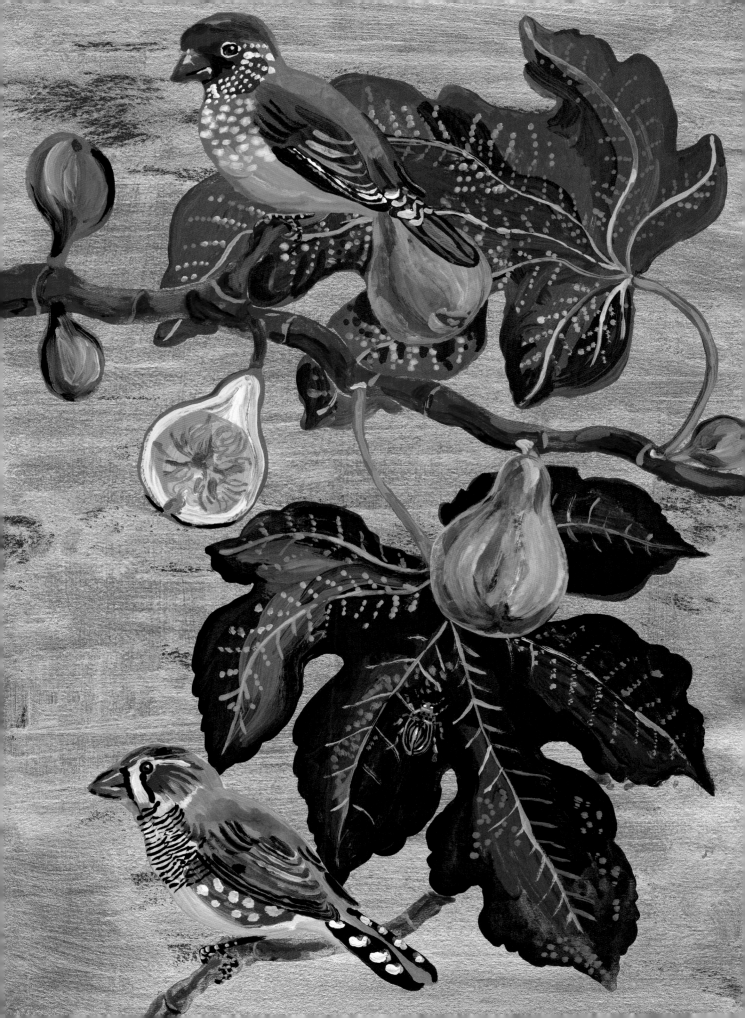

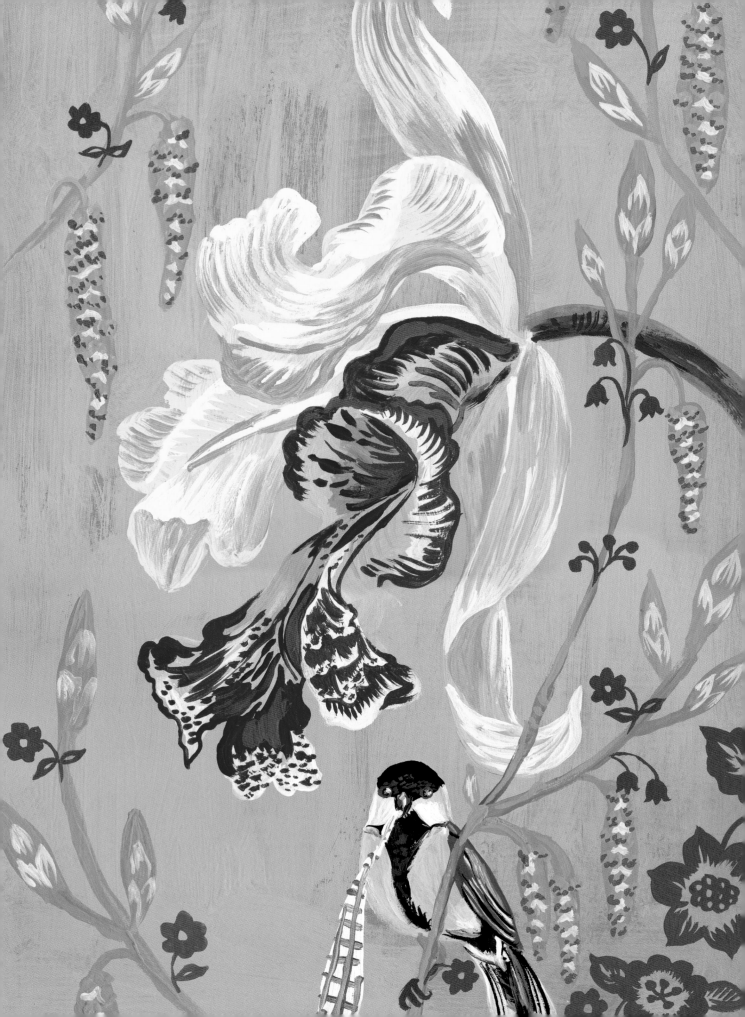

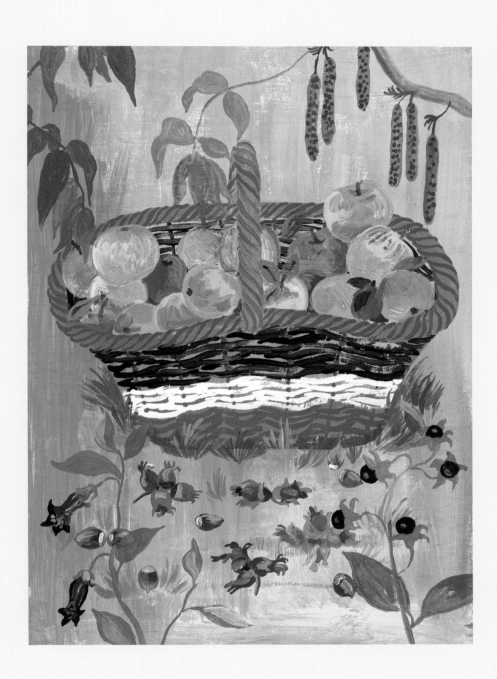

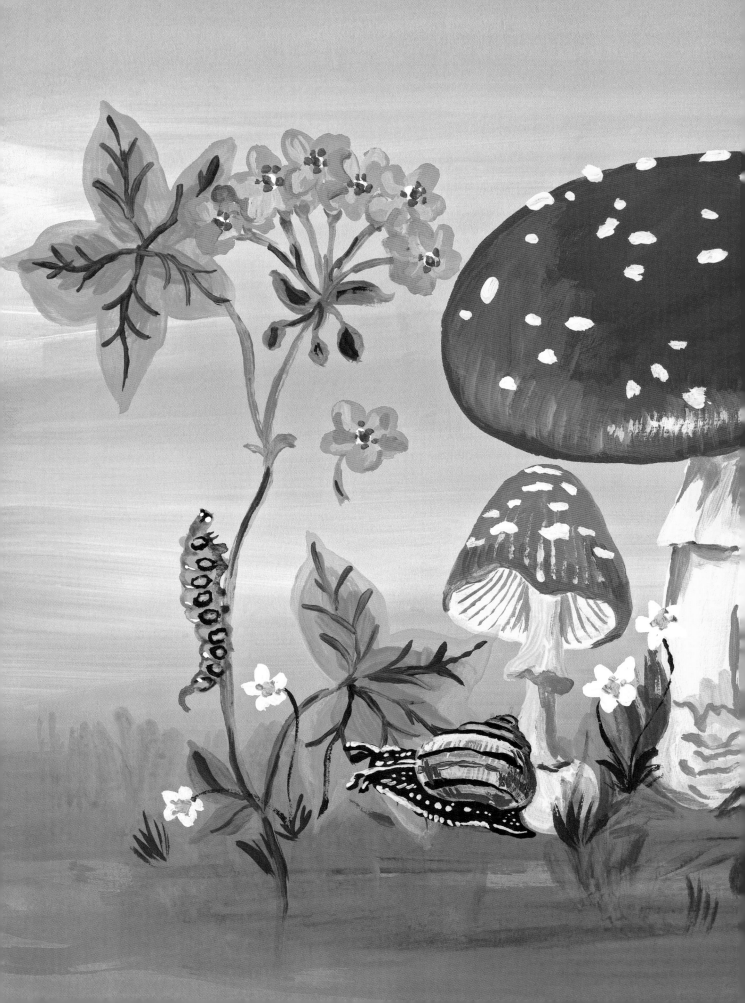

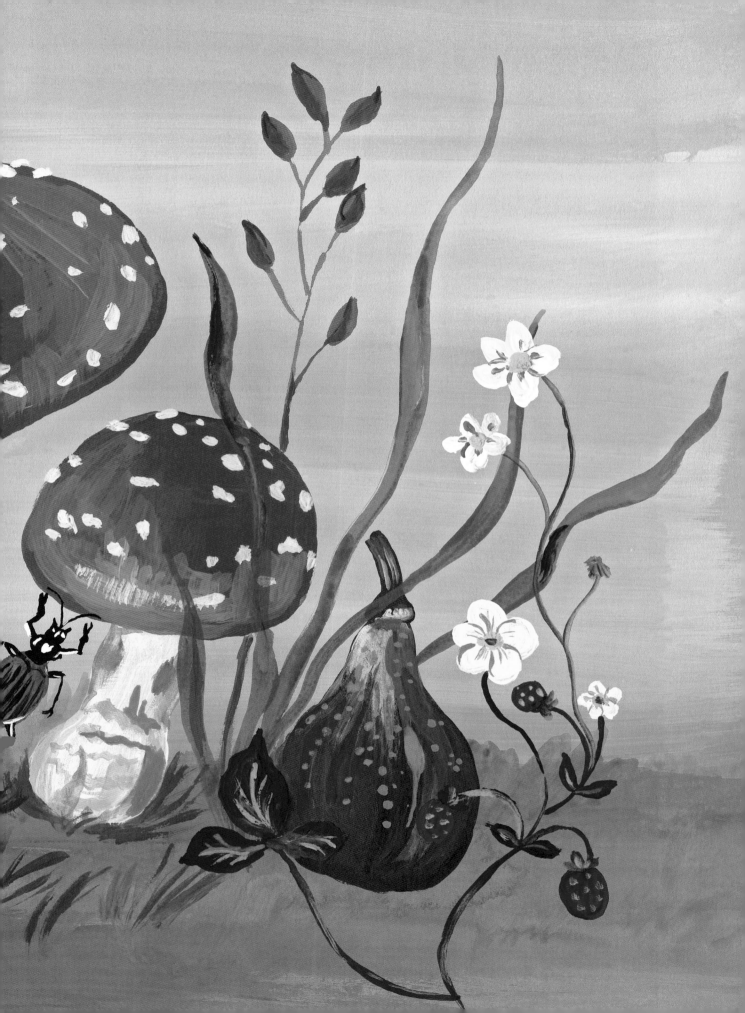

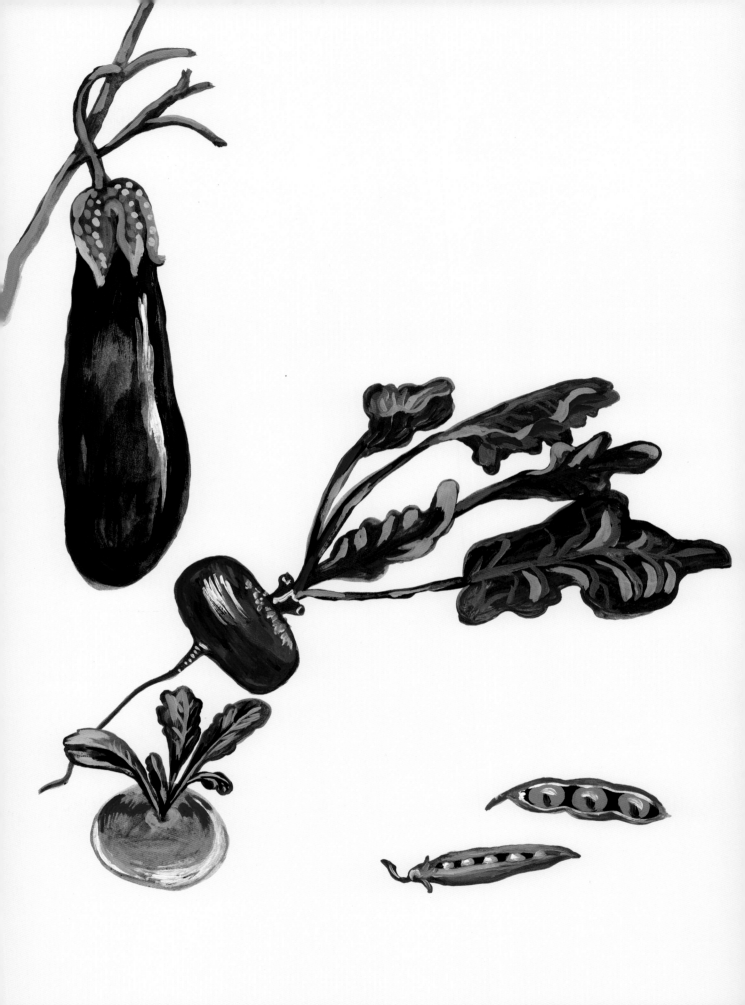

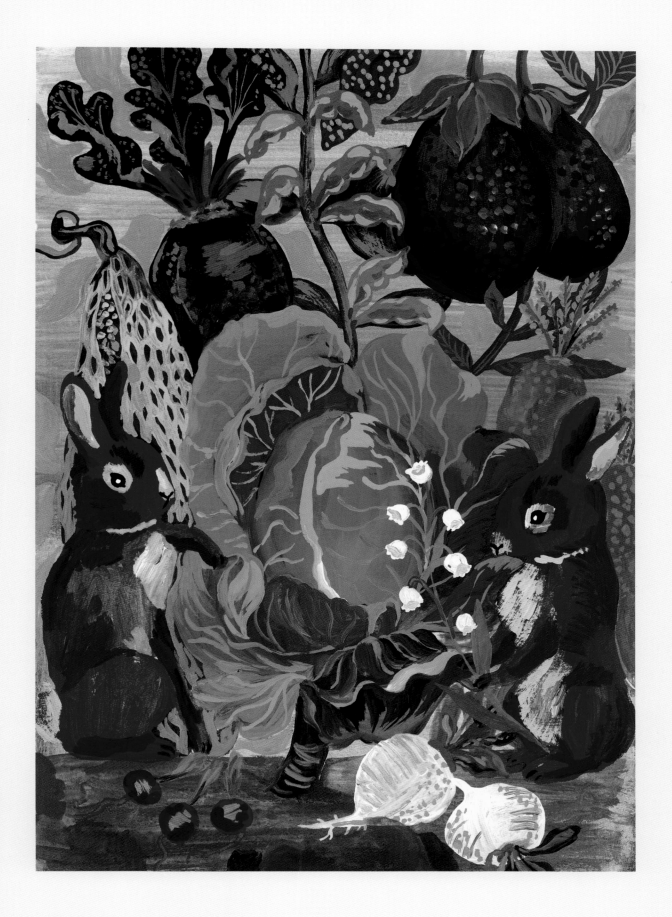

ABOVE: **The Rabbits' Rendezvous** | *Le rendez-vous des lapins*

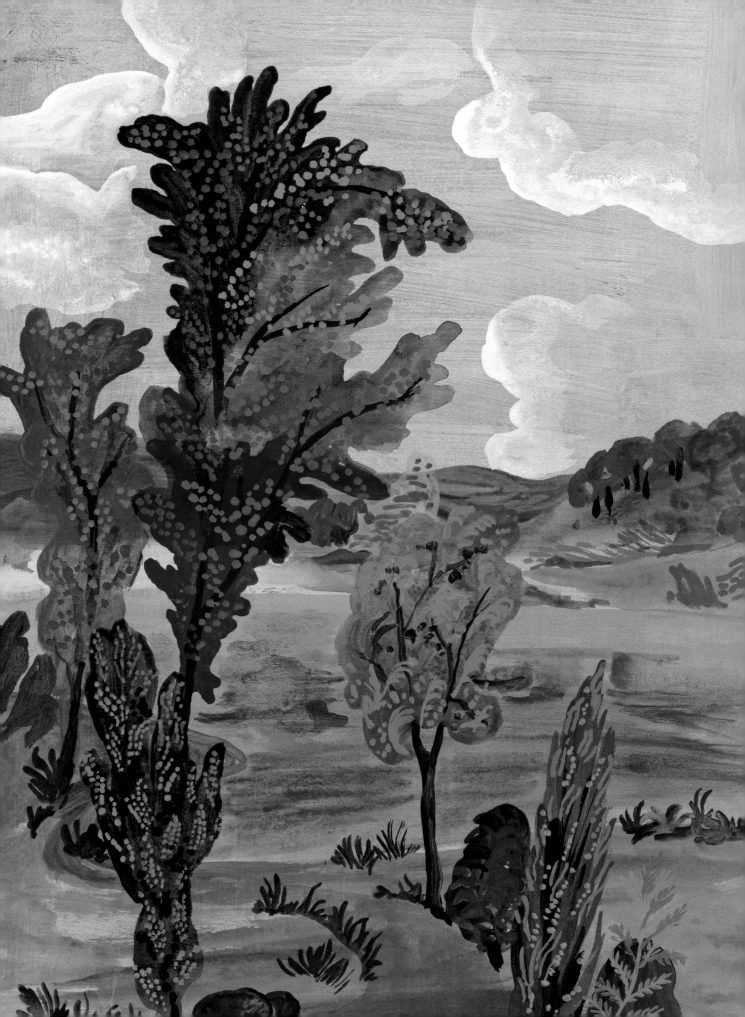

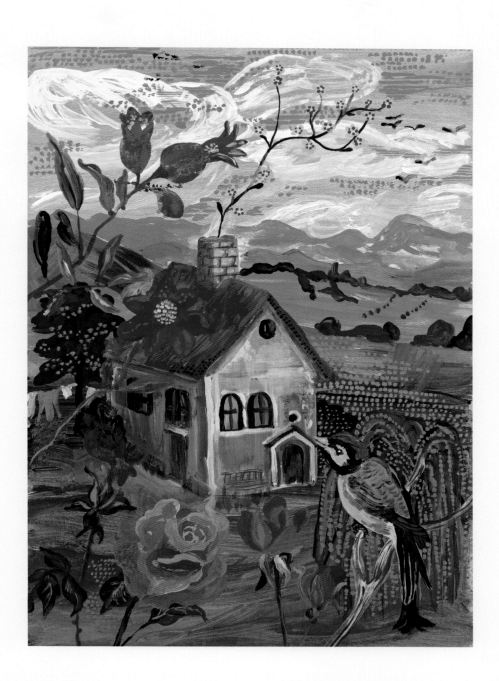

OPPOSITE: **The Wind Picks Up** | *Le vent se lève*

ABOVE: **The House in the Garden** | *La maison dans le jardin*

When I was around thirteen years old, I went to the Austrian Alps. It was the beginning of summer, the slopes were in bloom, and there were lots of butterflies. As a city kid, I was dazzled. I was already painting on silk at that time, and I decided then that when I got home, I would make a scarf covered in butterflies.

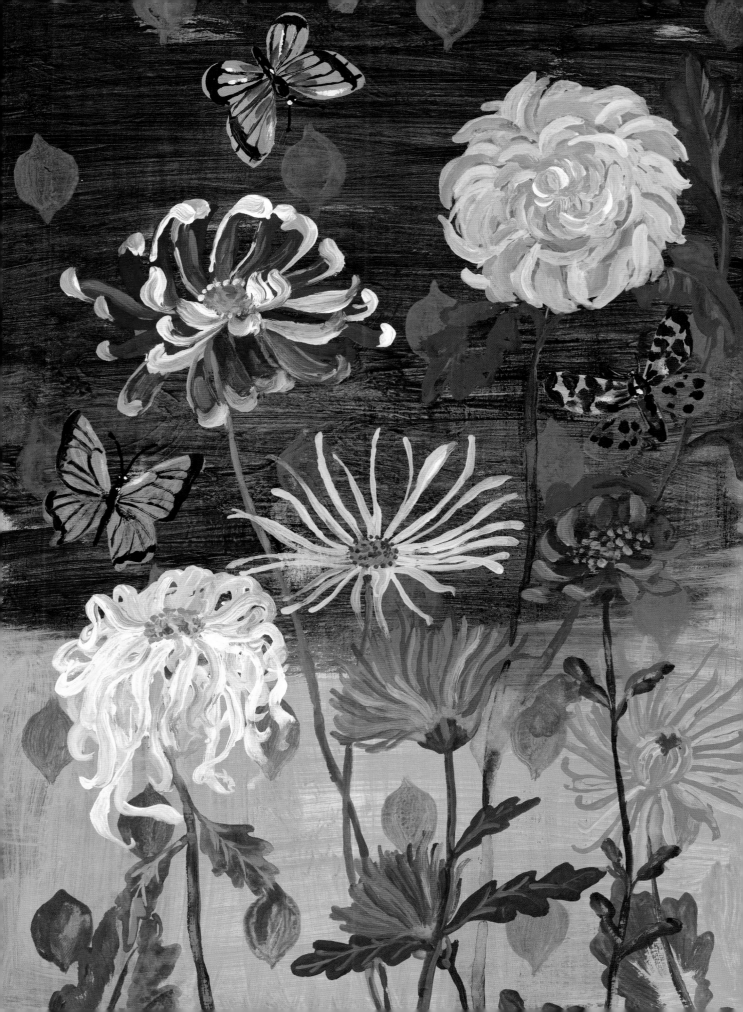

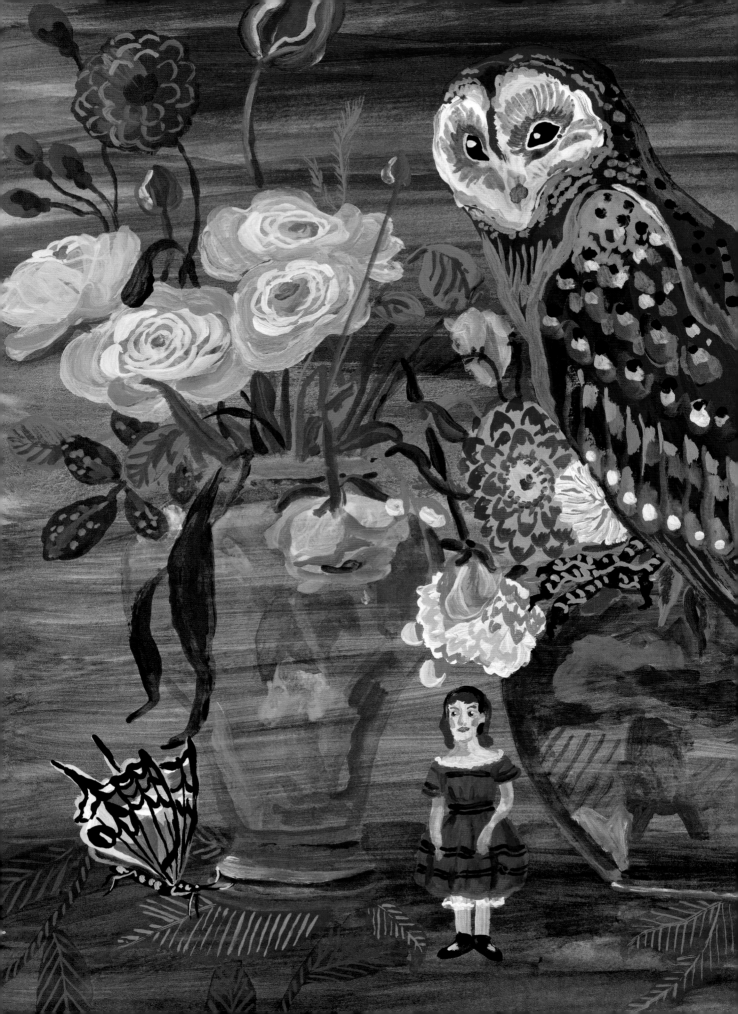

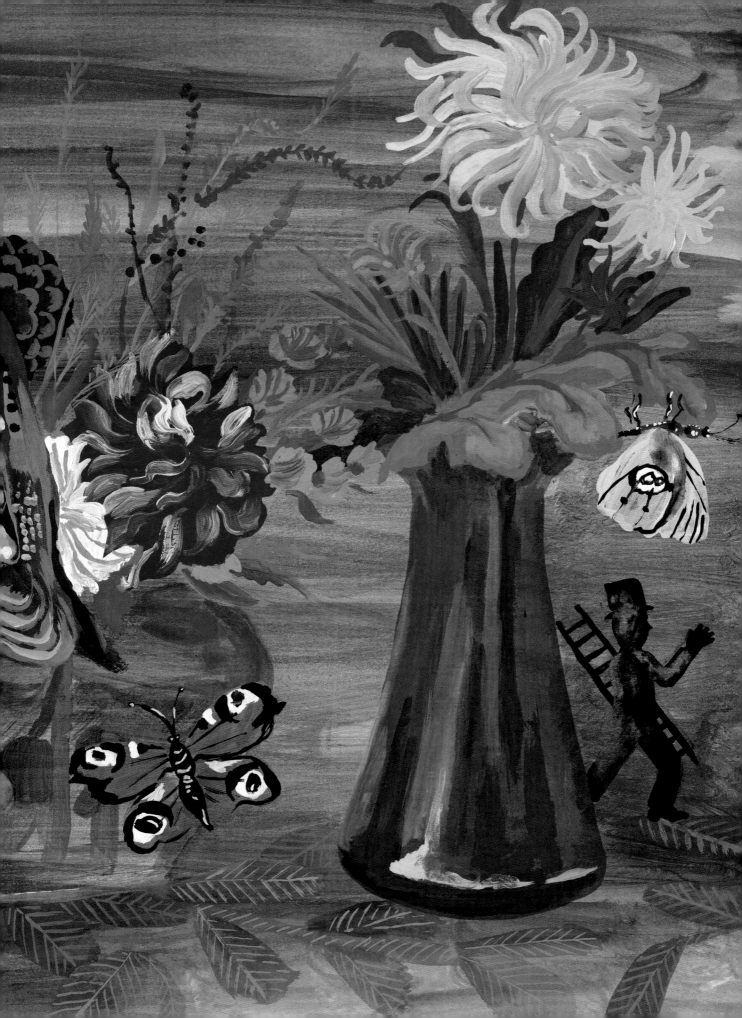

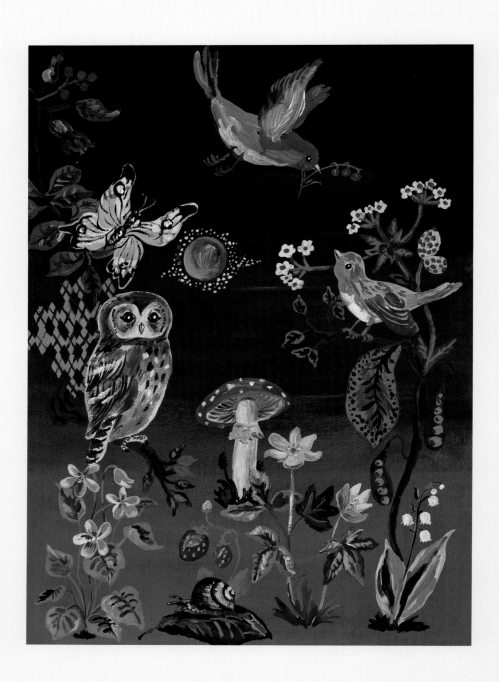

ABOVE: **Birds and an Owl** | *Les oiseaux et la chouette*

OPPOSITE: **Under the Cherry Tree** | *Sous le cerisier*

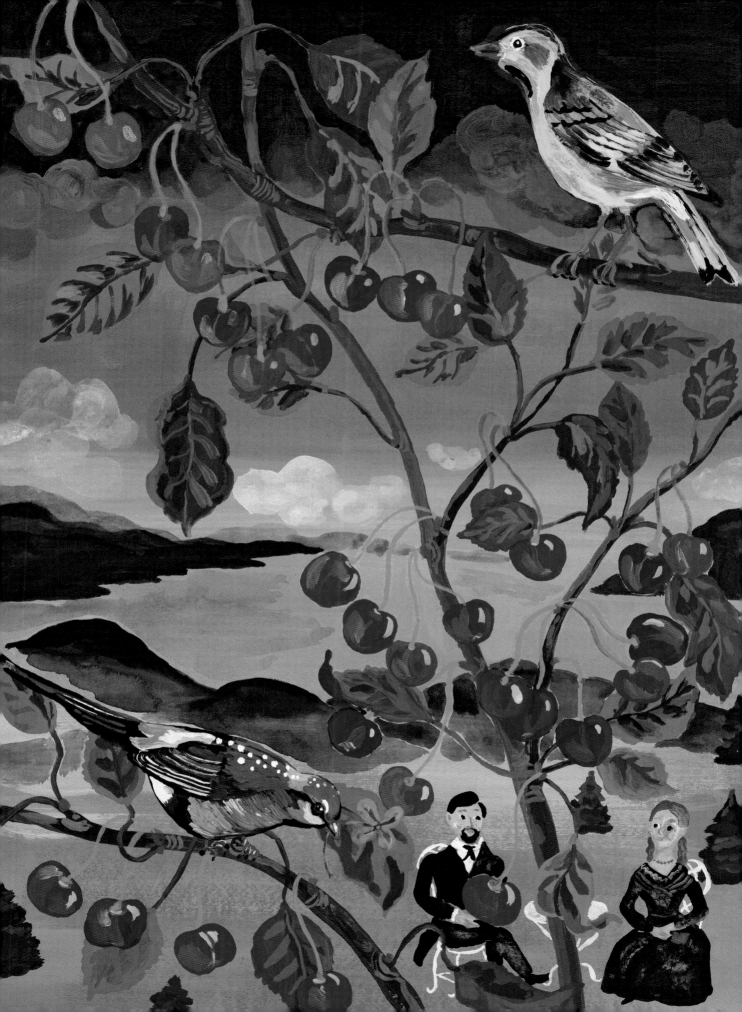

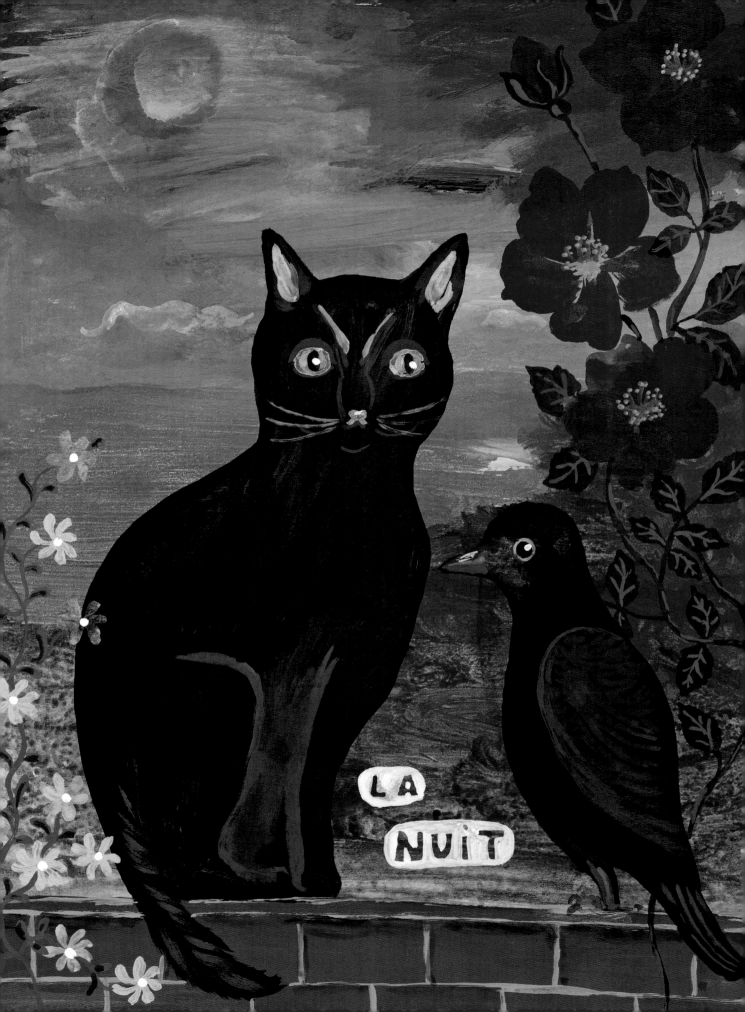

DARKNESS SCARES ME. I NEVER FEEL COMFORTABLE
AT NIGHT, BUT I TRY TO OVERCOME MY FEARS
BY MAKING IT LOOK MORE FRIENDLY. IN MY
PAINTINGS, NIGHT IS MORE LIKE A BACKGROUND
TO SHOWCASE BEAUTY AND COLORS. I PREFER DAWN
AND THE SUNSHINE.

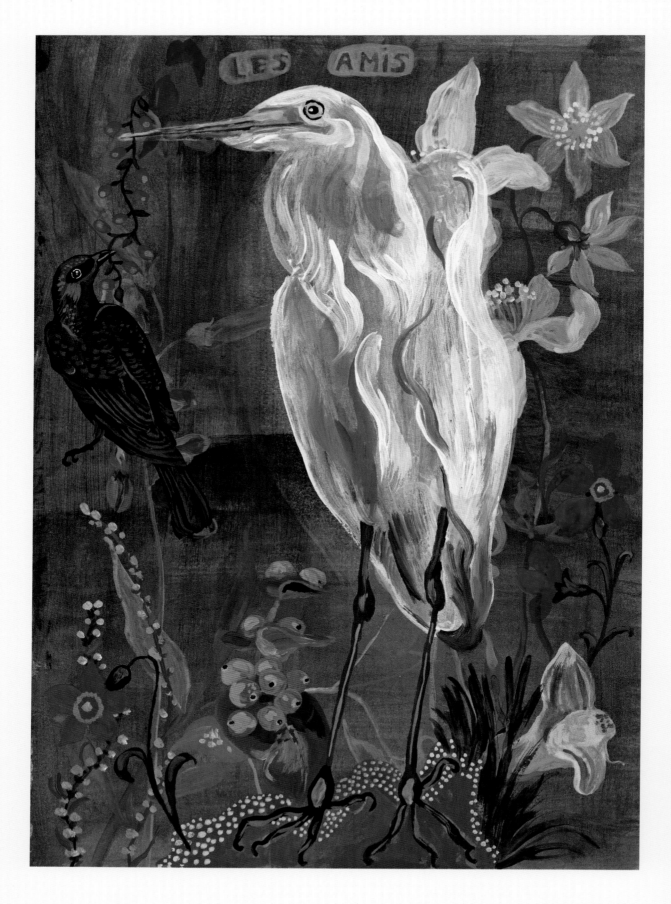

ABOVE: **Friends** | *Les amis*

OPPOSITE: **At Dawn** | *Aux aurores*

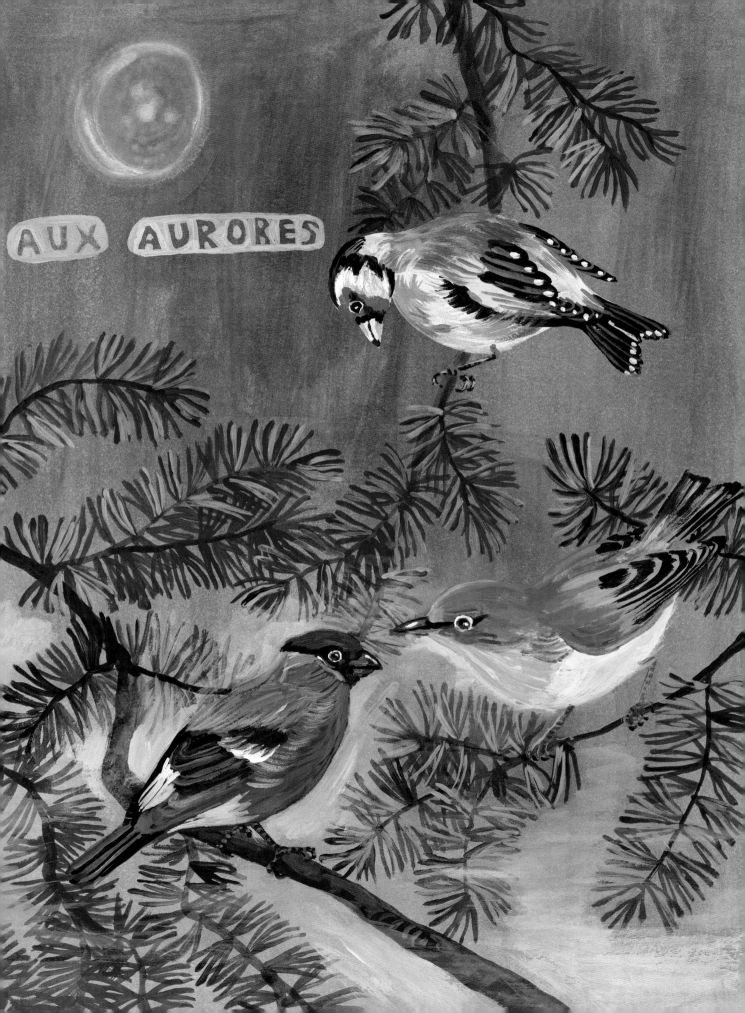

AUX AURORES

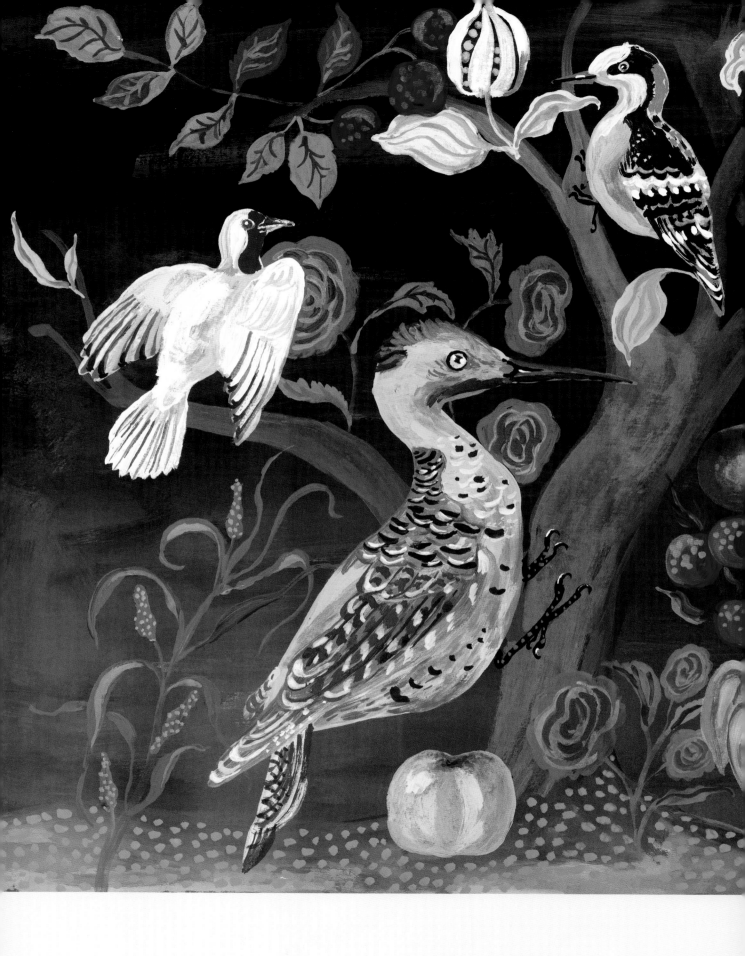

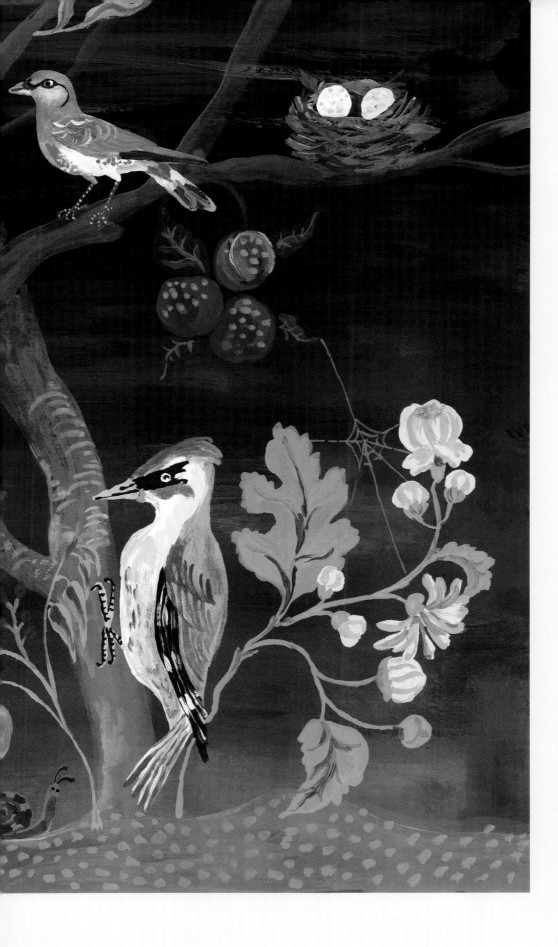

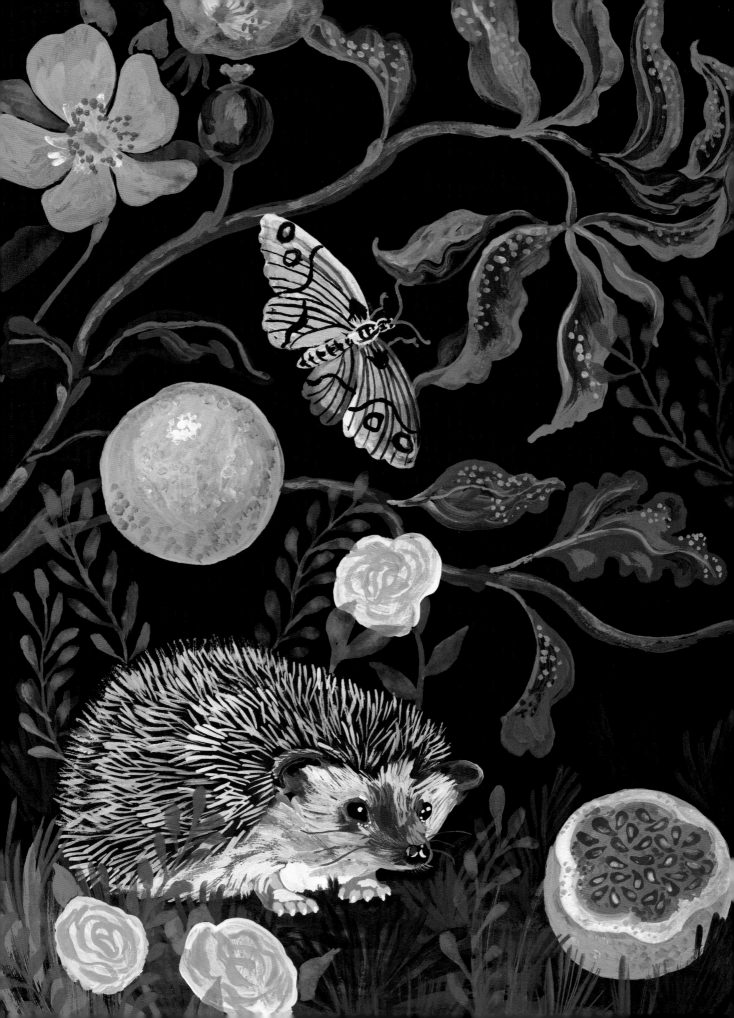

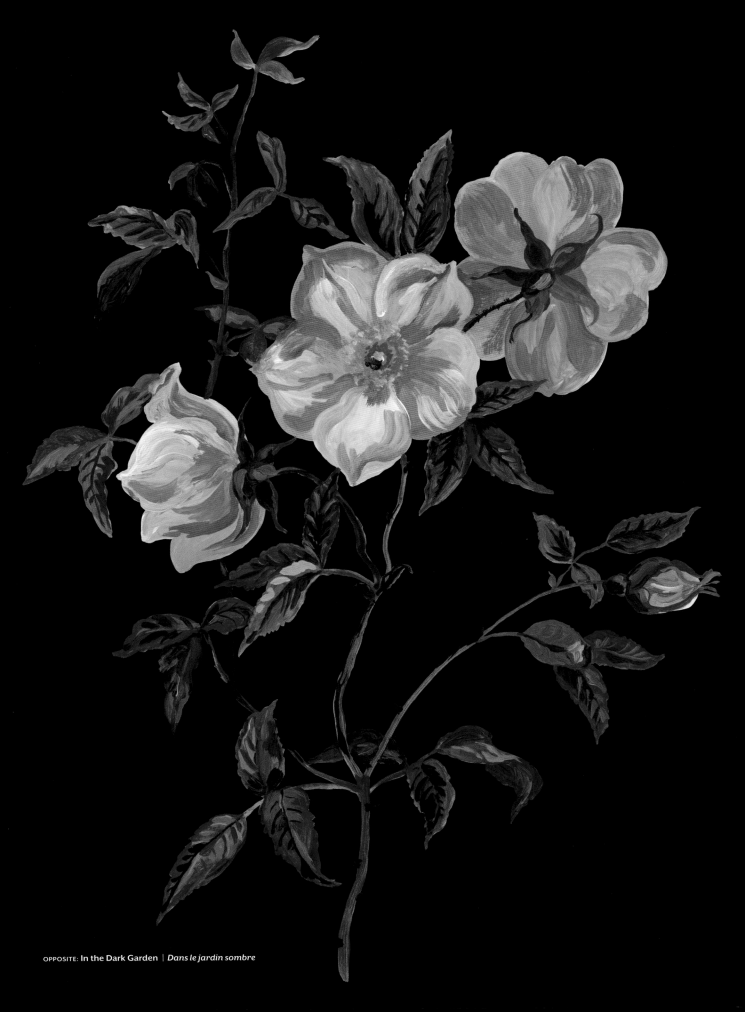

OPPOSITE: **In the Dark Garden** | *Dans le jardin sombre*

As a child, I spent my holidays in Bavaria, and there were lots of gnomes in the village gardens. I've always found them to be very sweet, as toys, as friends. I love the world of miniatures. It's like a secret world.

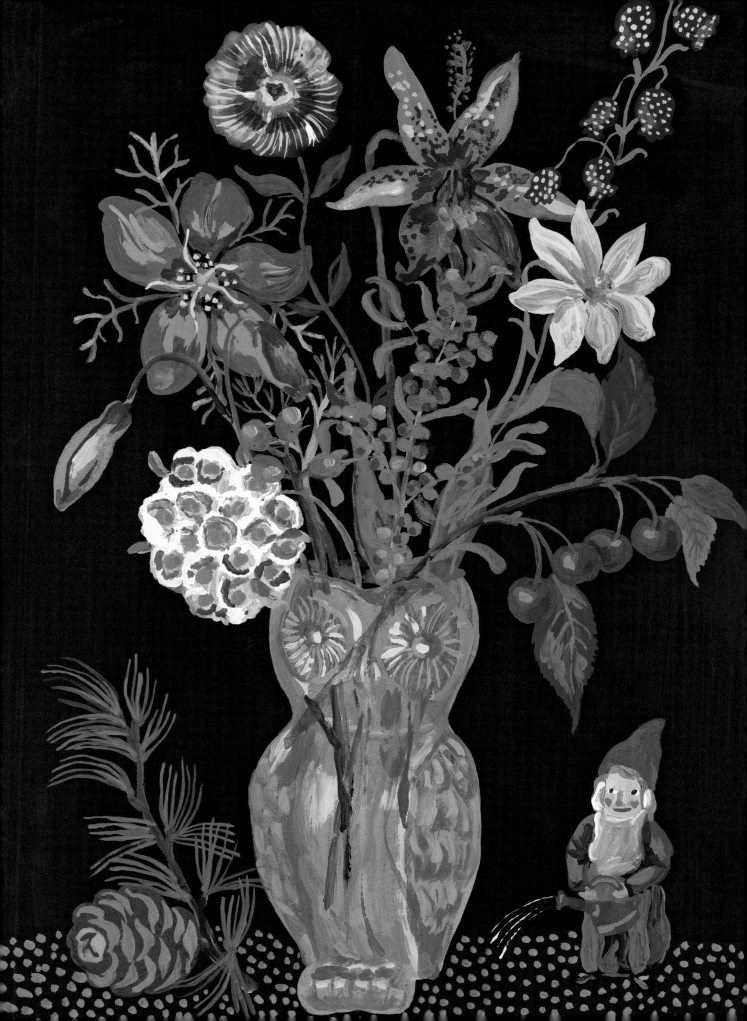

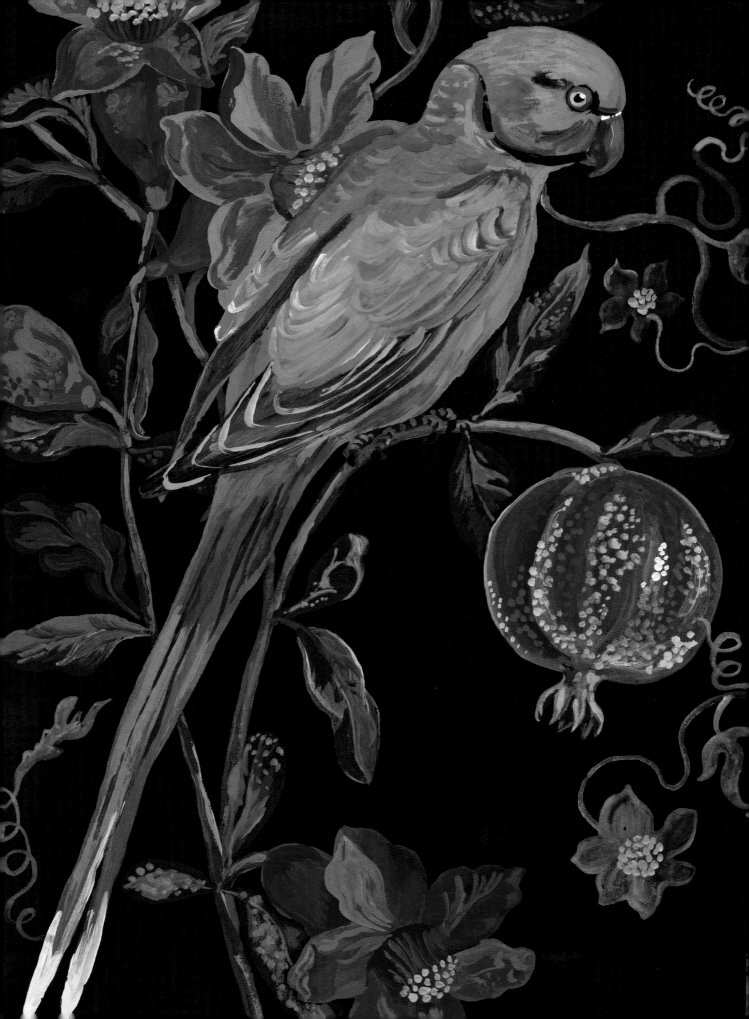

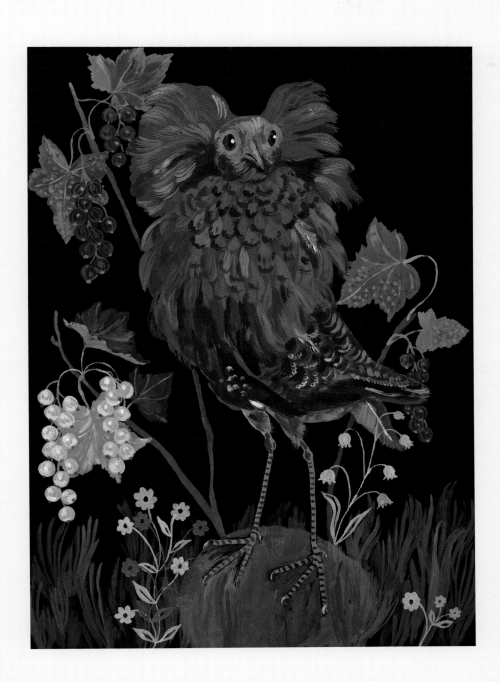

OPPOSITE: **Green Parrot** | *Le perroquet vert*

ABOVE: **Mrs. Bird and the Currants** | *Madame l'Oiseau et les groseilles*

Alice in Wonderland fascinated me
for its magical fantasyland. And
the fact that it was all but a dream,
like a parallel world.

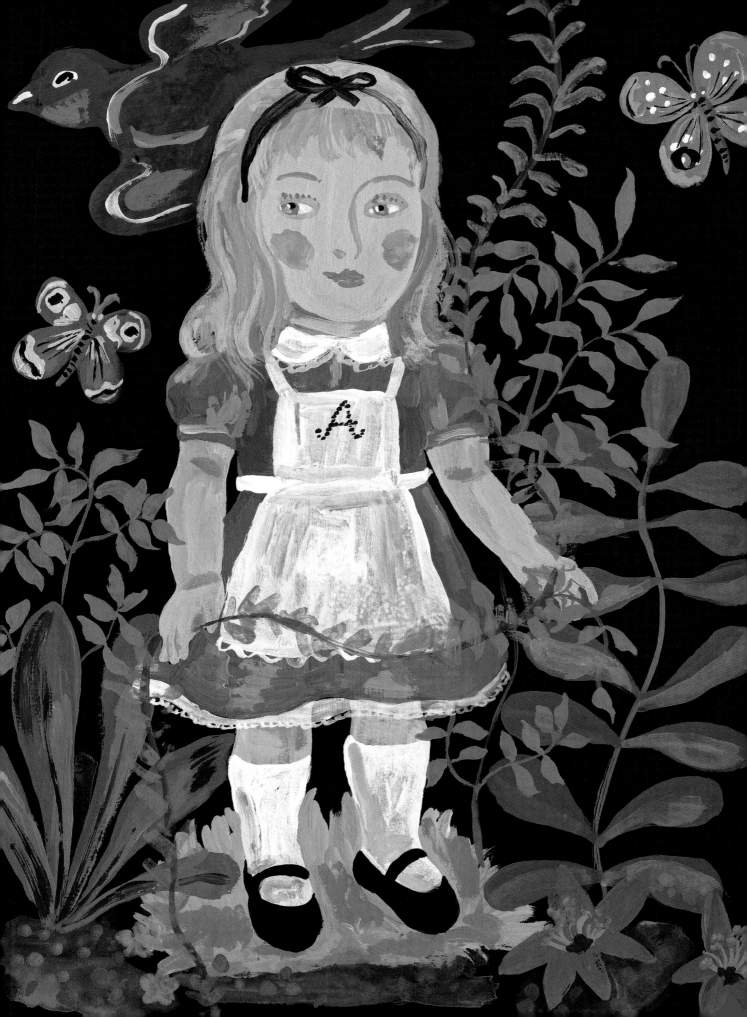

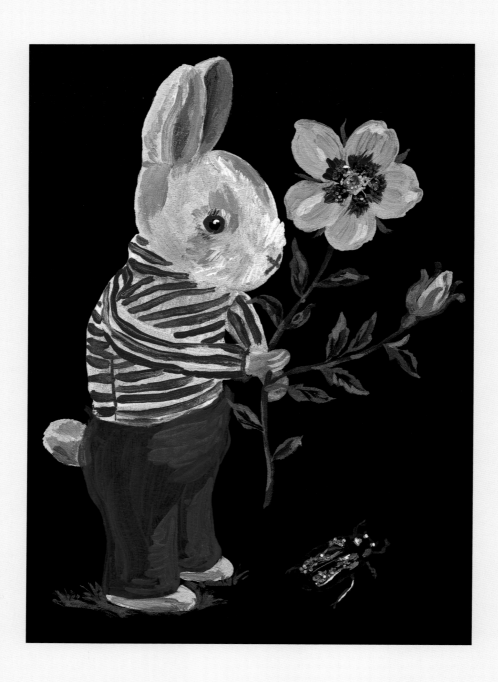

ABOVE: **The Rabbit in a Striped Sweater** | *Le lapin au pull rayé*

OPPOSITE: **Apples** | *Les pommes*

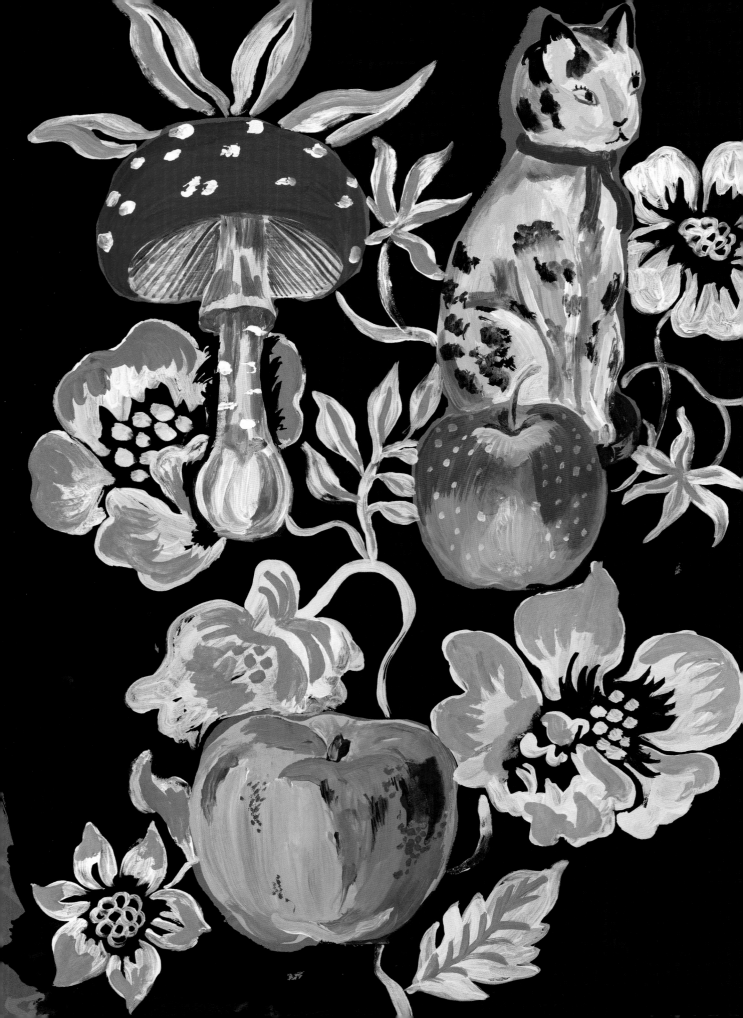

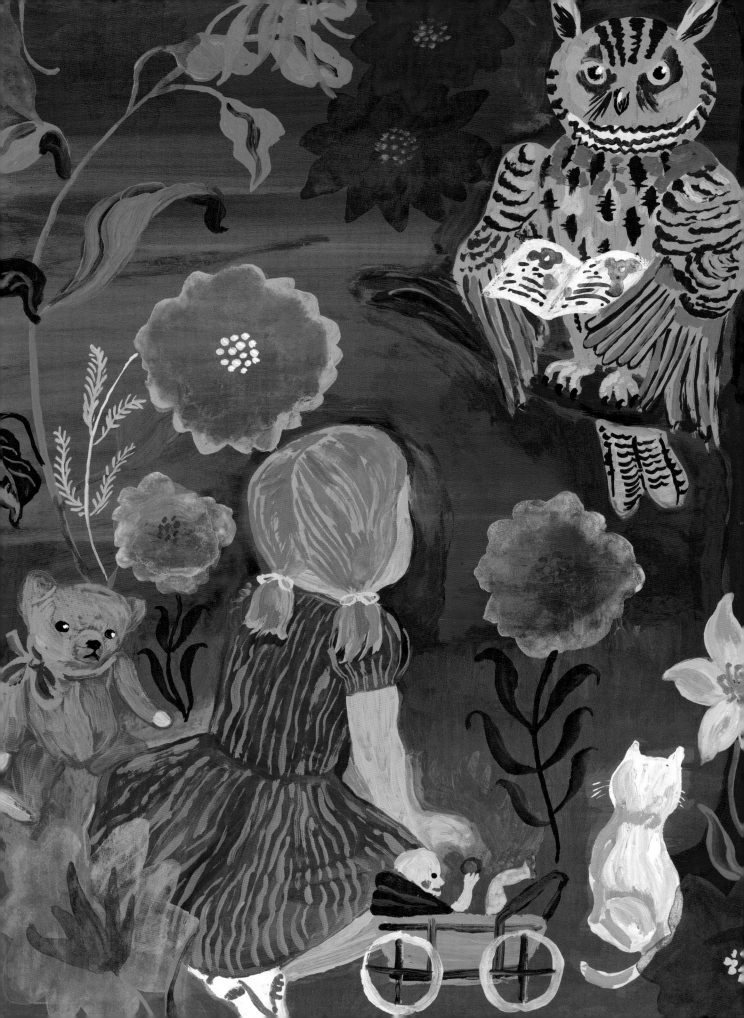

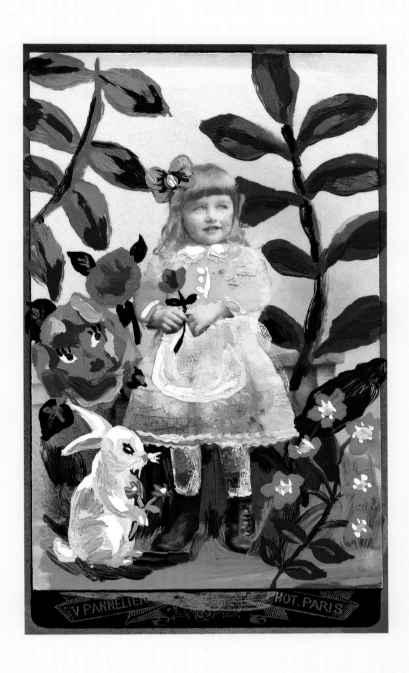

OPPOSITE: **Read Me a Story** │ *Lis-moi une histoire*

ABOVE: **Alice, the Rabbit, and the Rose** │ *Alice, le lapin et la rose*

FOLLOWING PAGES: **The Fruit Harvest** │ *La récolte des fruits*

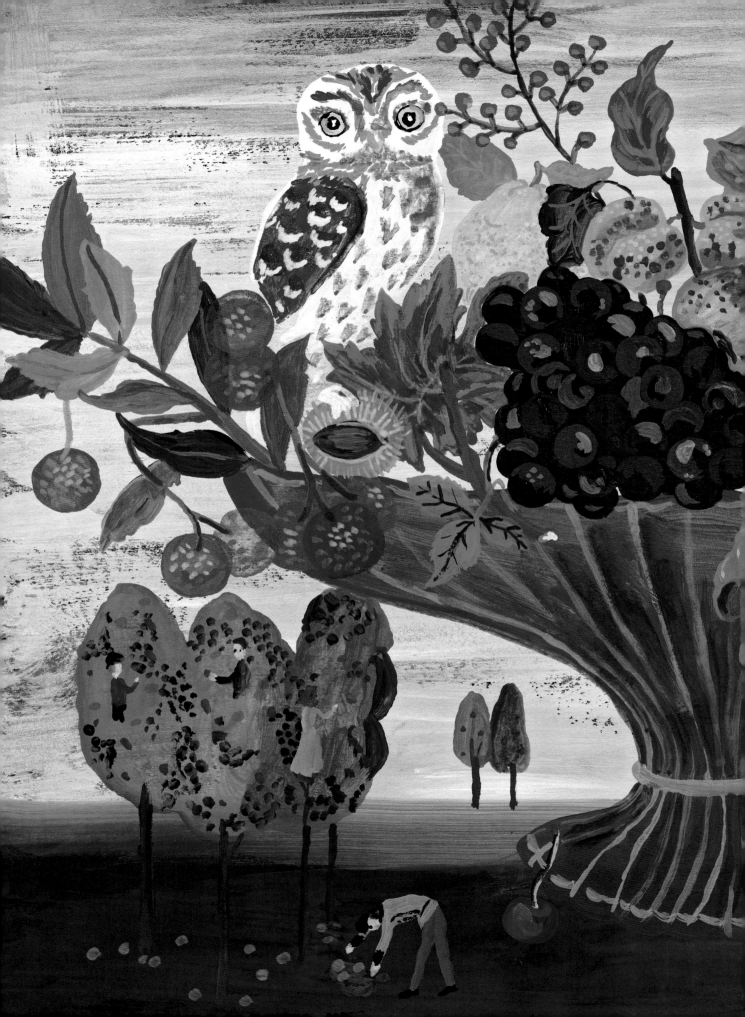

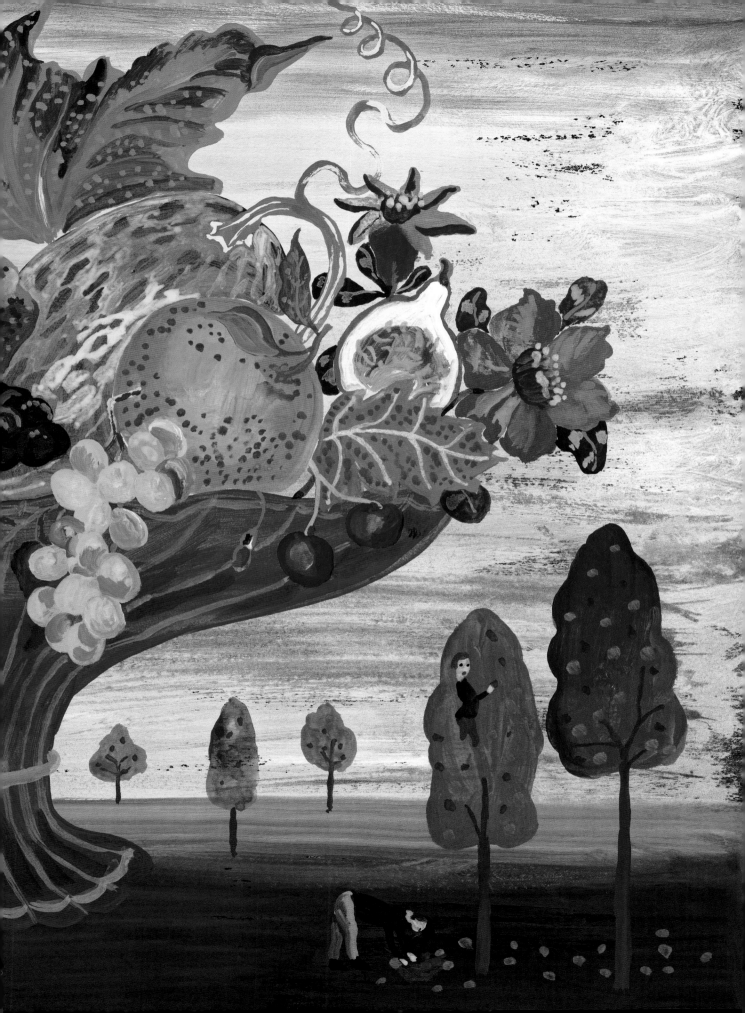

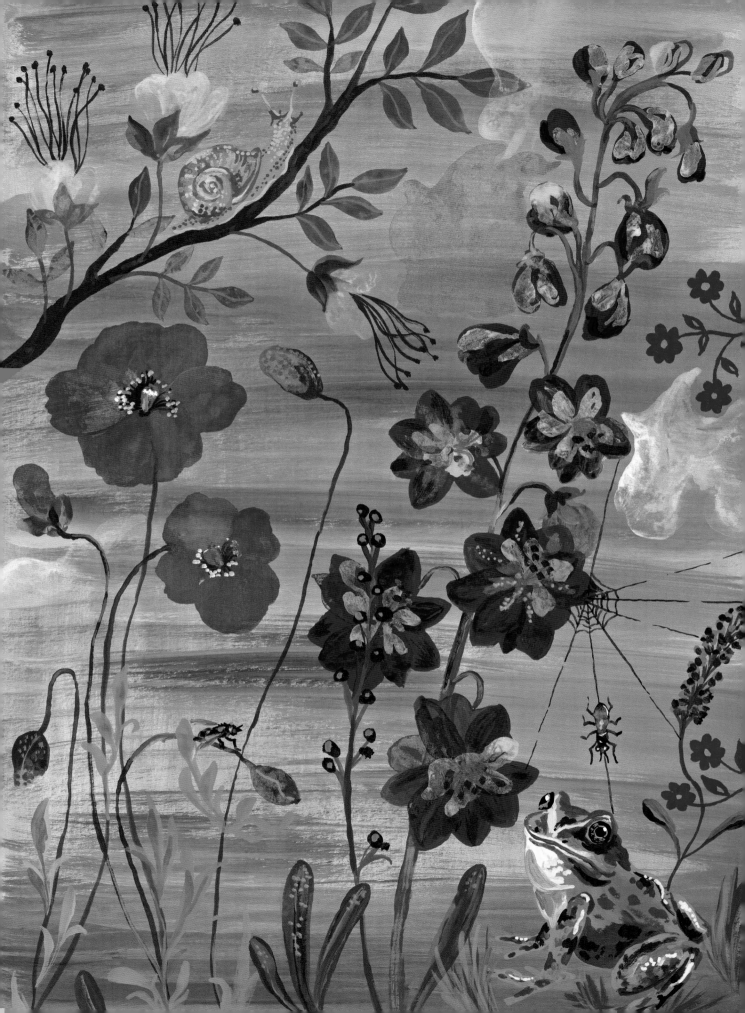

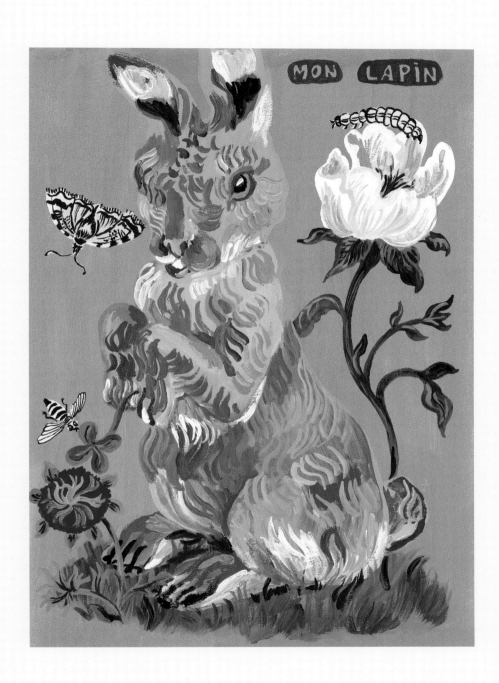

MON LAPIN

OPPOSITE: **Green Frog** | *La grenouille verte*

ABOVE: **My Bunny** | *Mon lapin*

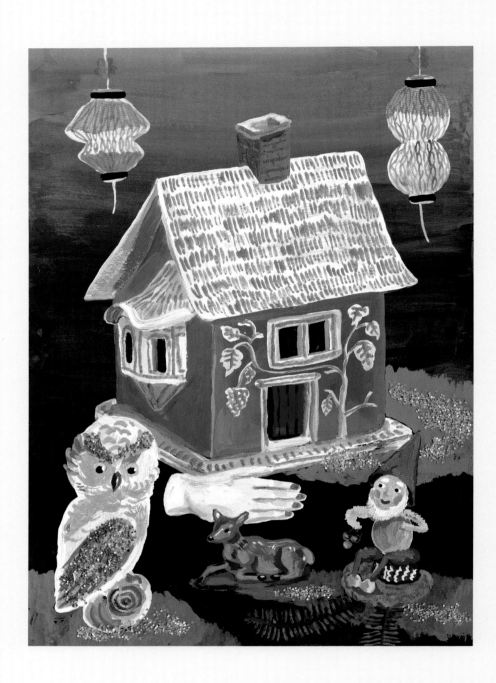

ABOVE: **This Is a Blue House** | *C'est une maison bleue*

OPPOSITE: **Young Girl at the Flea Market** | *Jeune fille au marché aux puces*

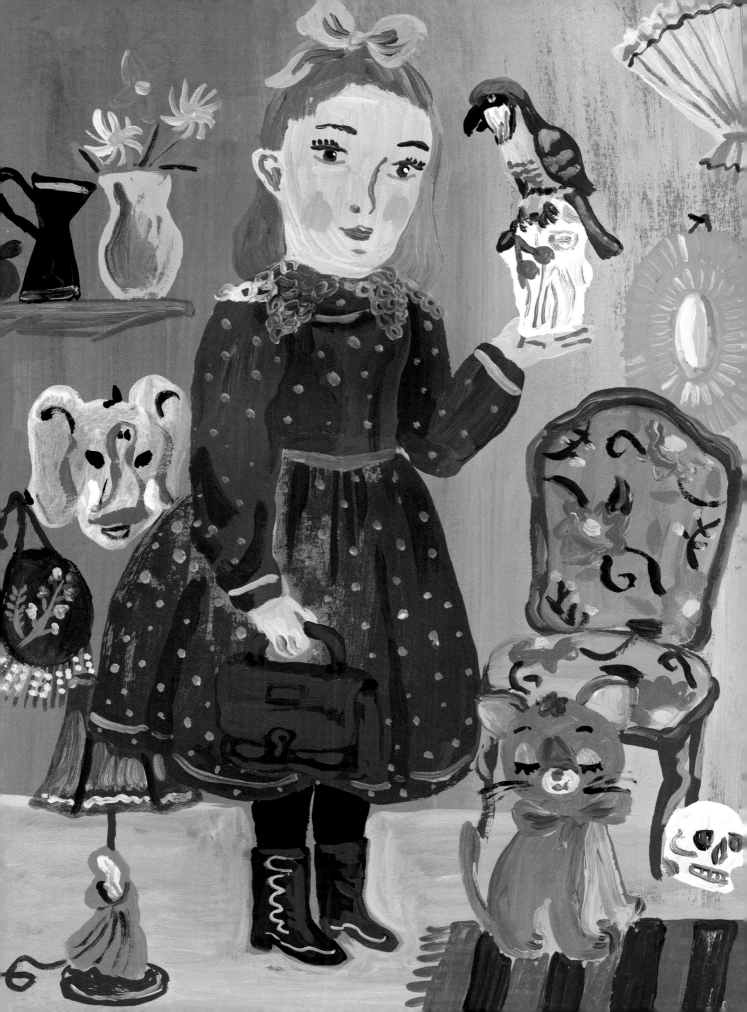

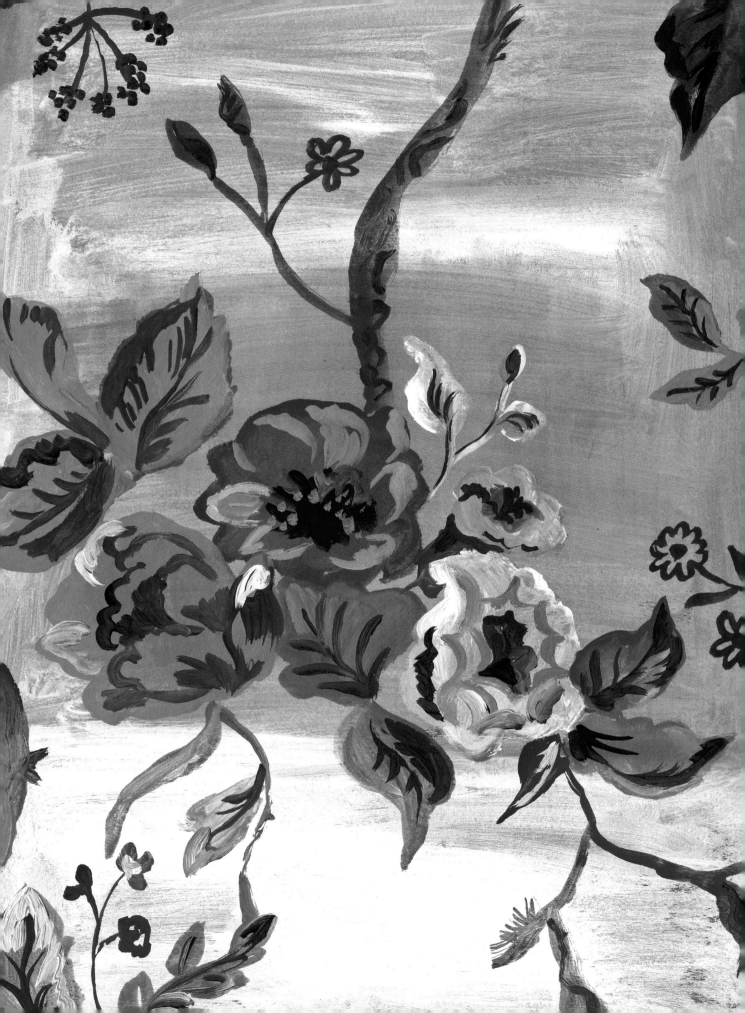

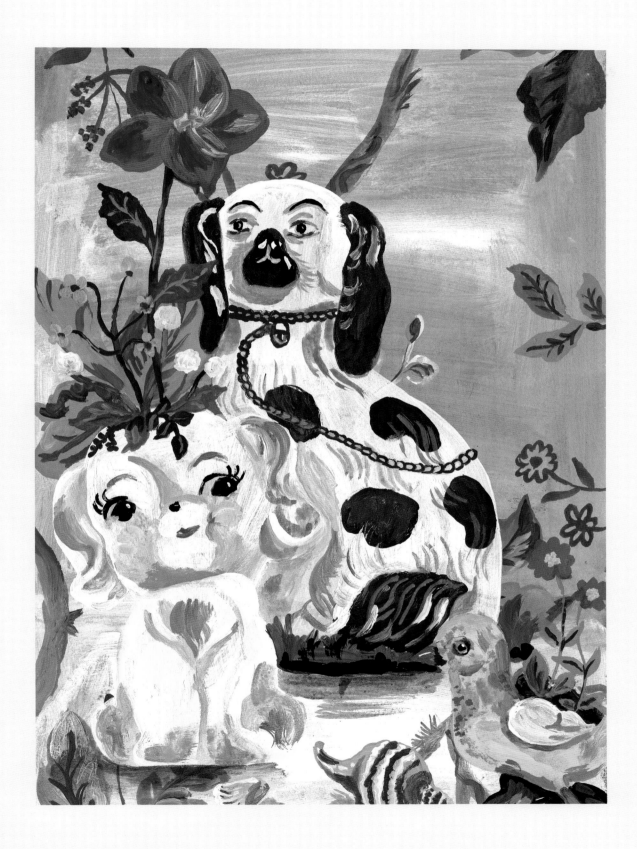

OPPOSITE: **China Blue** | *Bleu porcelaine*

ABOVE: **Porcelain Dogs** | *Les chiens de porcelaine*

FOLLOWING PAGES: **A Garden to Dream In** | *Un jardin pour rêver*

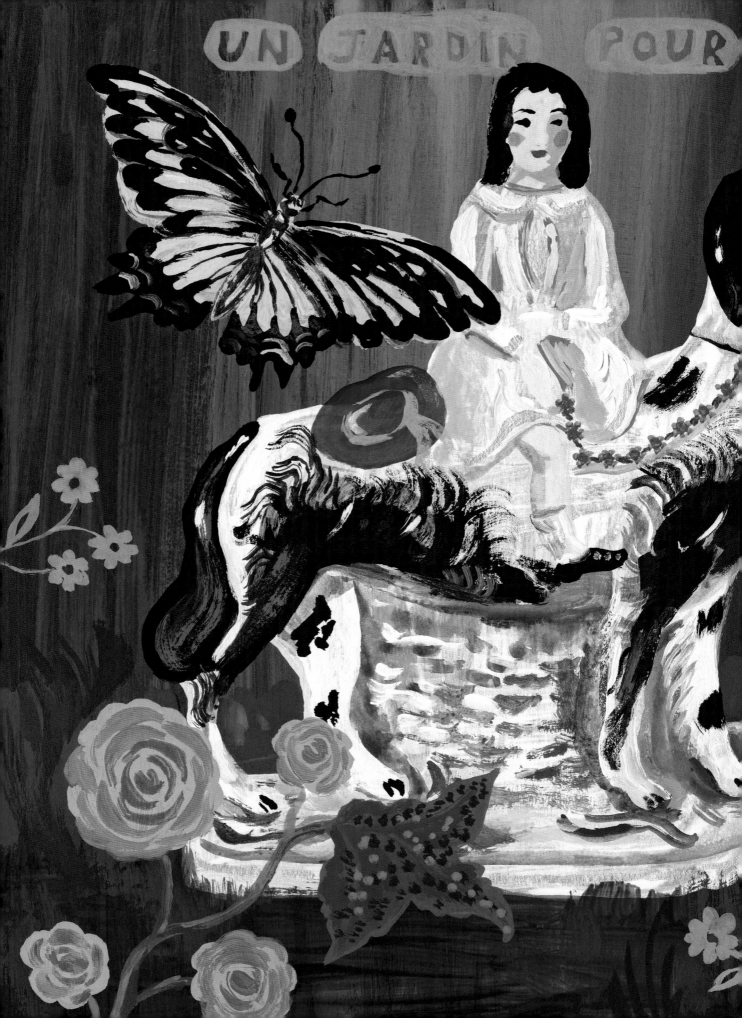

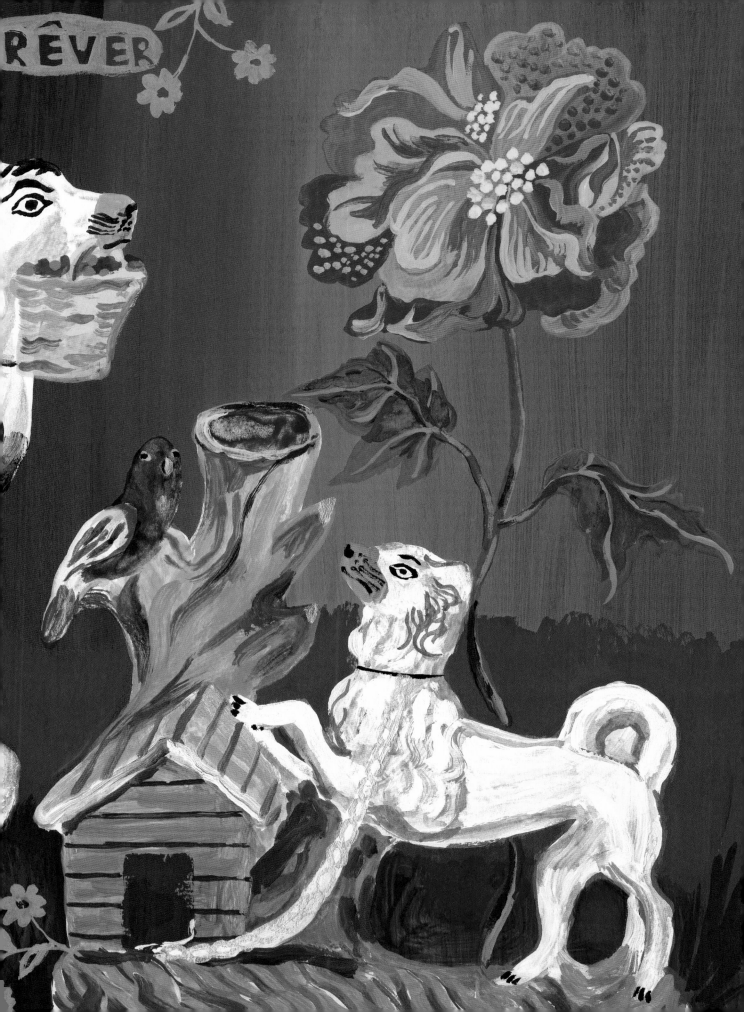

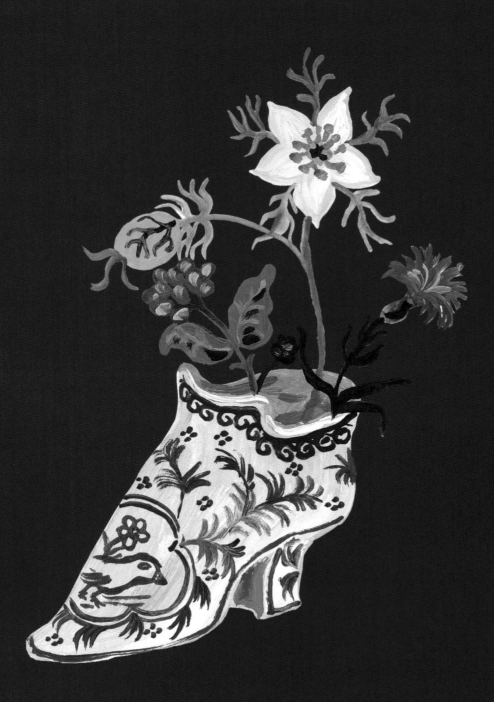

OPPOSITE: **Cat with a Raccoon Tail** |
Le chat à la queue de raton laveur

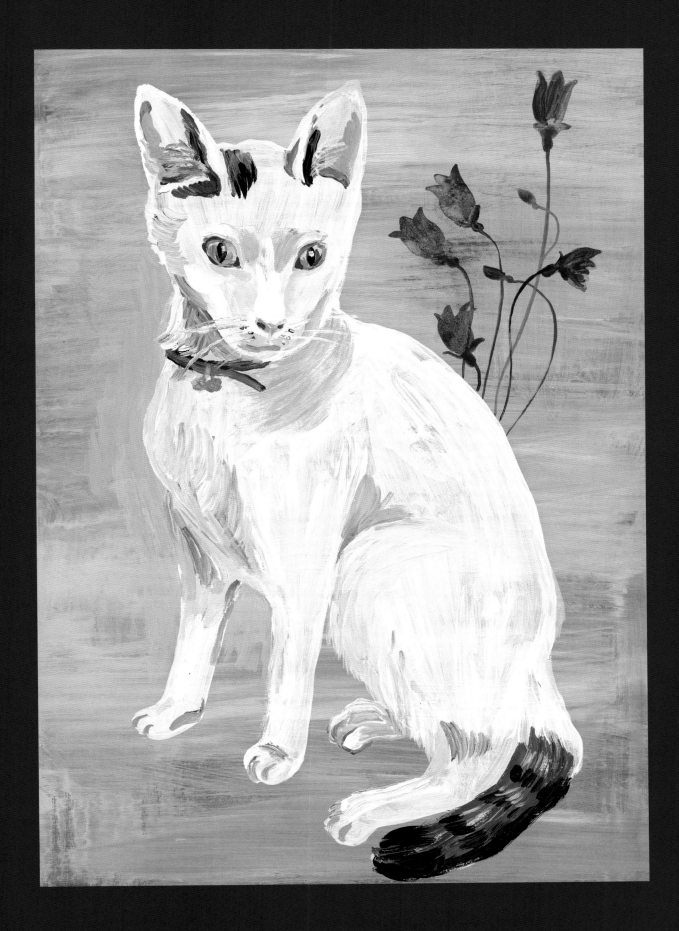

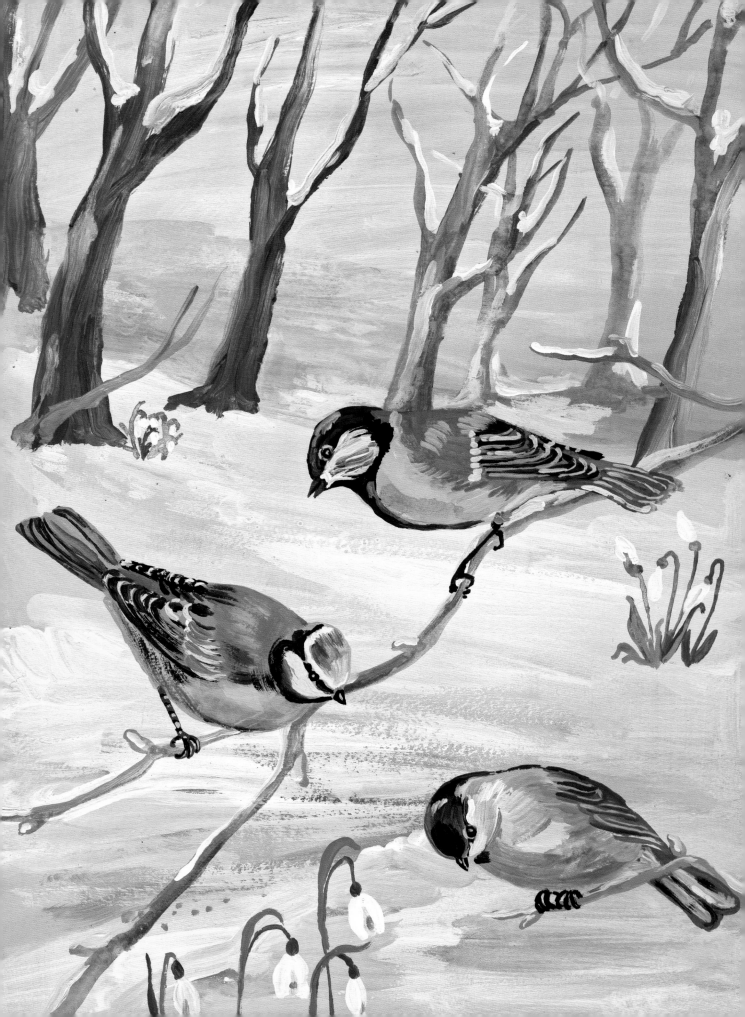

I love the silence brought on by the snow.
My snowy landscapes are like the views
you'd have sitting on a train watching the
scenery go by.

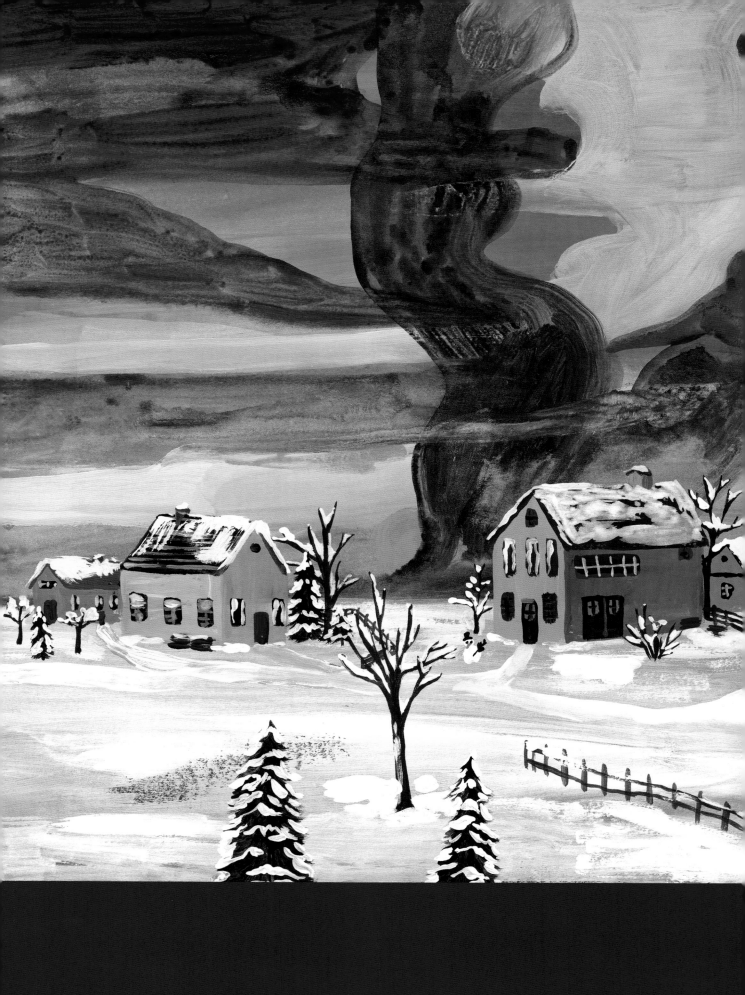

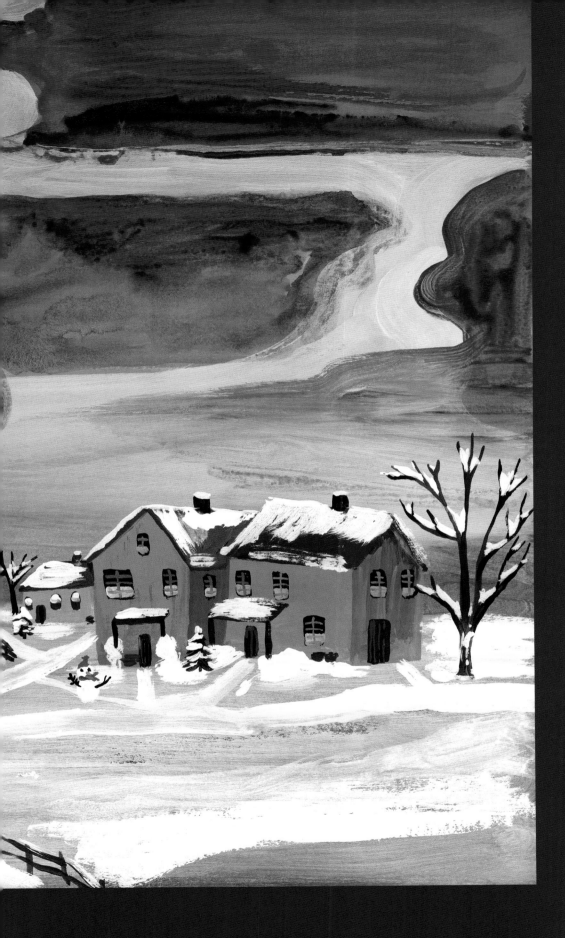

ABOVE: Snow Country | *Le pays des neiges*

FOLLOWING PAGES:: Snowbound Village | *Le village sous la neige*

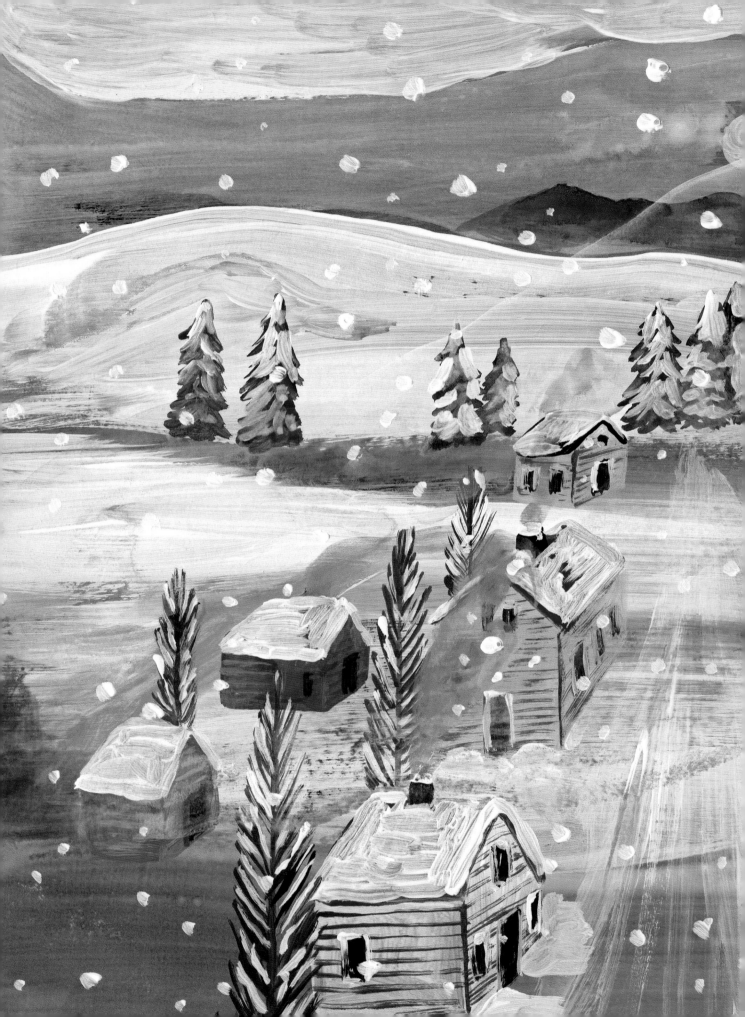

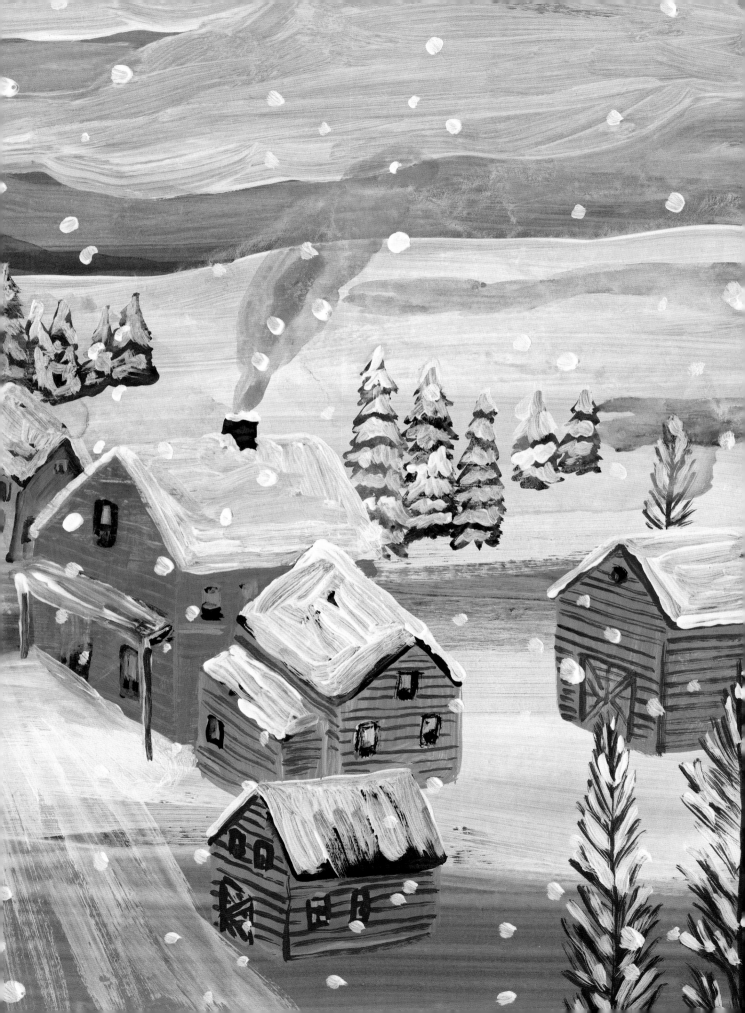

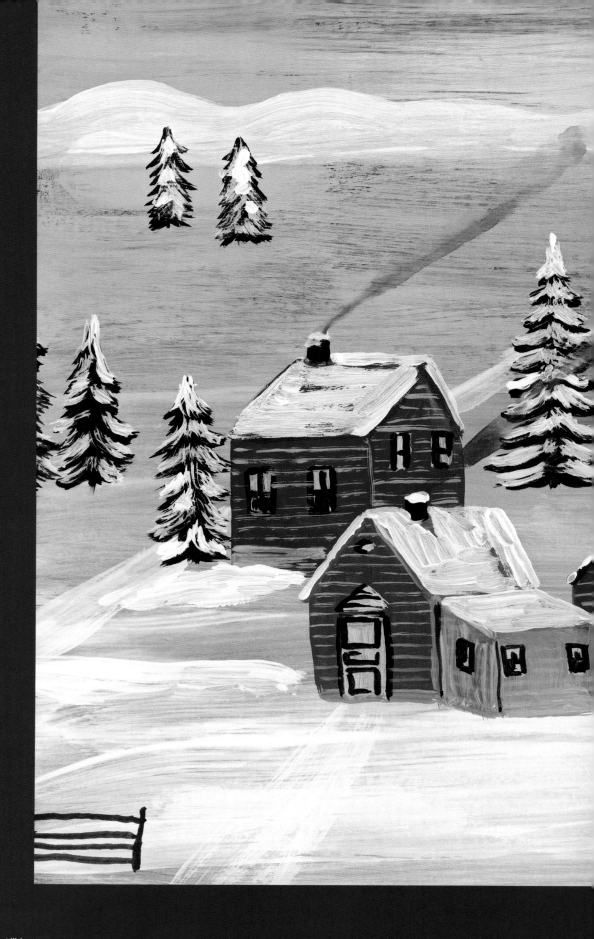

ABOVE: **It's Winter** | *C'est l'hiver*

FOLLOWING PAGES: **A Winter Walk** | *Promenade en hiver*

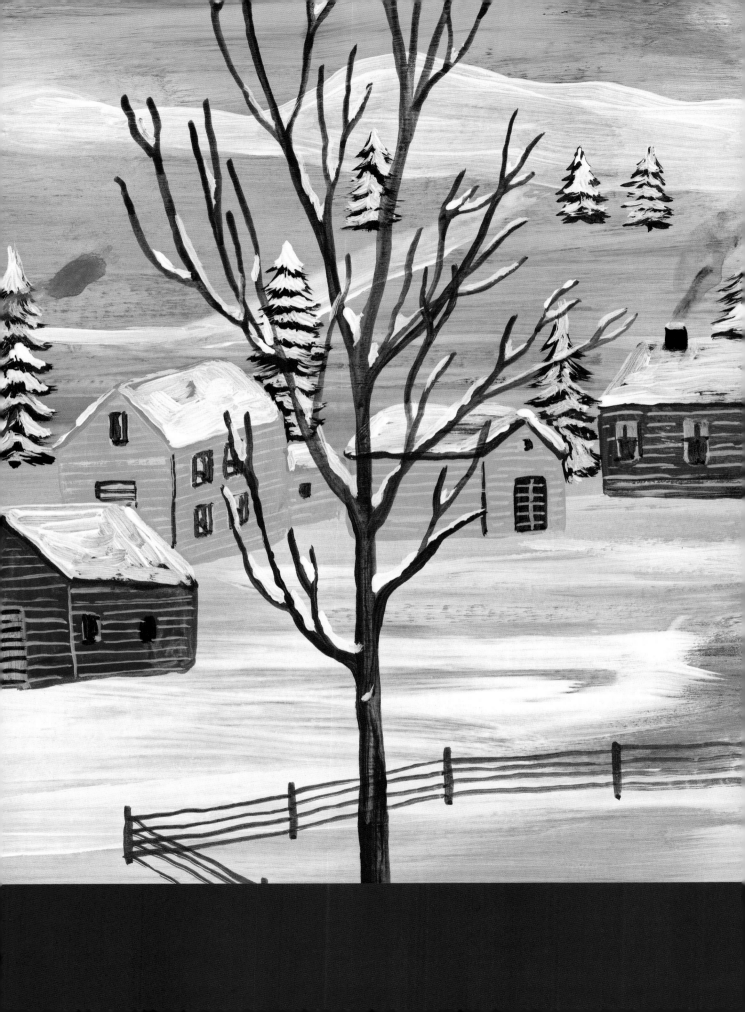

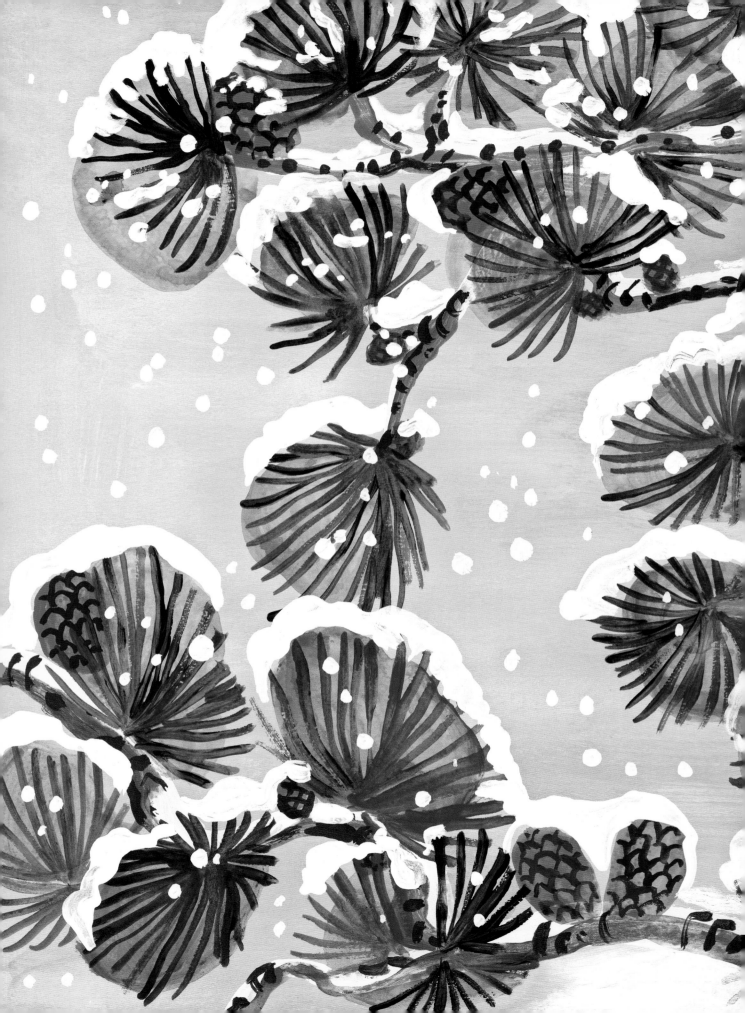

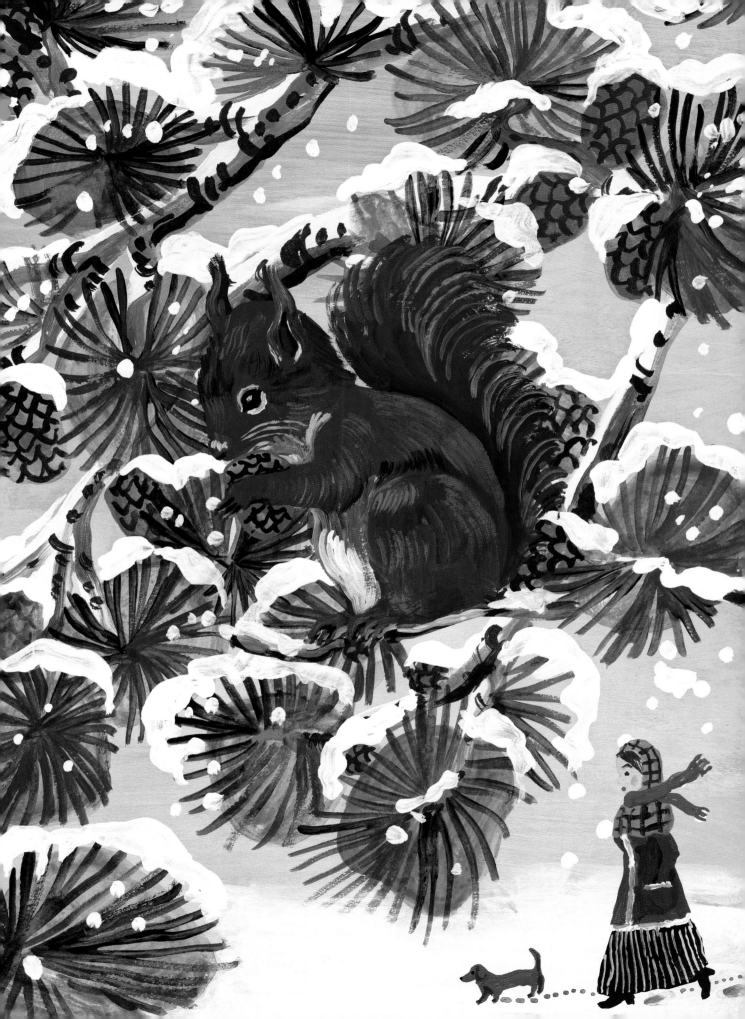

NATURE, KIND AND PROTECTIVE, IS ALWAYS THE
BACKGROUND OF MY STORIES THROUGH WHICH
I SOMETIMES STROLL, LIKE A TINY LITTLE FIGURE.

OPPOSITE: **Have a Nice Day** | *Bonne journée*

FOLLOWING PAGES: **The Love Tree** | *L'arbre d'amour*

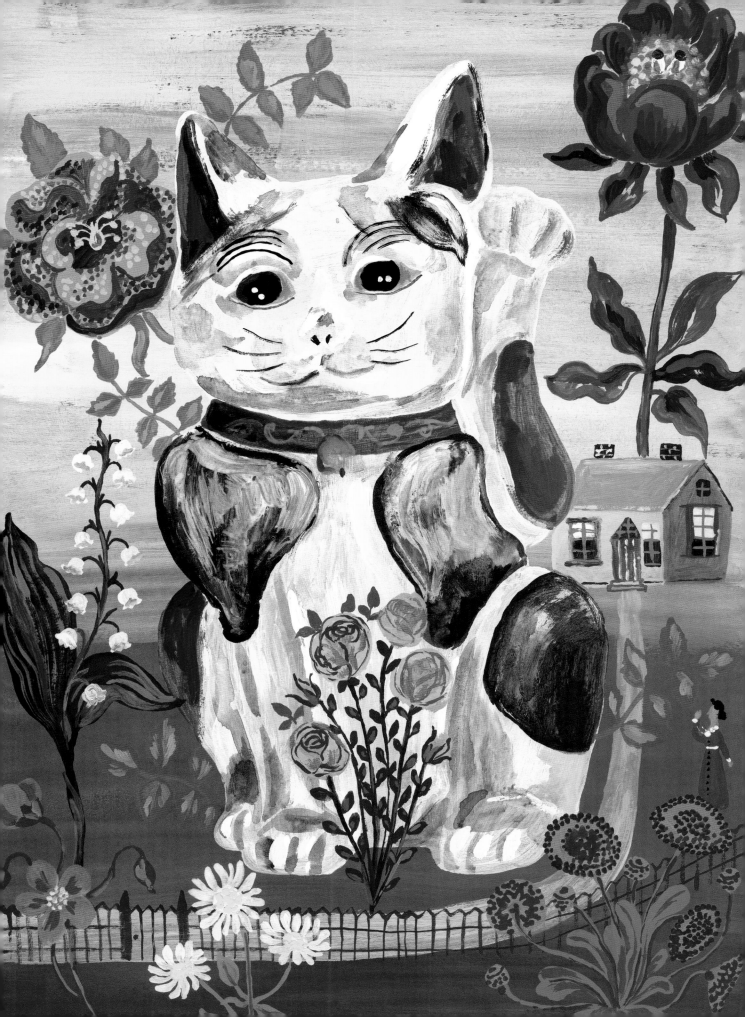

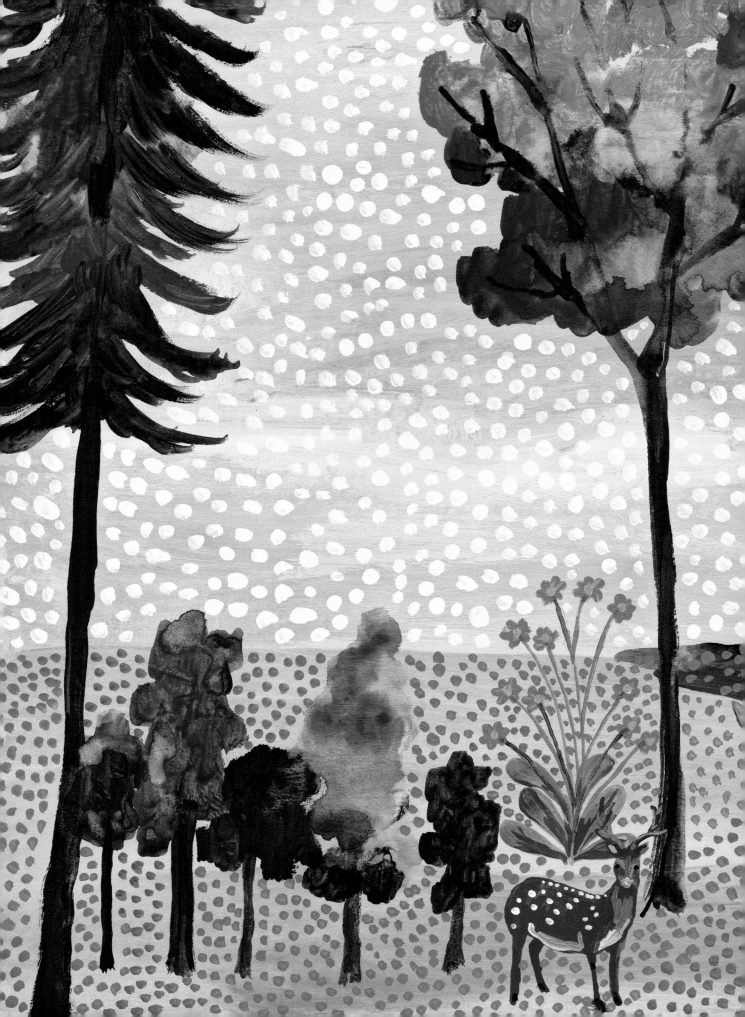

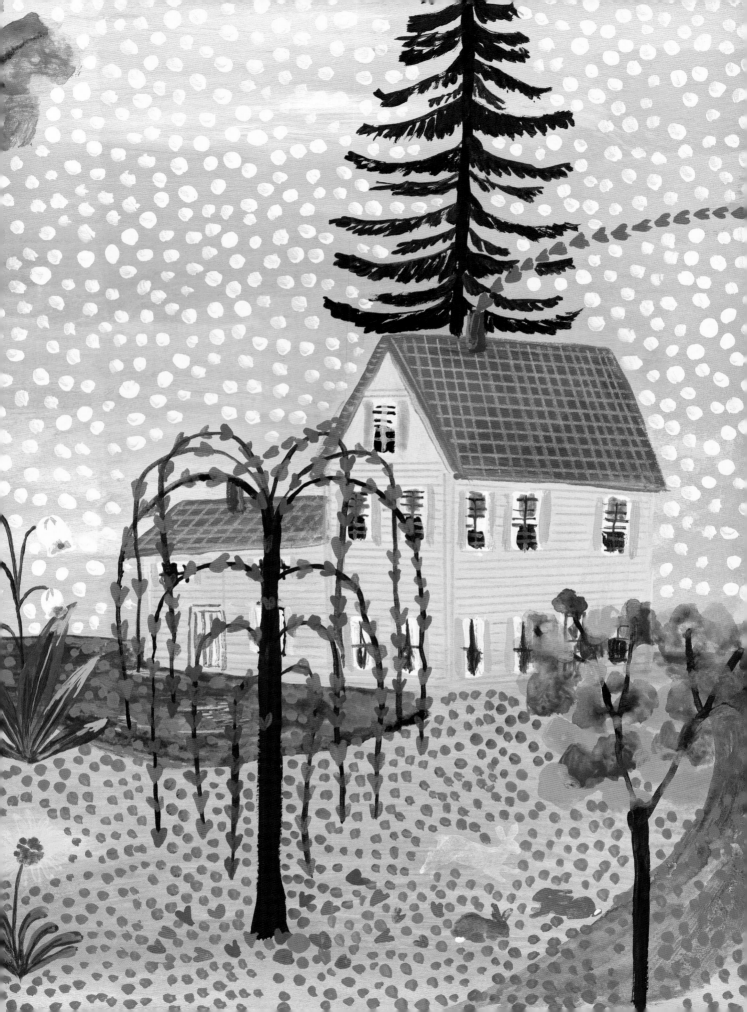

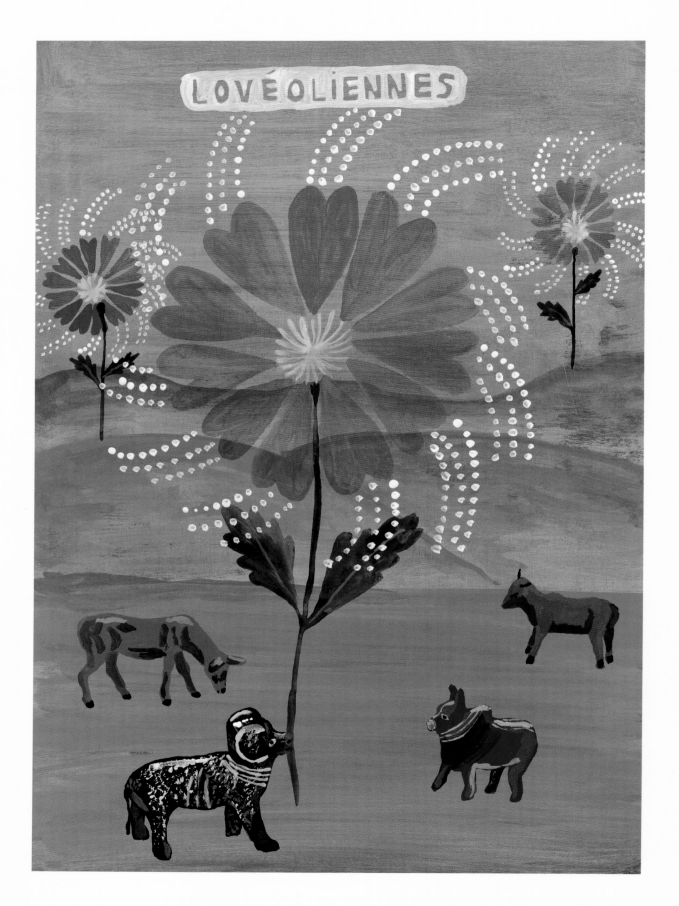

ABOVE: **Wind Turbines of Love** | *Lovéoliennes*

OPPOSITE: **The Monkeys' Rendezvous in the Cherry Tree** | *Le rendez-vous des singes dans le cerisier*

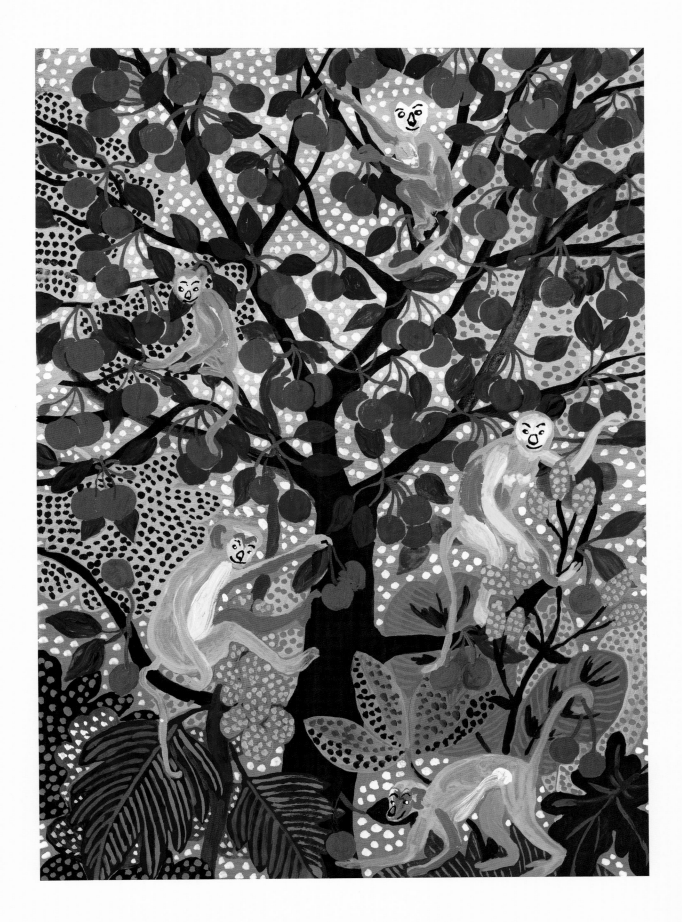

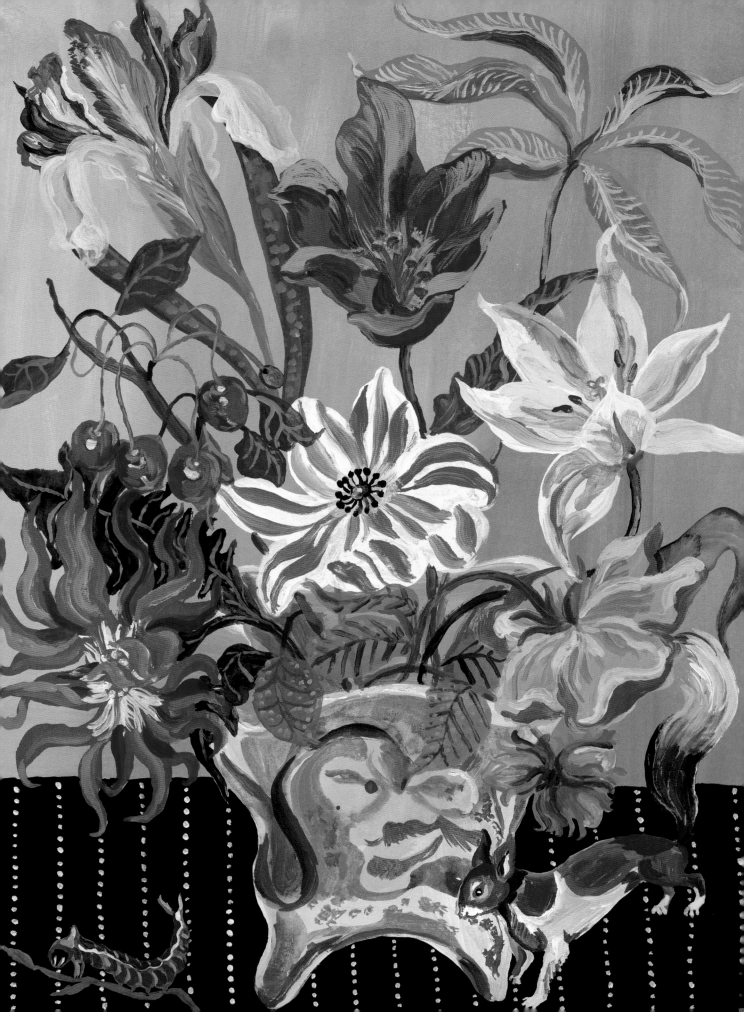

I like to paint elements of nature—flowers, fruits, and vegetables. Flowers in particular because they afford me more freedom to paint their shapes. You can be realistic, observing the flower and trying your best to faithfully re-create its species, but you can also let your imagination run free and paint it in a more decorative way, almost reflexively.

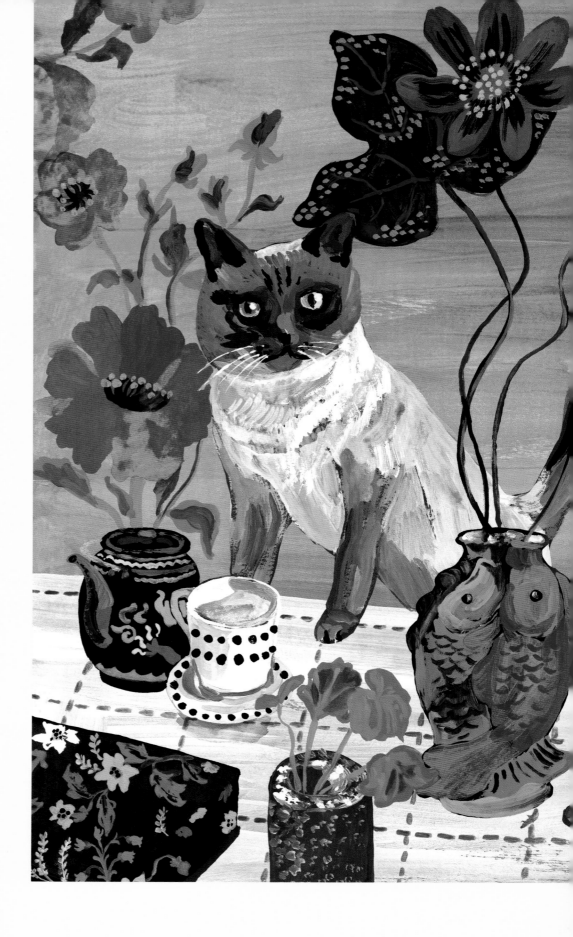

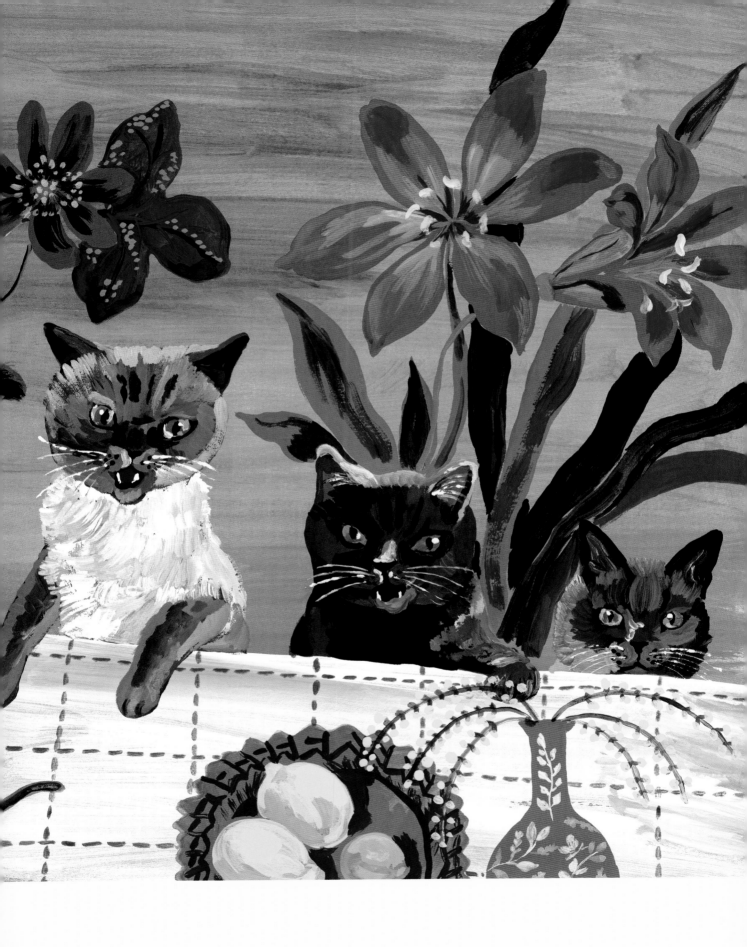

I'D LIKE TO HAVE SEVERAL LIVES SO THAT I
COULD LIVE IN DIFFERENT TYPES OF HOUSES.
I THINK THAT'S ONE REASON I LIKE PAINTING
HOUSES. IT'S A SYMBOL OF MY ENDLESS RESEARCH
INTO MY "HOME SWEET HOMES." RECENTLY I WENT
TO A NUMEROLOGIST, AND SHE SAID, "YOU ARE
OBSESSED WITH HOUSES!" AND THAT I HAD BEEN
AN ARCHITECT IN PREVIOUS LIVES. THAT DOESN'T
SURPRISE ME AT ALL!

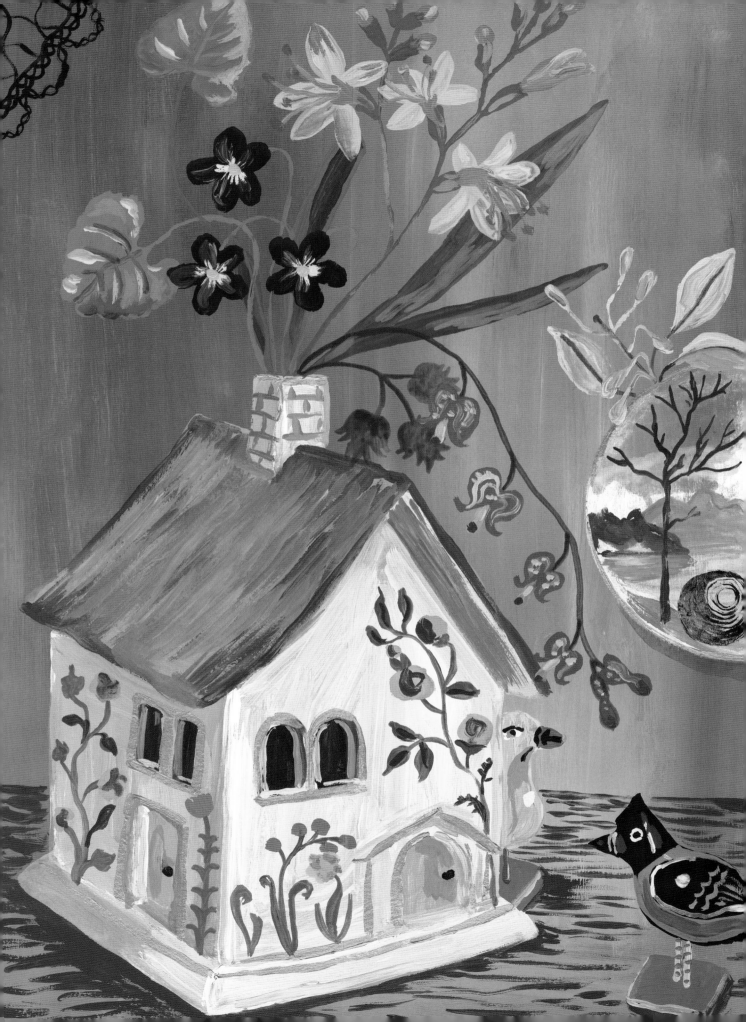

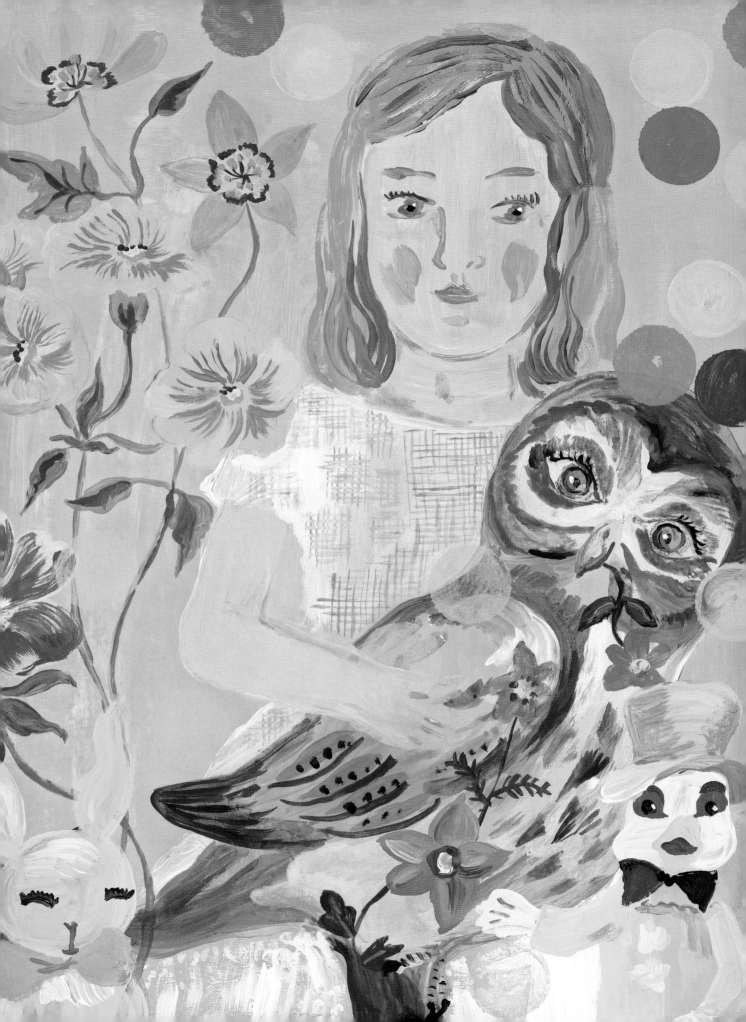

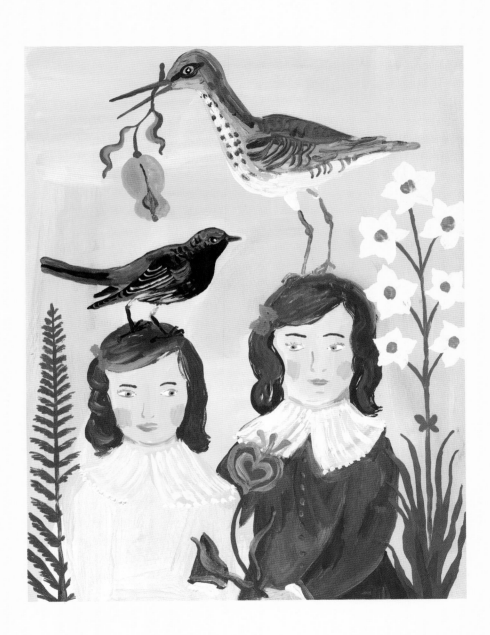

OPPOSITE: **Girl with Owl** | *La fille à la chouette*

ABOVE: **Two Sisters** | *Les deux sœurs*

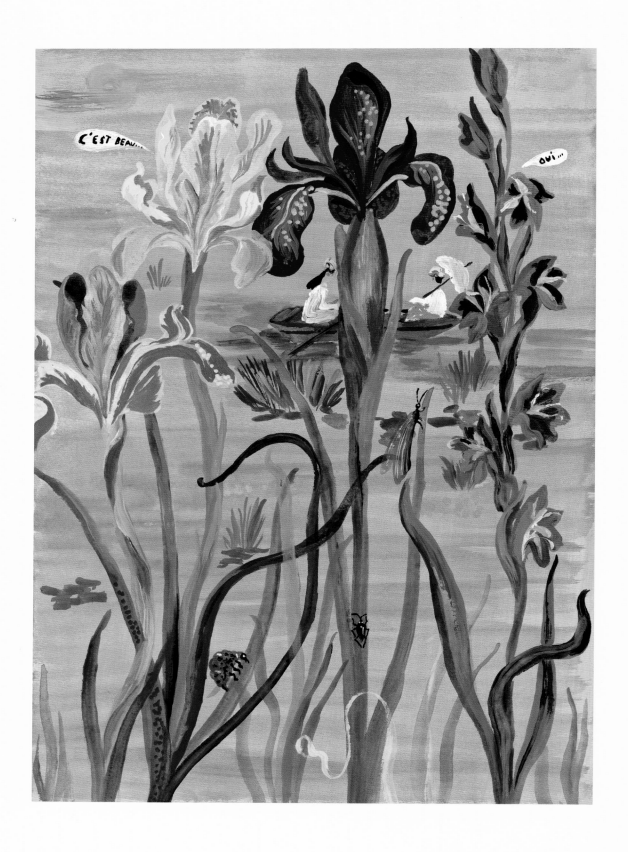

ABOVE: **It's Beautiful . . . Yes . . .** | *C'est beau . . . oui . . .*

OPPOSITE: **Follow Me** | *Suis-moi*

FOLLOWING PAGES: **Yellow Frog** | *La grenouille jaune*

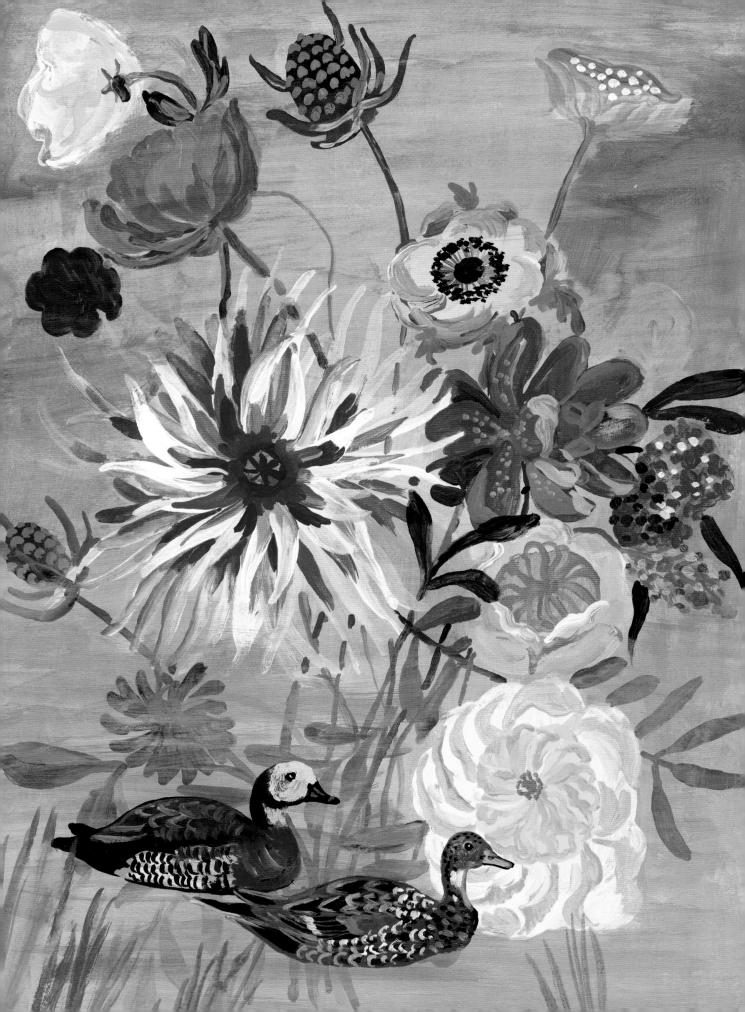

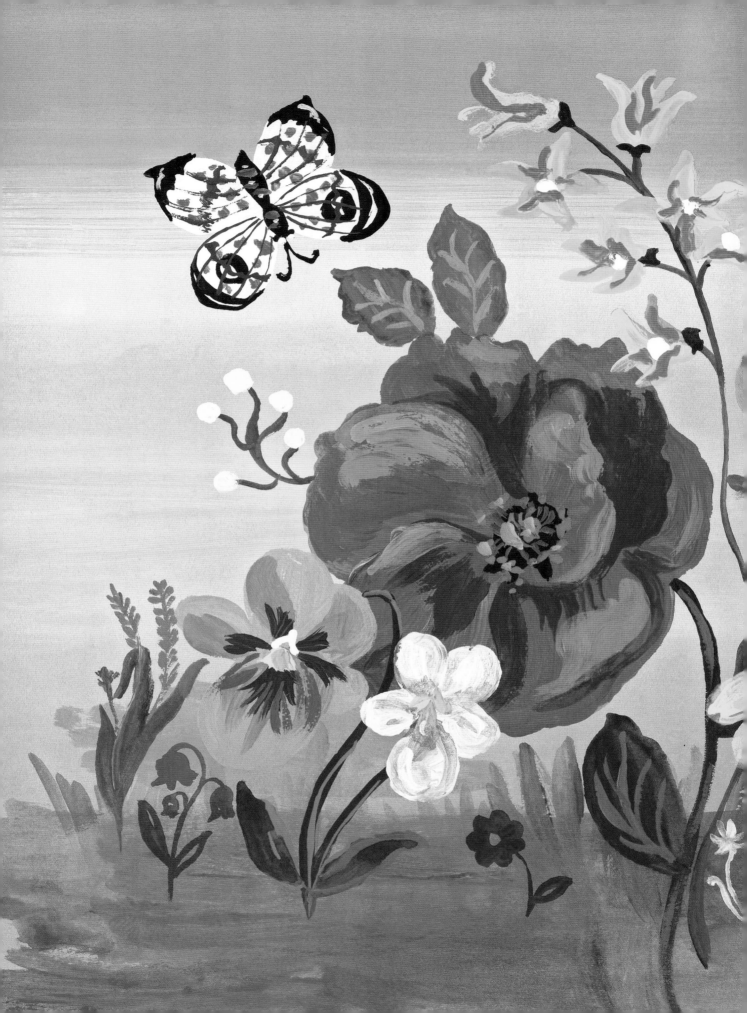

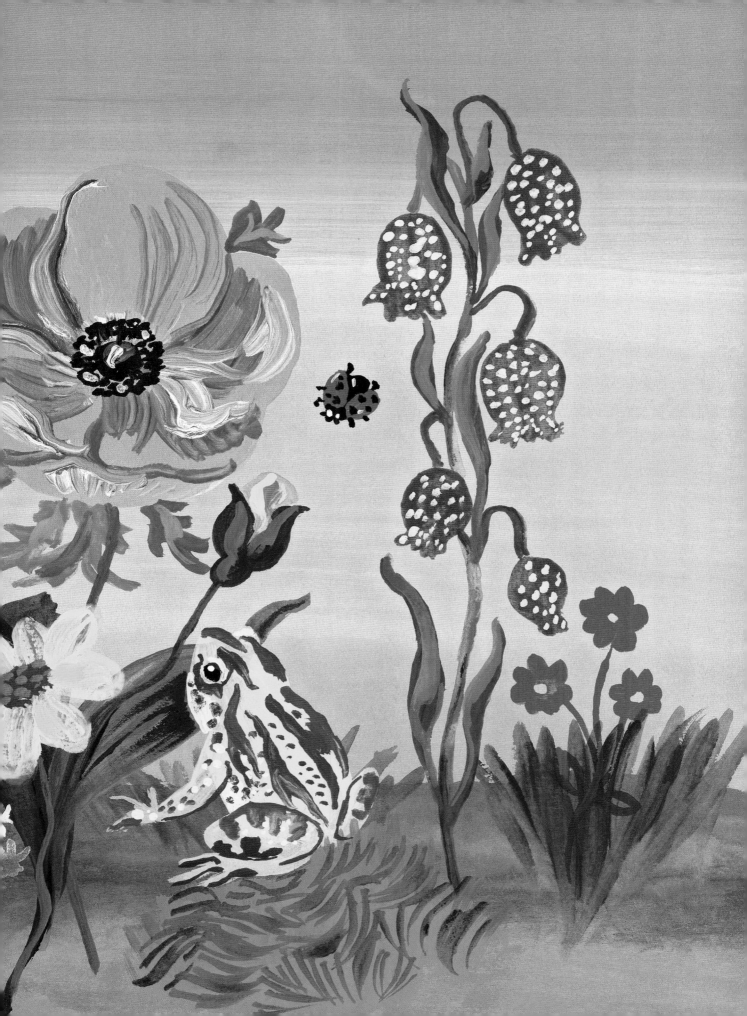

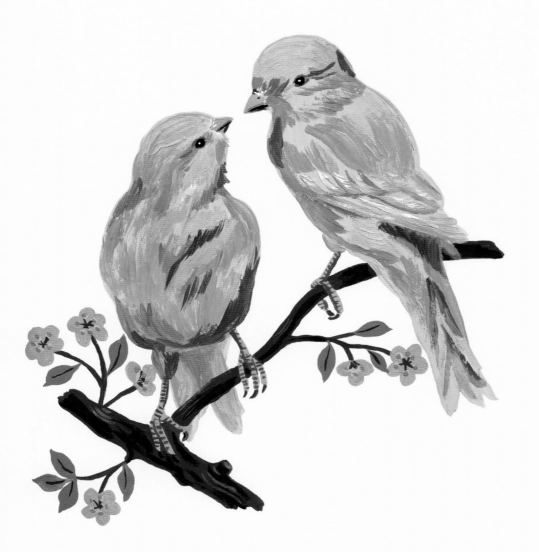

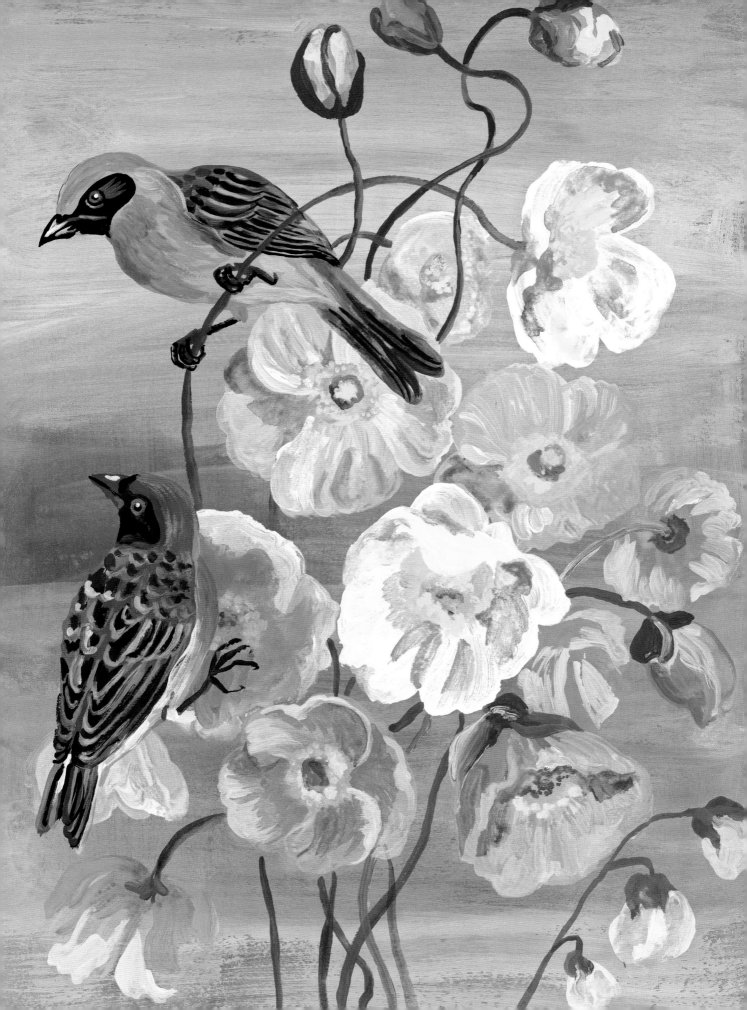

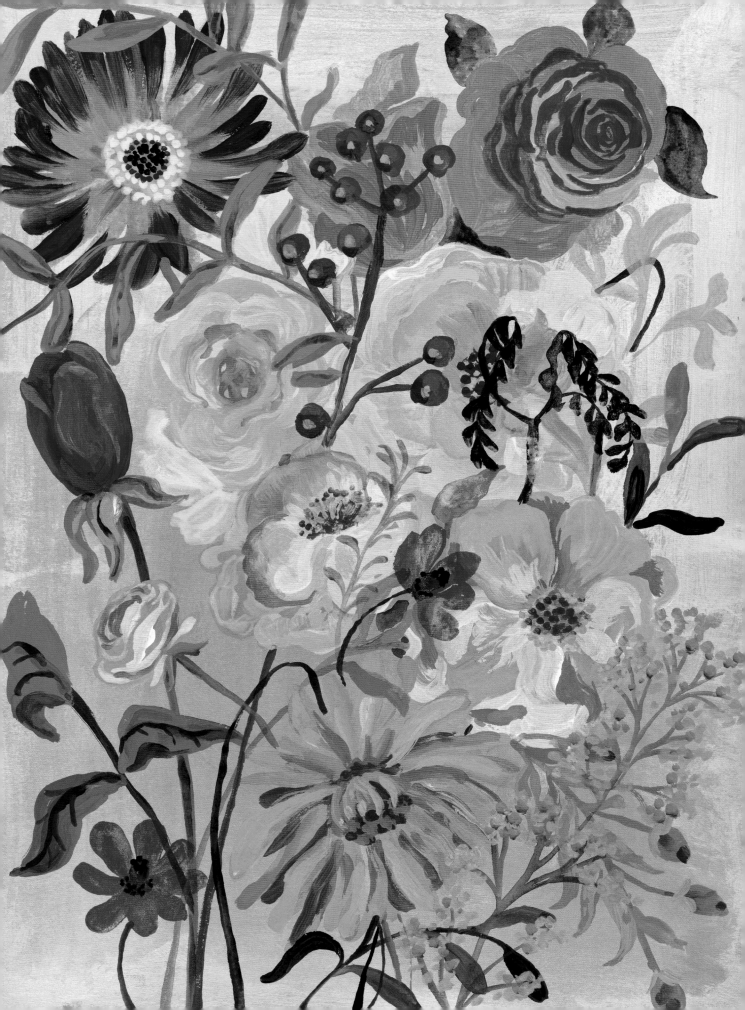

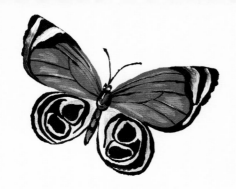

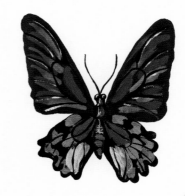

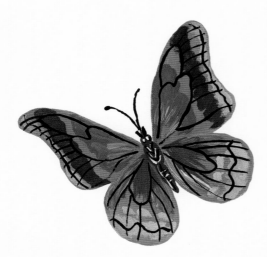

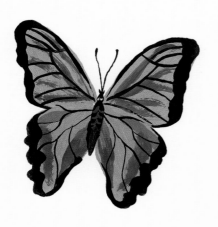

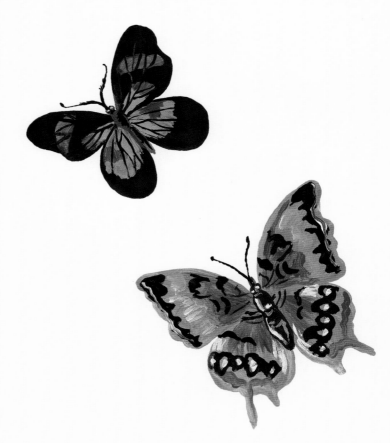

OPPOSITE: **A Spring Bouquet** | *Bouquet de printemps*

FOLLOWING PAGES: **Mating Season** | *Période des amours*

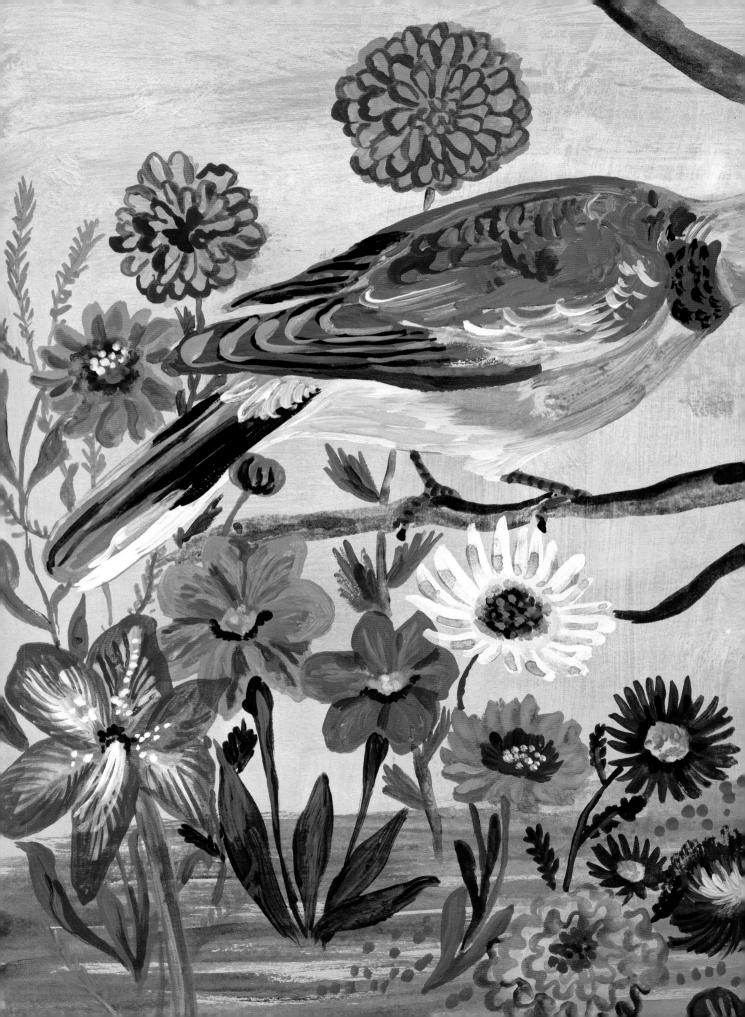

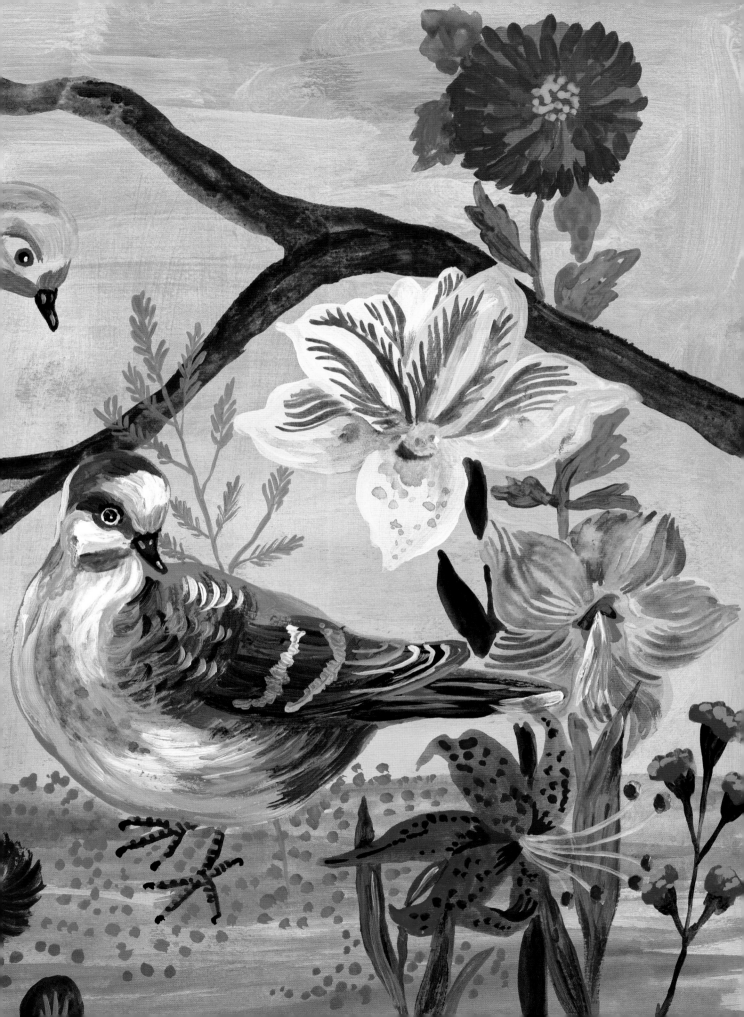

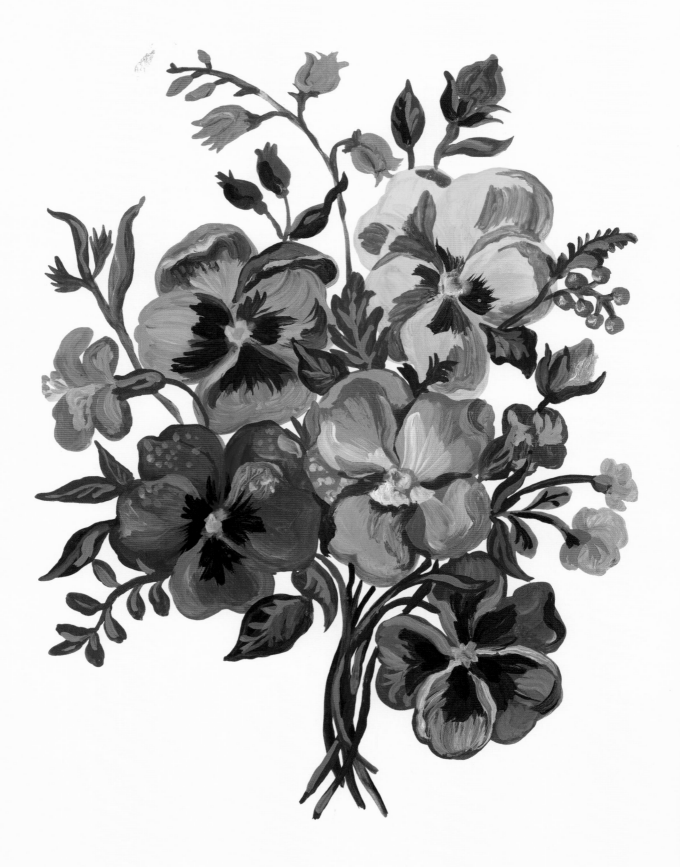

OPPOSITE: **Bird with Peonies** | *L'oiseau aux pivoines*

FOLLOWING PAGES: **Explosion of Flowers** | *Explosion de fleurs*

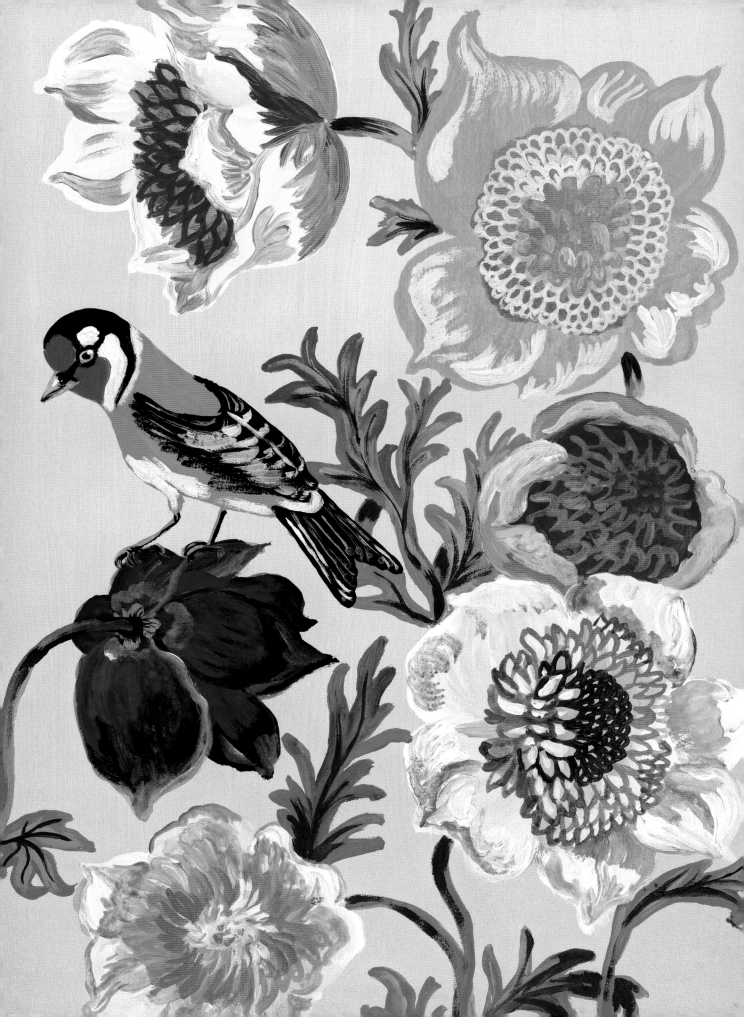

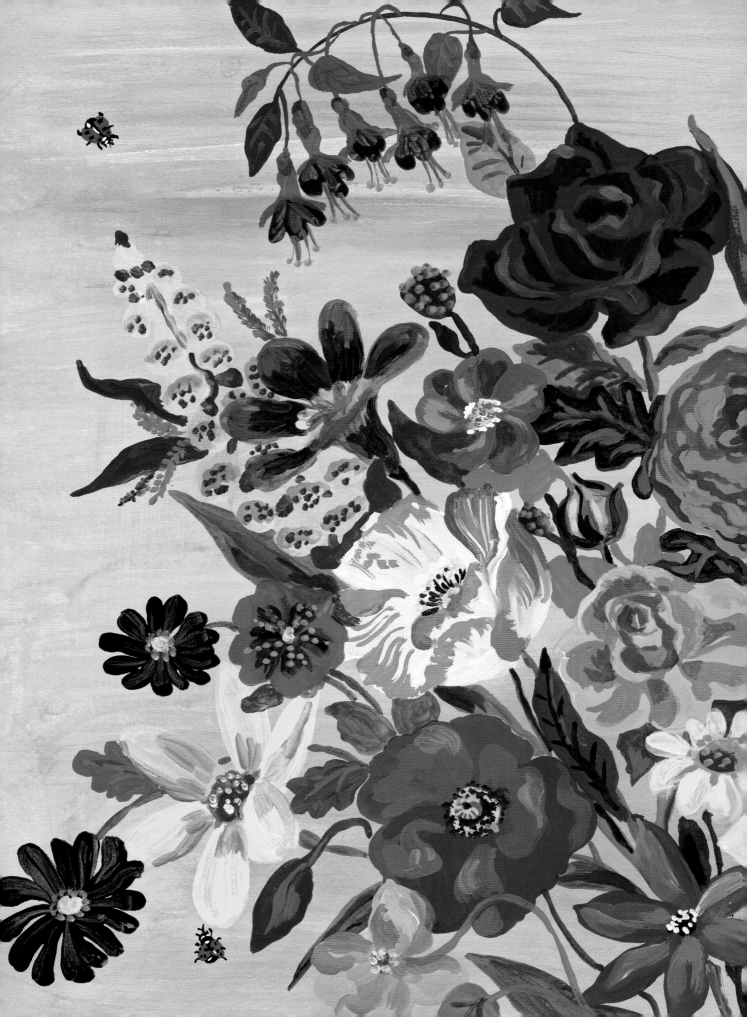

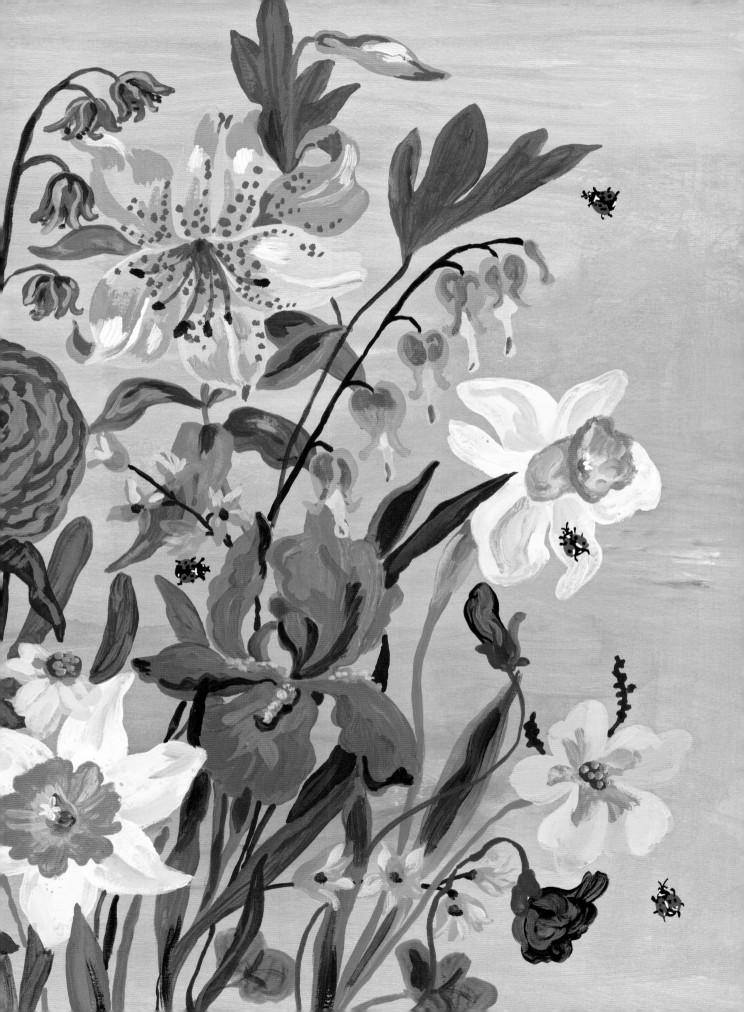

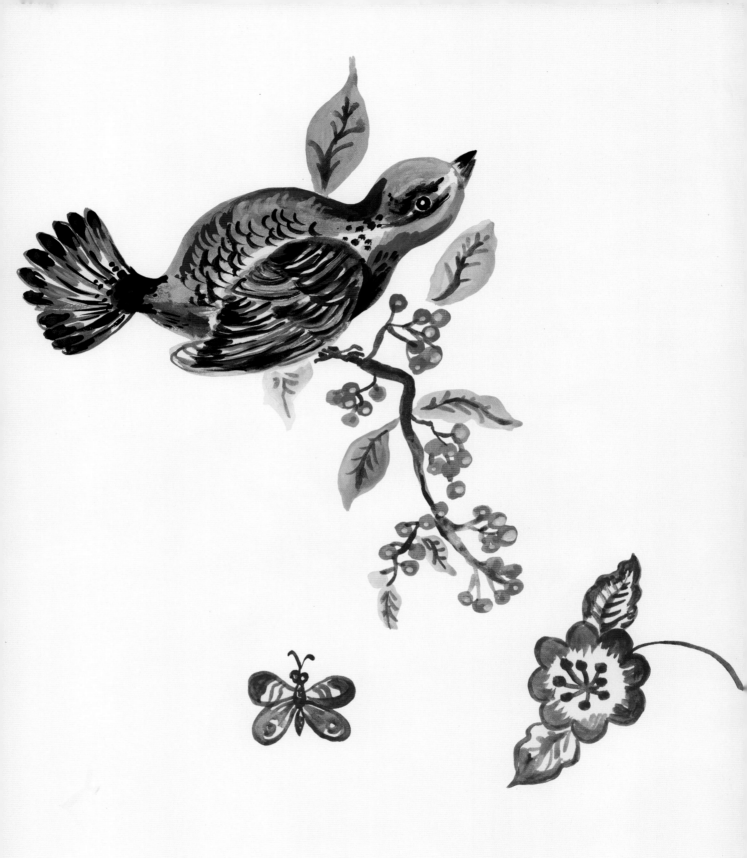

Nathalie Lété was born in France to a German mother and a Chinese father. A prolific and versatile artist, she has been commissioned to create work for brands around the world. Her paintings are used for clothing, home decor, stationery, ceramics, and textiles. She has held independent exhibitions around the globe, and in 2015, a retrospective of her work was mounted at the Musée de la Piscine in Roubaix, France. She lives and works in Paris.

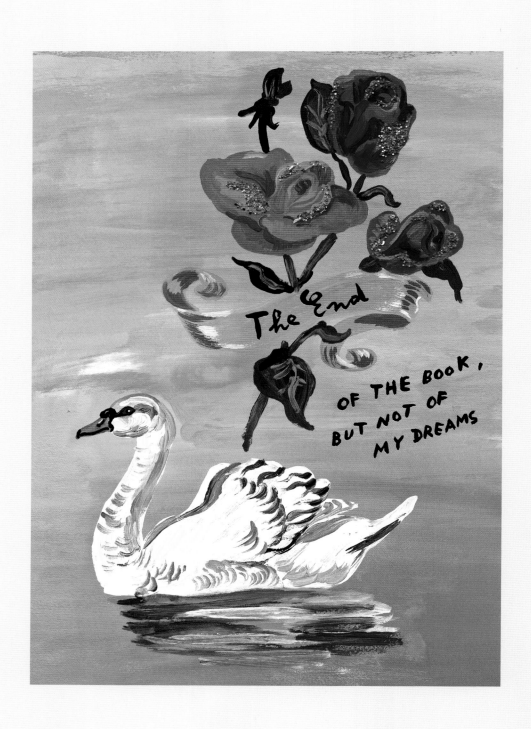

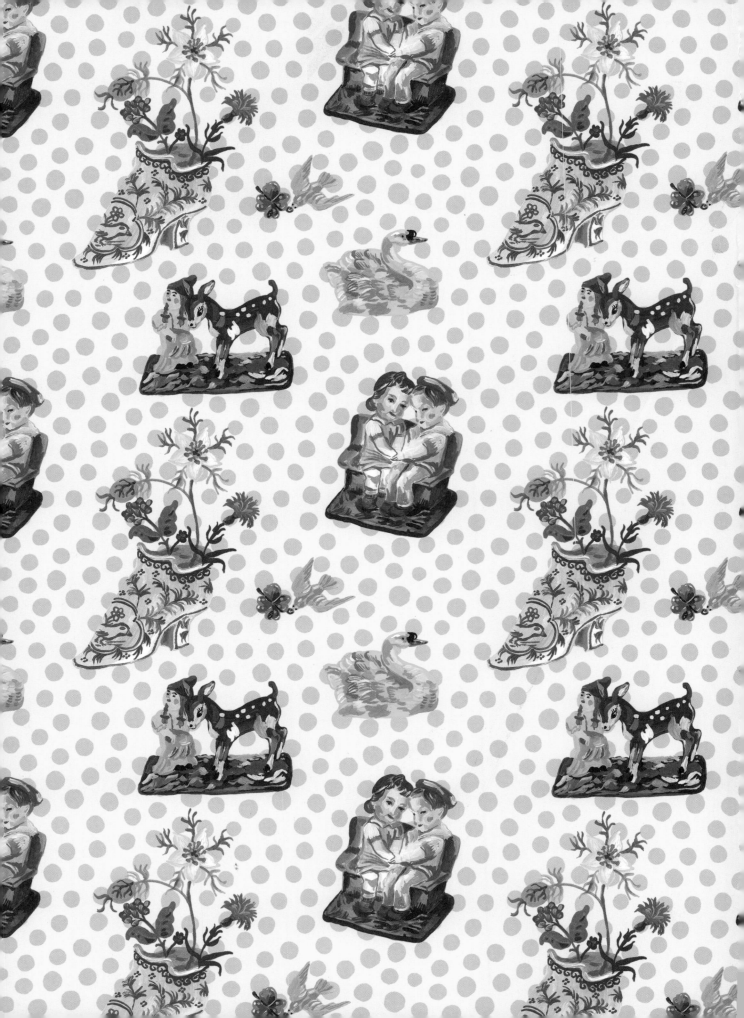